PERFORMANCE ANXIETIES

Routledge
New York and London

PERFORMANCE ANXIETIES
Staging Psychoanalysis, Staging Race

Ann Pellegrini

Published in 1997
by Routledge
29 West 35th Street
New York, NY 10001

Published in
Great Britain by
Routledge
11 New Fetter Lane
London EC4P 4EE

Copyright © 1997 by
Routledge
Printed in the
United States of America
on acid-free paper.
Book design:
Jeff Hoffman

Library of Congress Cataloging-in-Publication-Data

Pellegrini, Ann.
 Performance anxieties: staging psychoanalysis,
 staging race / by Ann Pellegrini.
 p. cm.
 Includes bibliographical references and index.
 ISBN 0-41591685-2. — ISBN 0-415-91686-0 (pbk.)
 1. Psychoanalysis and feminism.
 2. Feminity (Psychology)—Cross-cultural studies.
 3. Freud, Sigmund, 1856–1939.
 I. Title.
BF175.4.F45P45 1996 96-28337
150.19'5'082—dc20 CIP

The parallel that has been sketched here may be no more than a playful comparison.

—Sigmund Freud,
A Phylogenetic Fantasy

ACKNOWLEDGMENTS

**For my parents,
whose encouragement and love did not wait on understanding,
but were its grounds**

NOT THE least of this book's pleasures has been the opportunity to place it and myself in conversation with others. I am grateful to the friends, colleagues, and teachers who have enriched this project and deepened the challenges and rewards of its writing. My warmest appreciation is due four people without whom this project would not have been dared: Marjorie Garber, Alice Jardine, Margaret Miles, and D. A. Miller. This book and its author are the better for their humane scholarship and critical imagination. My thanks also to Daniel Boyarin, Jonathan Boyarin, Judith Butler, Diana Fuss, Jay Geller, and Carol Ockman for taking the time to read and respond to earlier versions of individual chapters or the manuscript entire and generously sharing with me their own works-in-progress.

Naomi Goldenberg invited me to a meeting of her spring 1995 graduate seminar on Religion, Gender, and Psychoanalysis at the University of Ottawa. I am grateful to her and her students for the seriousness and imagination with which they read and discussed the dissertation version of this text. Rachel Rosenthal gave her permission to use an image from her 1981 performance piece "Taboo Subjects: Performance in the Masochist Tradition" as this book's

cover. I thank her and her assistant Tad Coughenour for making it possible. A grant from Barnard College made the final stages of producing and editing this book more manageable.

At Routledge, Eric Zinner was the model of editorial patience and care (even to the point of letting me in on the secret of electronic return receipt), performing above and beyond his call of duty. Special thanks to Bill Germano for his commitment to me and this project, for his grace under pressure, and for making me think I possessed same.

Friends and colleagues in Cambridge, New York, and the elsewhere of cyberspace kept me sane (more or less) during this book's many lives. I give special notice to Liz Zale for the love and support she offered this book and me during its first life; Paul B. Franklin and Linda Garber for the gifts of their conversation and their friendship; David M. Halperin for the warm intelligence of his example; Timea Szell and Tally Kampen for losing just the right amount of patience and telling me to be done revising already; Robin Weigert for the emergency food rations and a good ear; Michael A. Snow for capturing me in black and white; Laura Levitt for the yellow shirt (this *is* how rumors get started); Liz Wiesen for not letting me get lost in the details even as she made sure I saw them; and these other lifelines in particular: Greta Edwards Anthony, Jess Gugino, David Lamberth, Elizabeth Lemons, Nancy Levene, Jane Shaw, and Kathleen Skerrett.

CONTENTS

THE *SEEN* OF DIFFERENCE
Re-Sighting the Performative

If we could divest ourselves of our corporeal existence,
and could view the things of this earth with a fresh eye
as purely thinking beings, from another planet for
instance, nothing perhaps would strike our attention
more forcibly than the fact of the existence of two sexes
among human beings, who, though so much alike in
other respects, yet mark the difference between them
with such obvious external signs.

—Sigmund Freud, "On the Sexual Theories of Children"

Difference produces great anxiety. Polarization, which is a
theatrical representation of difference, tames and binds
that anxiety. The classic example is sexual difference
which is represented as a polar opposition (active-passive,
energy-matter—all polar oppositions share the trait of
taming the anxiety that specific differences provoke).

introduction

—Jane Gallop, *The Daughter's Seduction:
Feminism and Psychoanalysis*

"DIFFERENCE," Jane Gallop understates, "produces great anxiety." But she holds out hope that feminism (and perhaps psychoanalysis) might be equipped to deal with this anxiety: "This problem of dealing with difference without constituting an opposition may just be what feminism is all about (might even be what psychoanalysis is all about)" (1982, 93). One of the things Gallop means to commend in feminism and in psychoanalysis is the way both discourses deconstruct and undermine binary oppositions.[1] How well they meet this commitment is, of course, quite another matter.

The radical promise of psychoanalytic thought lies in its destabilization of oppositions such as masculine/feminine or hetero/homo. There is, for example, a leading emphasis in Freud's sexual theories on bisexuality, continua, degrees of difference rather than on absolute, ineradicable difference. Yet, there is also much ambivalence—perhaps even constitutive ambivalence—on this

front. At the same time that Freud calls into question the absolute difference between "man" and "woman," he also reinserts sexual polarization: when he repeats what he himself terms the merely "conventional" alignment of masculinity with activity and femininity with passivity, when he asserts that the "truest" type of woman is the narcissist, when he shifts gears in the *Three Essays* to make reproductive heterosex the *telos* of female and male sexual development.[2]

Feminist theory, taking a page out of Freud's book and writing it anew, has helped to uncover the hidden assumptions of Freudian psychoanalytic theory, indicating how masculinity—Freud's protests to the contrary—slips back in as femininity's ungrounded ground. But white feminism and feminist theory too have been susceptible to a particular form of backsliding. In their commitment to expose the blind spots of patriarchal ideologies they sometimes have been blinded to their own omissions. In this, feminist theory may seem to have taken over psychoanalysis's virtual fetishization of sexual difference as its point of every return. However, I do not here want to elide important and enabling differences between and among feminisms. As Biddy Martin suggests (1994, 105), we do a great disservice to the enormous range of feminist approaches and to the women and men invested in (and by) them if we reduce these multiple feminisms to one feminism—and a guilty one at that.

Perhaps this is all to Gallop's point; "dealing with difference" has been an ongoing problem for feminist (as for psychoanalytic) theory. Even good faith efforts to recognize differences, plural, *without* either reasserting polar opposition or (what may amount to the same thing) ranking them in order of presumed priority, can occasion their own anxieties—as both feminism and psychoanalysis have also discovered.

Race, ethnicity, gender, sexuality, class, religion, nationality … and other differences. This endlessly expanding enumeration of difference—an invocation as formulaic as any Homeric catalogue—is a gesture of inclusion, feminist in its commitments, yet exasperated in its tone. Where and when does this catalogue of identificatory markers end, if it does? And what is the relation between and among them? The attempt, feminist or otherwise, to interpret the relation or set of relations between and among these terms will fail if it is conditioned, as my sentence itself has been, by a logic of additive equation. The anxiety-producing challenge for feminist theory (and for a feminist-informed psychoanalytic critique) is, as Mary Ann Doane writes, "how to acknowledge and analyze a multiplicity of differences and articulate their extraordinarily complex relation to each other, without reducing the specificity of different modes of oppression" (1991, 9).

Instead of conceiving gender, race, and sexuality (to name the three terms of difference that will occupy me in this study) in analogical relation; or instead of hierarchically ranking them, assigning priority of history, social

meaning, and/or psychical force to one term over and above the other, it is necessary to rethink these differences as inter-implicating or "interarticulated." In this model, the historical meanings and discourses of gender, race, and sexuality emerge through and against each other.

It is one of the claims of this study that the feminist project of analyzing and articulating the complex crossings of difference is implicated, for better and for worse, in psychoanalysis. This is so for a number of reasons. First, and perhaps most to my point, feminism and psychoanalysis have the "same" conceptual blind spot or—to use Gloria Anzaldúa's term—"blank spot" (1990, xx). Both discourses have tended to emphasize sexual difference over and above every or (in the case of classical psychoanalytic theory) any other difference. Where "other" differences have entered the field of vision, they have, in the main, been taken up and absorbed into the framework of sexual difference. To the extent that it refers differences of race and sexuality, for example, to "the" difference above all—the difference "man"/"woman"— feminist theory is caught up in the act of reinstating the terms of its own critique.[3] However, the way out of this impasse is not to abandon psychoanalytic categories or theory—as if psychoanalysis (and Freud) could be so easily bracketed from the narrative frame of modernity and postmodernity. What is called for is the engagement of psychoanalysis on very altered terms.

It is my own sense that feminism, as an historically situated intellectual and political project, cannot go forward without taking seriously the claims of psychoanalysis. Whether or not psychoanalysis is "true" in any descriptive sense is not the issue here (although let me "come clean" from the start and say that I believe Freud got a lot of things discomfortingly right in the theory, if not in the details). Rather—and this is my second point regarding the necessary connection of feminism and psychoanalysis—psychoanalytic claims and insights are now part of what modernity and postmodernity mean. Psychoanalysis is a powerful cultural narrative, providing patterns of order and interpretation for telling, retelling, and making sense of life experiences, and this is no less the case when the story told emerges in reaction against psychoanalysis. Psychoanalysis constitutes a rich and necessary field of meaning for feminisms to challenge and contest.

This process goes both ways. To the extent that psychoanalysis, at its origins, was spoken through and against early twentieth-century European feminisms, it makes sense to speak here of psychoanalysis and feminism as themselves interarticulated discourses.[4] Certainly, *this* study represents one such interarticulation.

When I refer to the historical and conceptual embeddedness of psychoanalysis in feminism and the "woman question," I am thinking above all of Bertha Pappenheim, the Jewish woman at the center of Josef Breuer's best known case study, "Anna O." In the decades after she concluded her analysis

3

with Breuer, Pappenheim would go on to inaugurate a very different kind of "talking cure," as founder and leading spokeswoman of the German Jüdischer Frauenbund, or "League of Jewish Women."[5] That feminism constitutes a critical backdrop for psychoanalysis is also clear from Freud's frequent allusions to feminists, more specifically to the upset he is sure his theories of female sexuality and femininity will cause them.[6]

To some degree, then, the interarticulation of psychoanalysis and feminism I am here enacting "faithfully" reenacts the "origins" of psychoanalysis. However, to borrow a phrase from Donna Haraway's "Manifesto for Cyborgs" (1990, 190), the "faithfulness" of my restaging should be seen not as reverent recapitulation or straightforward identification, but as the serious play of blasphemy. (As I will argue throughout this study, there is nothing straightforward about identification.)

But there is another way in which this study faithfully reproduces the mise-en-scène of psychoanalysis. From its beginnings, psychoanalysis was involved, through the person of Freud, in the question and the "problem" of racial difference, more specifically of *Jewish* difference. The "Jewish question," at least as it was posed for psychoanalysis, will be the focus of Part I, "Jewishness." For now, I want to make only these two related claims. First, within the anti-Semitic discourses operative in Freud's day, "the Jew" (who was always a *male* Jew) was assimilated to the category "woman." Second, Freud's theories of sexuality and sexual difference may represent Freud's attempts to work his own way out of the damning alignment of male Jewishness, the feminine, and sexual "deviance."

To say this is not, however, to reduce all of psychoanalysis to a case history of Freud and Freud only. Quite the contrary: through carefully historicized re-readings of Freud, I believe it is possible to outline new analytical models in which racial and sexual difference are understood as co-implicating (though not co-extensive). This is the explicit ambition of chapter one, in which I re-read Freud's *Fragment of an Analysis of a Case of Hysteria* in the light of recent historical work on Jewishness, "race," and gender. Much of this work has concentrated its attention on the meaning of Jewishness for male Jews. In chapters two and three, I give Sarah Bernhardt and Sandra Bernhard, respectively, center stage as I try to complicate this history by asking how and what Jewishness means for Jewish women.

I attempt throughout this study to historicize the texts I am discussing. Among other things, this involves saying something about the social, cultural, and historical pressures operating on and through a given text and its author. This is not, I want to insist, a version of the biographical fallacy. Arguably, Freud's struggles to dislodge his own identity as a male Jew from the problematic of psychoanalysis reveal at once Freud's particular historical and symbolic frame *and* the regulatory effects of socially constituted, psychi-

cally instituted sexual and racial norms. The latter schema implicates all subjects, not just Freud.

Freud is not the only figure given back to history in this study. In Part II, "Blackness," as I range across different geographical, political, and historical scenes, serving some biographical notice on Anna Deavere Smith, Frantz Fanon, and Albert Memmi becomes one way to denote the different historical meanings of blackness and the different ways in which subjects have been incorporated "as" black. Once again, however, if I mention the "interracial" marriages of Memmi and Fanon, for example, during my discussion of their erasure of women of color, I do not thereby refer either man's analyses of cross-racial desire to questions of biography. Rather, I mean to mark the sometimes tense crossings of theory and practice (to cite a binarism which is not one). Rather than conceive discrepancies or contradictions which may arise between an individual's theoretical claims and what she or he does in practice as always a question of hypocrisy, false consciousness, and/or the unconscious run amok (even if one or more of these factors may sometimes be at work), it seems to me more fruitful to reconceive such contradictions as a kind of crossing. This fraught crossing exposes the messy, often dangerous, and necessary endeavor of theorizing one's life as a way to save it and gives the lie to the too-facile division of theory "versus" practice.

My understanding of the urgent necessity, for theory and for praxis, to develop psychoanalytic models attentive both to the racialization of sexual difference and to the sexualization of racial difference has been crucially informed by the on-going work of Judith Butler. From Butler, too, I (and many other feminist and queer theorists) have been brought to conceptualize the compulsory call and response of gender under the rubric of "performativity" and "citationality" (1990a and 1993a). One of the most notable strategic accomplishments of Butler's theory of gender performatives is the way that it effectively cut through a theoretical knot, essentialism "versus" constructionism (AKA cultural feminism "versus" poststructuralism), which had been exhausting the energies and resources of feminist critique.[7] What I am trying to do is extend the concepts "performativity" and "citationality" to the experiences and idea of "race."

Instead of conceiving the relation between sex and gender as a matter of interpretation—more exactly, as a relation between *matter*, "sex," and its *interpretation*, "gender"—Butler challenges feminist theory to understand their relation as a form of citational performance. The embodied subject is that form. It is not that there "is" some Platonic idea of "sex" out there, always on the verge of our vision, but ever not quite. Rather, "sex" is a regulatory ideal or commandment, to whose perfect measure gendered subjects must always hopelessly approximate themselves. The normalizing power of "sex" is functionally dependent upon its citation, that is, upon the compulsory

5

reiteration of the law of "sex," and gender is the performative occasion of that approximation.[8]

(Mis)identifying "sex" as "nature" shores up the cultural imperatives of gender by giving them an approximate point of reference. Taken as the "natural" substance, which culture-bound understandings of gender conceal, "sex" emerges as the ultimate reality or transcendent referent of gender. In its inaccessibility to human experience, encrusted as it is in the sedimentations of discourse and history, "sex" holds out the anxious and eschatological promise of an elsewhere before discourse, outside history. Nonetheless, the theoretical limitations of thinking in terms of a sex/gender system (Gayle Rubin's term [1975]), with all it implies in the way of a covert essentialism, might themselves be usefully redirected to another, avowedly feminist task: identifying the ideological strategies whereby culture seeks to pass itself off as nature. And it is the body which is posed as the last and first best hope of holding the line between nature and culture, "sex" and gender, and perhaps also "race" and ethnicity. The body, far from "realizing" nature, is a contested discursive site through which ideological concepts are naturalized as biology. What Freud names as the "working" requirements of psychoanalysis also feature prominently among the foundational ideological props of the body, masculinity and femininity:

> But psycho-analysis cannot elucidate the intrinsic nature of what in conventional or in biological phraseology is termed "masculine" and "feminine": it simply takes over the two concepts and makes them the foundation of its work. (1920, 171)

The line separating sex from gender, and masculinity from femininity, might also be called the heterosexual bar.

Let me be very clear on this matter from the beginning. To argue, as I do, that gender, race, and sexuality are cultural, historical, and psychical "productions," and not natural givens, is in no way to deny their bodily or socio-psychical force. The point, my point, is not to establish the truth or falsity of these terms, but to point out their reality effects—which are at least conceptually separable from the facticity of their referents.

Like gender and the categories it authorizes ("male" and "female" or, in another and closely related scene, "man" and "wife"), race and racial identity are historically contingent, socially constructed categories of knowledge and bodily experience.[9] As David Theo Goldberg suggests, the concept of "race" is both artifact of and instrument for boundary construction, "[serving] to naturalize the groupings that it identifies in its own name" (1992, 559). The divisions established by race—the divisions gathered under the sign "race"—have been linguistic, biological, genetic, social, cultural, geographic,

national, aesthetic, moral, intellectual. One constant in the conceptualization of "race" seems to be the idea of descent, the belief that whatever characteristics "race" stands for or realizes, they are somehow heritable—whether through genetic inheritance, cultural commerce between generations, social or environmental impact.[10]

At different historical moments, race has signified different relations between the body and society, in-group and out-group, and self- and group-identity. Or, to put the matter slightly differently, race has not always cut the same way; the boundaries keep moving. If Sander Gilman, for instance, can meaningfully ask whether the Jew is white (1991), this is because the ways "whiteness" and "blackness" have been imagined and mapped out in the modern West have not been continuous. This is not, however, to deny marked continuities in Western images of Jews or blacks throughout the modern era. Goldberg argues that race acquires significance and meaning "in terms of prevailing social and epistemological conditions at the time, yet simultaneously [bears] with it sedimentary traces of past significations" (1992, 559).

Racial difference, like sexual difference, provides one of the instituting conditions of subjectivity. It helps to set limits between self and other, precariously identifying where the "I" ends and unknowable other begins. Whiteness, for example, defines itself in opposition to blackness; the "I" knows itself by what it is not. Thus, an hypostatized blackness is actually part of the meaning of whiteness. The race of the Other, his or her "immutable" difference (and this is a difference that conventionally assumes also a moral form, of superiority/inferiority), announces and confirms the self-identity of whiteness. But it is a self-identity that must always look anxiously outside for its confirmation, disavowing any relation between inside and outside, self and mirroring image.

And what of those who are constituted as the outside of "whiteness"? For any subject, the Law—of gender, of race, of sexuality—represents an impossible ideal. However, for racialized others, subjectification to what Butler calls "annihilating norms" imposes still harsher realities (1993a, 124). A "racial epidermal schema" (Fanon's term), imposed from without and incorporated as the "truth" of the subject, may render the body in pieces. Patricia J. Williams, Smith, Memmi, and Fanon (the subjects of Part II) speak to and detail, each in her or his own fashion, how racial identifications form and deform the bodily ego.

Even within the same generation and geographic region, the meaning of race or experience of racialization is by no means uniform or univocal. If what and how race means differs, for example, between whites and blacks, it also differs *within* those social groupings (and within individuals). The expectation that all blacks should speak as one is no less impossible a dream or coercive a hope than the demand that all women should speak in one voice, feminist.[11] Of course, the denial or erasure of differences *within* marginalized or oppressed

classes has much more often been a tactic imposed from "above" than asserted from below in the name of liberation. Homogenization, the refusal to recognize particularity, is one of the better-known mechanisms of subjugation.

It is this awareness of the way group identity has historically been forced on the colonized Other that makes Fanon so skeptical of negritude and its claims to group empowerment. For Williams and Smith, on the other hand, blackness is able to provide "moorings." Yet, differences between these self-representations of blackness are not just an effect of their different national and generational locations, but may also reflect the different positions subjects of blackness occupy at the "crossroads" race/gender. Racial difference is imbricated in other socio-psychical processes—of gender, sexuality, class, and religious-cultural identity, for example.

My own examples, or re-presentations, of the complex crossings of racial and sexual difference are drawn from a diverse range of sources, both "popular" and "elite": film, theater, professional bodybuilding, psychoanalytic texts. In reading psychoanalytic texts through and against *other* performance texts (and vice versa), I am arguing not just the impossibility of drawing the line between psychoanalysis and performance, but the hopelessness of trying to demarcate where performance ends and any "real" begins. Moreover, through the particular version of intertextuality I am enacting I mean explicitly to counter a whole series of not unrelated splittings: *physis* "versus" *psyche*, materialist critique "versus" psychoanalytic theory, Marx "versus" Freud, the boys "versus" the girls, center "versus" margin.[12]

Perhaps it is one index of my stubborn resistance to thinking in twos that I have divided this study into three and each third into three again. These three parts and the terms each is working—"Jewishness," "Blackness," and "Womanliness"—are not discrete. Rather, in keeping with my theoretical stress on the interarticulation of gender, race, and sexuality, the three parts of this study are in conversation with each other. Although one term might become the focal point of a particular part or chapter, points of contact are never far from view. In Part III, "Womanliness," for example, attention to the racial subtext of Joan Riviere's 1929 essay "Womanliness as Masquerade" in chapter seven names whiteness and suggests that gender masquerades are never only about gender. The focus of chapter eight narrows to a consideration of sexological accounts of "the" lesbian's gender trouble. Attention to the interarticulations of gender, race, and sexuality returns to orient my discussion of *Pumping Iron* and *Pumping Iron II* in chapter nine.

Where psychoanalysis in particular is concerned, the hybridity of this study does not depart from, but actually retraces the path already taken by Freud (and Fanon). Freud's psychoanalytic *corpus* is a fantastic demonstration of inter-textual citationality: to make his case, he repeatedly turns to examples from literary, theatrical, and folkloric sources. Even Freud's case histories take on the

aspect of a popular romance or melodrama in which Freud comes to supplant his analysand as the central subject. (As I will argue in Part I, Freud's recognition of the way his own "definite position" as a Jew implicates him in, for example, the scene of hysteria launches, in its turn, a series of *displacements*.) Fanon too proceeds by way of literary example. In *Black Skin, White Masks*, his principal case studies come not from "life," but from literature. Freud's and Fanon's dependence on citation does not, I suggest, constitute any deficiency in either man's methods, but their provocation. Two questions, no answers: If postmodernity is characterized as the hyper-real, hybridity verging on pastiche, am I here making psychoanalysis over in postmodernity's image? Or is the always already "mixed" medium of psychoanalysis the tale waving postmodernity's proverbial dog?

Whatever differences of genre or audience may be identified between my preferred performance texts, they share this common feature: each seems to me to represent the nonreferentiality of representation. That is, what Freud's analysis of Dora has in common with Sandra Bernhard's black (and white) masks, to take just one of my examples, or what Fanon's white masks have in common with Smith's multiple voices, to take another, is the way each unsettles what it means to "have" or "be" a subject, to "have" or "be" any identity at all.

Paradoxically, each of these "performance pieces" succeeds only to the degree that it brings its audience to identify with it. They are "collaborative" events or occasions.[13] And collaboration, as Wayne Koestenbaum reminds us, is notoriously double-edged (1989). It invites the happy scene of individuals making common cause—*identifying*—with each other. But collaboration also conjures up the troubling specter of the double agent, that treasonous representative of misplaced identifications.

It seems to me that this crisis of identification, which I am "identifying" as the critical method and madness of performance (and, so, of subjectivity), may also provide some first response to the question I have so far suppressed. Namely, where is performativity—that is, the theory of performativity—taking "us"? (And who are "we" to be taken?) If everything is performance, and everyone, at once performer and performed; if there is no "Real," but only its endless dissimulations—what (and wherefore art thou) next? Surely, no theory could have been more fit for the postmodern scene we now inhabit than this. The "trick" is to exhaust the trope of performance before it exhausts "us"—at any rate, before I have exhausted my readers with it.

In saying this, I do not align myself with those who, with something of the paranoiac's air, regard poststructuralism and postmodernism as the grandest of conspiracy's theories. If theories of performativity are such a good match for our contemporary situation, this is because performativity seems actually to describe the postmodern condition. Infomercials and "reality" programming;

9

talk shows and shock radio; criminal trials and court tv; electronic communities and virtual reality; transglobal economy and disappearing (or was it: movable?) national borders—in everyday experience, the line between "fact" and "fiction" has been blurred, if not erased.

Something more than description is needed. The political and, dare I say, ethical direction of this study consists in my attempt to tease out of the performative another (though related) challenge for theory and for practice: the challenge of identification. In psychoanalytic terms, every identification entails, at the same moment, a (corresponding?) disidentification. The classic Freudian scene of identification is the "seen" of sexual difference: seeing what the other hasn't becomes the model for all of life's misrecognitions, big and small. Fanon recapitulates Freud on identification, but with this difference: for Fanon, it is the difference white/black, not male/female, which makes all the difference in the world.

Within either conceptual frame, Freud's or Fanon's, what is clear is the alternating pleasure and danger of identification. As Freud and Freud's own textual identifications certify, identification is a restless and unpredictable process. It is less a matter of arriving at a fixed and final destination as it is of stopping off at points along the way to a somewhere or someone else. Processes of identification are the subject's constitutive condition. Through identification, individuals effectively solder their egos to others, both real and imagined. Psychoanalytic accounts of identification, of the subject divided from itself, wreak havoc on identity politics as "we" know it. Slipping the grasp of will or exceeding the wishes of conscience, identifications, unconscious and unruly, disturb the smooth surface of all-for-one and one-for-all to leave their mark on the futures, coalitions, theories, and politics we dream *and* the ones we won't. If, as Diana Fuss remarks, "identification is never outside or prior to politics" (1994, 39), neither is politics ever outside or prior to identification. Throughout this study, I try to mark the co-implication of the psychical and the political in a way that does not assign priority to either one but engages and operates through their tension.

I try to trace, as well, identification's troubling tendency to cross over into desire and vice versa. In this, I take my cue from Freud's sometimes contradictory, but always fascinating theories of identification and desire. But psychoanalysis does not just frame the other performance texts. It is also framed by them. So, for example, if my reading of Anna Deavere Smith's *Fires in the Mirror* is filtered through Fanon's *Black Skin, White Masks*, the converse is also true. I re-view Fanon's *Masks* through Smith's looking glass. The center cannot hold, because the margins keep on moving. I also want to see what happens by centrally engaging the performance in performativity *and* in psychoanalysis.[14]

If I try to get to what performativity means by citing specific performances; if I try to make the interarticulation of gender, race, and sexuality in some way

speak through these performance pieces—perhaps this is because "we" (the collective and collaborative "we" of writer and reader, performer and audience) can only catch ourselves in the act of becoming subject when we see ourselves as if through the other's "I." Theatrical, cinematic, and textual scenes of identification restage that other scene, but with a critical distance built in. For an afternoon or an evening, there is—as Anna Deavere Smith says—the possibility of "stepping back, stepping back, stepping back, stepping back" and getting a different view of things, gaining a renewed sense of ourselves (1994, 107).

Nonetheless, to return to the citation that launched this introductory excursion, "[d]ifference produces great anxiety." So too does identification. In the pages of the *New York Times*, Henry Louis Gates, Jr. has called for a new "politics of identification" (1994), which he envisions as a way round the balkanization of old-fashioned identity politics. Yet, Gates and other progressive proponents of identification politics (in whose company I would include myself) would do well to keep before them (before "us") the energizing and terrifying redirections of identification.[15] The dream of coalition, expressed by identification politics, has to take seriously the nightmares of dis- and mis-identifications uncovered by the performance pieces (psychoanalysis included) analyzed below. Nonetheless, identify and disidentify "we" must; so too must "we" be subject to and subjectivated by gender, race, and sexuality. This is what it means, in this particular time and place, to take up our own definite positions as subjects.

The problem of dealing with difference without reasserting opposition or checking off either/or—which Gallop identifies as the defining problem for feminism as for psychoanalysis—is also the problematic and the risk of my text. And, at last remove, it is Smith's hopefulness and Fanon's terror before the scene of identification that are, not the opposed poles of this text, but its doubled direction: optimism at what identifications across difference may enable; painful awareness of who and what may go missing in the scene, and the "seen," of difference.

NOTES

1 This, at least, is how Barbara Freedman interprets Gallop's claim. For the issue Freedman takes with Gallop's emphasis on polarization as a "*theatrical* representation of difference," see Freedman 1990, 57; Freedman's emphasis.

2 The purple passage in "On Narcissism" reads: "A different course is followed in the type of female most frequently met with, which is probably the purest and truest one. With the onset of puberty the maturing of the female sexual organs, which up till then have been in a condition of latency, seems to bring about an intensification of the original narcissism, and this is unfavorable to the development of a true object-choice with its accompanying sexual overvaluation. Women, especially if they grow up with good looks, develop a certain self-contentment which compensates them for the social restrictions that are imposed upon them in their choice of object" (1914b, 88–89).

3 For black and U.S. Third World feminist critiques of white feminism's "blind/spot," see—for starters—hooks 1981, Combahee River Collective 1983, and essays in Anzaldúa (ed.) 1990.

4 I am grateful to Kathleen Greider, whose gracious response to a paper I gave at the 1993 annual meeting of the American Academy of Religion pressed me to consider the historical relations of psychoanalysis and feminism from both directions.

5 See Daniel Boyarin's discussion of Pappenheim in his forthcoming study *Unheroic Conduct: The Rise of Heterosexuality and the Invention of the Jewish Man.*

6 See, for example, Freud's essays "Some Psychical Consequences of the Anatomical Distinction Between the Sexes" (1925, 258), "Female Sexuality" (1931, 230n1), and "Femininity" (1933, 116–17).

7 For some other routes through this impasse, see Fuss 1989 and de Lauretis 1989.

8 For a clarification of these views, see Butler 1993a, esp. 9–13.

9 There is a growing and rich bibliography that examines the historical and epistemological claims of and to "race." My own understanding of race as contingent, historical, and contested has been influenced by Appiah 1992; Gilman 1993a; Goldberg 1992; Harding (ed.) 1993; Roediger 1994.

10 In making this claim, I am explicitly challenging the views of David Theo Goldberg (1992), who argues, contra Appiah, that "race" does not always entail a commitment to biologically based difference.

11 On the way that the ideal of community may reinstate oppositions between "us" and "them," see my discussion of Anna Deavere Smith's *Fires in the Mirror* (chapter four), and see Iris Marion Young (1990).

12 I am in sympathy with Peggy Phelan's strategy for resisting these splittings (1993, 167-80).

13 Cf. Phelan 1993, 173.

14 Freud's theory of identification displays a fascinating (and at times fasci-nated) relation to the theatrical. His account depends upon theatrical metaphors, such as "character" and "imitation," as well as his own skill in depicting scenes, subject matter, and personalities his readers might rec-ognize. In this regard, his method and ambition are not so far from the ones he attributes to playwrights and actors in the posthumously pub-lished essay on "Psychopathic Characters on the Stage" (1942 [1905-6], 305).

15 The question of identification's political re-uses also occupies Diana Fuss in *Identification Papers* (1995). Her cautionary approach has informed and enlarged my own concern with the psychical and political stakes of identification(s).

13

JEWISHNESS

…I found that
I was expected
to feel myself
inferior and an
alien because I
was a Jew. I
refused
absolutely to
do the first of
these things. I
have never
been able to
see why I
should feel
ashamed of
my descent or,
as people were
beginning to
say, of my
"race."

—Sigmund
 Freud,
An Autobio-
graphical Study

Part I

JEWISHNESS AS GENDER
Changing Freud's Subject

Throughout history people have knocked their heads against the riddle of femininity....

—Sigmund Freud, "Femininity"

Our investigation may perhaps have thrown a little light on the question of how the Jewish people have acquired the characteristics which distinguish them. Less light has been thrown on the problem of how it is that they have been able to retain their individuality till the present day. But exhaustive answers to such riddles cannot in fairness be either demanded or expected.

—Sigmund Freud, *Moses and Monotheism*

WITHIN THE western—and Christian—imagination "Jewish difference" has been articulated through overlapping and often contradictory appeals to "race," gender, religion, and nation. The intersection of race and gender at and *as* the site of Jewishness can be seen in much of the popular and "scientific" literature of nineteenth- and early twentieth-century Germany and Austria, where a stereotyped femininity underwrote representations of Jewishness. For Jewish male bodies, marked for an anti-Semitic imaginary as "black," "effeminate," and "queer," the sexualization of "race" and the racialization of "sex" were constitutive features. Indeed, the feminization of Jewish men was so frequent a theme in this period that Jewishness—more precisely, the Jewishness of male Jews—became as much a category of gender as of race.[1] It remains to be asked what such "interarticulations" (to borrow Judith Butler's formulation) of gender and race may have meant for Jewish women.[2]

The Jewish male's putative effeminacy came to signal "the" Jewish people's "racial" difference, effectively eliding differences between Jewish men and Jewish women.[3] For example, many of the medical conditions for which all Jews were held to be at higher risk as a "race" were the same conditions to which all women were believed predisposed as a "sex." Perhaps the most telling case in point is hysteria. The root "cause" of Jews' allegedly heightened risk for hysteria was much debated, with some putting it down to environmental factors (including anti-Semitism) and others, to heredity ("race"). Not in dispute, however, were claims, by fin de siècle medical specialists in Europe and the United States, that hysteria and other forms of mental illness occurred with greater frequency among Jews (Gilman 1993a, 111-13). Although hysteria's principal sufferers and "textbook cases" were women, a high incidence of hysteria among Jewish men, especially Jewish men from Eastern Europe, supposedly distinguished Jewish men from other men. Images of the "eternal Jew" here converge with the "eternal feminine" to articulate the male Jew's "racial" difference from his Aryan counterpart through and as "sexual difference."[4]

But what room does the intensely anti-Semitic and implicitly misogynist identification of male Jews with "woman" leave for Jewish women? The collapse of Jewish masculinity into an abject femininity displaces Jewish women. Yet, Jewish women, differently from but no less than Jewish men, were objects and subjects of sexualized and racialized forms of knowledge/power: the stereotype. In an important essay on "The Other Question," Homi K. Bhabha describes the stereotype as a mode of differentiation which does not just secure the borders between "us" and "them," but also articulates ambivalent points of identification for racialized and sexualized others.[5] Putting Bhabha's observation together with Butler's reformulation of social construction in *Bodies that Matter*, we might say that stereotypes participate in "a process of materialization" that produces the body as an "effect of boundary, fixity, and surface" (Butler 1993a, 9). How did stereotypes of "the Jewess" bear on the Jewish female body? One of the ambitions of this section is to bring the construction of the Jewish female more directly into analysis, though it is not my aim to emphasize sexual difference over and against racial difference in order to make the Jewish female body appear.

Significantly, in the homology Jew-as-woman, the Jewish female body goes missing. All Jews are womanly; but no women are Jews.[6] This, at any rate, is one of the consequences of Otto Weininger's infamous 1903 study, *Sex and Character*. For Weininger, Jew clearly means *male* Jew. He explicitly refers to "the Jewess" in only one passage in *Sex and Character,* and there, as Nancy A. Harrowitz and Barbara Hyams have also noted, to indicate how the deficiencies of Jewish masculinity set the Jewish woman's chances at achieving full subjectivity even lower than the Aryan woman's.[7] The displacement of Jewish

women from the scene of Jewishness is also one of the unfortunate side effects of Sander L. Gilman's pathbreaking studies of race, gender, and Jewishness. Gilman has framed his arguments through and around the Jewish male. For the most part, the Jewish female enters the frame of analysis only to exit as a man in female drag.[8]

Ironically, during the very period in which Weininger was writing, which is also the historical period Gilman examines, Jewish women—far from disappearing from the scene—prominently figured in the literary and aesthetic imagination of fin de siècle Europe. In the novels of Eliot, James, and Proust, for example, Jewish women are exotic and erotic spectacles. Moreover, to name two celebrated figures from "real" life, the French stage was dominated and dazzled by Rachel in the first half of the nineteenth century and then, in the latter half and into the early decades of the twentieth century, by Sarah Bernhardt. Both women were also international stars, their exploits on stage and off frequently the subject of newspaper profiles and of popular and "high society" gossip. Jewishness—as performatively constituted and publicly performed—clearly needs to be thought through the female Jewish body, no less than through the male.

In what follows I want to restage some representative performances of the Jewish female body. I revisit Freud's Dora, laying especial stress upon the status of the name. My interest in this opening movement is to show how Freud's transcription of the signs of male Jewishness into the enigma of woman and femininity does not finally succeed in erasing either the male or *female* Jewish body. These claims will be fleshed out more directly entr'acte, when the image of another Dora takes the stage. Next I move to a recent and contradictory occasion of Jewish female performativity, Sandra Bernhard's 1990 film, *Without You I'm Nothing.* My reading of Sandra Bernhard's queer (and queerly Jewish) enactments is an analogy extended: I trace theatrical tropes of performance quite nearly to their source. In other words, I make Sandra Bernhard perform for me.

19

To introduce "race" into the domain of psychoanalysis is also a retrieval. Psychoanalysis, after all, dates to an historical period when the medical and natural sciences were deeply concerned with and, to some degree, even determined by biological theories of race. In the historical context of psychoanalysis, race means "Jewishness." Nor is this only because of the historical fact that the founders and leading practitioners of psychoanalysis were Jewish.[9] Within the "thought-collective" of late nineteenth-century Austro-German medical science, "race" called up the opposition "Jew/Aryan."[10] In the increasingly secular, urban landscape of nineteenth-century Europe, categories of religious difference, Christian/Jew, were transformed into categories of "racial" science, Aryan/Jew (Gilman 1991, 202).

Nonetheless, the transformation was not total. The opposition Jew/Aryan vacillates among boundaries based on religion and culture (Jew as standing in for Judaism; Aryan as the standard-bearer for an unnamed, but always implicit Christianity), "race" (Jew and Aryan as opposed racial categories in the emerging "science" of race), and language (Aryan as the name for a family of languages whose influence and highly "evolved" character contrasts with the "static," "immutable" Semitic languages).[11] This vacillation is itself instructive, indicating as it does the competing discourses which mapped late nineteenth- and early twentieth-century imagination of Jewishness variously into religion, nation, and race. Thinking *das Wesen des Judentums* through racial difference did not replace thinking the essence of Judaism through religious or cultural difference.[12] Rather, the rhetoric of "race" secularized the difference of the Jewish body from the Christian body (Gilman 1991, 38).

But it is important not to lay too much stress on this rhetorical shift from the language of theology to the language of scientific reason, especially given the epistemological links between these two world views. Eve Kosofsky Sedgwick's challenge to historians of sexuality is worth repeating in this context. In *Epistemology of the Closet*, Sedgwick criticizes attempts to locate a great paradigm shift in the definitional understanding of homosexuality. Such efforts, she argues, have the effect of flattening out "a space of overlapping, contradictory, and conflictual definitional forces" into a unidirectional, coherent narrative field (1990, 44-48). This insight applies also to contemporary efforts to understand the historical meanings of Jewishness and anti-Semitism. Discontinuity and "rupture" do not tell the whole story; neither does continuity. Gavin Langmuir argues that the transhistorical application of the term "anti-Semitism" unwittingly replays the racist stereotype of Jews as "unchangeable," "eternal," a people outside history (1990).

The historical forms taken by anti-Semitic discourse in the nineteenth century were informed not only by emerging racial "sciences," but by developments in anthropology and ethnology. Increasingly, Jewish difference was charted across a geography of race, and "black" Africa was one region to which the racial difference of the Jew was frequently traced back. The putative blackness of the Jew was a sign of racial mixing and, so, racial degeneration. The English anti-Semite Houston Stewart Chamberlain attributed Jews' "mongrel" nature to their indiscriminate race-mixing; during the period of their Alexandrian exile, Chamberlain asserted, Jews had "interbred" with black Africans (qtd. in Gilman 1993a, 21). In 1935, W.W. Kopp could warn of the dangers Jewish blood posed to Aryan stock; race-mixing with Jews was liable to produce offspring with notably "Jewish-Negroid" features (qtd. in Gilman 1993a, 22).

Nonetheless, "color" was not the only nor even the dominant way of imagining the racial otherness of Jews. Moreover, even in instances where color-coding was the privileged mechanism for "fixing" Jewish difference, the color

was as likely to be "yellow" as black. The eighteenth-century Jewish physician Elcan Isaac Wolf identified the Jew's "black-yellow" skin color with disease (qtd. in Gilman 1993a, 20). Additionally, as Gilman points out, the Jew was also represented as a *Mischling*, or "half-breed" (1991, 101–2, 175–76; 1993a, 21–22). Gilman does not himself pursue what seems to me the fascinating contradictions and ambivalences between the Jew as "black" and the Jew as "mulatto." However, this mixed characterization necessarily complicates and destabilizes the terms of the black–white dyad. Perhaps it is possible to make only this qualified claim, then: the Jew was not "white," but was rather—to borrow Daniel Boyarin's term—"off-white."[13] As a kind of third term, Jewishness may thus represent the crisis of racial definition. Moreover, to the extent that management of the male Jew's difference was carried out, in large part, by assimilating him to the category "woman," the wishful containment of his racial difference potentially provokes other anxieties and category crises—of gender and sexuality, for example.[14]

Fascinatingly, at the same time (and often by the same people) that Jews were accused of too much crossing racial lines, they were also held to exemplify the perils of *in*-breeding.[15] In her study of eighteenth- and nineteenth-century British animal husbandry, Harriet Ritvo points to the stress set on maintaining just the right balance between going outside and staying within "family" lines. Ritvo suggests that the anxious attention taxonomists and animal breeders gave to the question of demarcating, managing, and naming "variety" may represent the displacement of broader cultural concerns over (and fascination with) differences within the "races of man" (1994). The parallels Ritvo identifies may provide some interpretive leverage for understanding how it is that Jews could be held to represent the dangers at once of too much and too little race-mixing. At both poles—hybridization (exogamy) and conservation (endogamy)—Jews were conceptualized as exceeding the norm. They were a "people" too much of extremes.

The problematics of racialized Jewishness provide the subtext for much of Freud's case studies. Freud, the Jewish scientist, was crucially implicated in medical narratives that placed the Jew, particularly the male Jew, at special risk for such diseases as syphilis and hysteria.[16] As Jay Geller has noted, the new bio-politics of anti-Semitism were shaped by—and adapted to—the changing economic, political, and social landscapes of nineteenth-century Central Europe. The emergence of political anti-Semitism with its often biologistic frame, Geller explains, coincided with the rapid development and advancement of syphilogical discourses (1992a, 22–23). Syphilology was harnessed to a political program whose aim was as much the management and containment of socially marginal(ized) populations—among them prostitutes, first generation feminists, and Jews (24)—as it was the management and containment of a contagious disease.

In order to put off these debilitating associations Freud transformed a medical discourse about masculinity and "race" into a discourse about femininity and "sex" (Gilman 1991, 81; 1993a, 44). Crucial to this project was removing the Jewish male from the scene—and "seen"—of femininity. This required concealing the Jewish male's hypervisible body, for his womanliness was written on and through that body. The caricatured signs of his effeminacy were visible in his stumbling gait and effete mannerisms, audible in his singsong voice, and detectable in his "peculiar" sexual tastes.[17]

This association between the Jewish male body and womanliness has a long history in European thought. A myth of Jewish male menstruation, for example, dates back to the medieval period, if not earlier. According to this tradition, although both Jewish men and women required Christian blood to cure the peculiar ailments of the Jewish body—such as copious hemorrhages, hemorrhoids, mysterious skin diseases, and sores that gave forth an unpleasant odor (a continuation, perhaps, of the fabled *foetor Judaicus*?)—the male Jew had a special complaint. In the words of a forcibly extracted 1494 "confession," the male Jew required a "remedy for the alleviation of the wound of circumcision" (qtd. in Trachtenberg 1943, 50, 149). The leading sign and originating occasion for Jewish male effeminacy, then, was the circumcised penis.

In Freud's own day, the myth of Jewish male menstruation underwent a curious, but historically symptomatic, revival. Magnus Hirschfeld, an early leader in the German homosexual rights movement and proponent of the "third sex" view of homosexuality, cited male menstruation as one of the "proofs" of a continuum between male and female sexuality (Gilman 1987, 303). For Hirschfeld, himself both Jewish and homosexual, the dangerously proximate body of the Jewish male could not be the exemplary site of male menstruation. Instead, Hirschfeld documented and analyzed the "neutral" case studies of menstruating hermaphrodites.

Even Freud was disposed to a version of male periodicity, that of Wilhelm Fliess. (Of course, if Freud was for a time enamored of Fliess's theory, this is because he was—again, for a time—enamored of Fliess himself.) In his letters to Fliess, Freud discusses his own monthly cycle. In a letter dated 15 October 1897, Freud tells his friend about the physical sensation that interrupted his (Freud's) self-analysis:

> ...I had the feeling of being tied up inside ... and I was really disconsolate until I found that these same three days (twenty-eight days ago) were the bearers of identical somatic phenomena. Actually only two bad days with a remission in between. From this one should draw the conclusion that the female period is not conducive to work. (1985, 270)[18]

The site of Freud's discharge was his nose, and in this may perhaps be detected a displacement upwards, from genitals to face.[19] Moreover, as in other

instances where Freud attempts to universalize a condition strongly, even uniquely, identified with the Jewish (male) body, Freud attempts to transform male menstruation from a sign of difference into a universal condition. Accordingly, the universal law of male periodicity became part of Freud's evidence for the universal condition of bisexuality (Gilman 1987, 304).

The feminization of the Jewish male body took on especial significance for the health of the body politic, which was identified with masculine vigor. Otto Rank, a prominent and Jewish member of Freud's Viennese circle, called Jews "women among the people," who must "above all join themselves to the masculine life-source if they are to become 'productive'" (rpt. in Klein 1981, 171). For another Otto (Weininger), Jewish male effeminacy had profound psychological and political meaning for the entire age. His bestselling 1903 study *Sex and Character*, which went through twenty-five printings in almost as many years, doubled as an attack on two late nineteenth-century emancipation movements, those of Jews and women.[20]

In the penultimate chapter of *Sex and Character*, "Judaism," Weininger joins the "woman question" to the "Jewish question." He takes up, reworks, and reinforces popular and "scientific" images of womanly Jews. In passage after passage Weininger pursues the homology of Jew and woman: "It is [the] want of depth which explains the absence of truly great Jews; like women, they are without any trace of genius" (316). Or again, "The congruity between Jews and women further reveals itself in the extreme adaptability of the Jews, in their great talent for journalism, the 'mobility' of their minds, their lack of deep-rooted and original ideas, in fact the mode in which, like women, because they are nothing, they can become everything" (320). But it is not just the Jew who is susceptible to the effeminizing character of Jewishness. In an age Weininger calls "not only the most Jewish but the most feminine" (329), Jewishness is a "tendency of mind," latent in all mankind, but "actual in the most conspicuous fashion only amongst the Jews" (303). His pseudo-scientific evaluation of the Jewish character installs Jews as a potential threat to the general health and psychological well-being of the body politic, while his uneasy attempt to distinguish between Jews and a Platonic idea of Jewishness—in which both Aryan and Jew might have a share—ultimately fails. However much Weininger insists on the distinction between Jews in "fact" and Jews in "spirit," he yet allows how it is in historical Jewry that the fullest embodiment of the Jewish spirit may be seen. This failure parallels Weininger's conflation of the abstract principles of maleness and femaleness—the twin foci of *Sex and Character*—with men and women, respectively.

Although *Sex and Character* represents itself as a "scientific" treatise on the nature of "man" and "woman," the insistence with which Weininger pursues the "homology of Jew and woman" (309) in his penultimate chapter indicates how thoroughly the social meanings of "race" and gender inform each other. The specific forms this interarticulation took also reflect deeply held anxieties—

23

and not Weininger's alone—about the increasing visibility of women and Jews in fin de siècle Austrian and, more broadly, Central European public life.

Weininger helped to seal the public notoriety of his book by committing suicide at the age of 23, some six months after the first German publication of *Sex and Character*, in the same house where Beethoven had died. But if Weininger's "self-hating" relationship to his own Jewishness cannot explain his suicide, his suicide cannot explain, nor explain away, the enormous popular and specialist audience Weininger's book reached.[21] Such "personalized" aetiologies leave out of view the larger social context the book was operating in and on. *Sex and Character*'s "success" depended in large part on its ability to lend legitimacy to popular prejudices, to blend the discourse of science with the discourse of stereotype.[22] To read Weininger in context, then, is not to read away either his anti-Semitism or his misogyny, but to historicize their terms and his situation.

Freud read the book in draft form *before* Weininger had added his concluding chapter on the Jewish character. Yet Freud was sufficiently familiar with the arguments of the published version to "feature" Weininger in a 1909 footnote, in the case history of "Little Hans," concerning the origins of anti-Semitism:

> The castration complex is the deepest unconscious root of anti-semitism; for even in the nursery little boys hear that a Jew has something cut off his penis—a piece of his penis, they think—and this gives them a right to despise Jews. And there is no stronger unconscious root for the origins of anti-semitism. Weininger (the young philosopher who, highly gifted but sexually deranged, committed suicide after producing his remarkable book, *Geschlecht und Charakter*), in a chapter that attracted much attention, treated Jews and women with equal hostility and overwhelmed them with the same insults. Being a neurotic, Weininger was completely under the sway of his infantile complexes; and from that standpoint what is common to the Jews and women is their relation to the castration complex. (1909b, 36n1)

Daniel Boyarin has suggested that, first appearances to the contrary, in this passage Freud actually ends up identifying with Weininger's position (1996). What Freud has obscured in this picture is not only the Jewishness—and so the circumcision—of Little Hans, but Freud's own Jewishness. In this footnote, Freud narrates the "seen" of Jewish difference as if it is the non-Jewish ("intact"?) boy gazing at, or imagining himself as gazing at, the circumcised penis. Yet, Boyarin argues, neither Little Hans nor Freud need look anywhere else. Boyarin concludes that Freud ends up putting Weininger forward not as an example of the neurotic roots of anti-Semitism, but as an example of a neurotic response *to* anti-Semitism. For Weininger, the end result was, quite literally, self-destruction.

Freud, of course, pursued a different course. Both in his psychoanalytic the-
ories and in his "life," Freud devoted himself to overcoming the pathological
"femininity" of the male Jew. One of the ways he accomplished this (or sought
to) was to shift the burden of signifying castration and lack wholly onto
women's bodies. The Jewish male's body and the anxieties his difference pro-
voked for Freud—but not only for Freud—are admitted into the scene of psy-
choanalysis only when, as above, the putative focus is the unknowing Gentile
male or a "proven" neurotic, like Weininger. This way of re-reading Freud's
reading does not reduce psychoanalysis to Freud's symptom. As Boyarin wit-
tily recommends elsewhere, an historicized symptomatic reading puts Freud
and psychoanalysis on "a Foucauldian couch of cultural poetics and critique"
(1995, 137n1).

It is against this volatile background of anti-Semitism, misogyny, and racial-
ized homophobia that Freud's *Fragment of a Case of Hysteria*, the case of
"Dora," must be re-evaluated. The case study was published in 1905, more than
four years after Dora broke off her analysis on the last day of 1900. Freud pref-
aces the case study with an apologia for having gone public with the details
of his patient's analysis:

> [In] my opinion the physician has taken upon himself duties not only
> towards the individual patient but towards science as well; and his duties
> towards science mean ultimately nothing else than his duties towards the
> many other patients who are suffering or who will some day suffer from
> the same disorder. Thus it becomes the physician's duty to publish what
> he believes he knows of the causes and structures of hysteria, and it
> becomes a disgraceful piece of cowardice on his part to neglect doing so,
> as long as he can avoid causing direct personal injury to the single patient
> concerned. (1905a, 8)

Freud attempts to balance his public responsibilities as a scientist against his
patient's privacy by giving the principals in the psychoanalytic drama he is
about to unfold stage names: "Needless to say, I have allowed no name to stand
which could put a non-medical reader upon the scent [*die Spur*] ... " (23).

This defensive tone returns throughout the case study—especially on the
topic of names and naming. In one instance, Freud is defending himself (again)
against the anticipated "horror" or "astonishment" of his readers that he should
have dared to broach such "delicate and unpleasant subjects [what he coyly
calls "sexual gratification *per os*"] to a young girl" (48). Freud declares that the
best way to speak about such things is "to be dry and direct." He prefers to
"call bodily organs and processes by their technical names, and ... [to] tell
these to the patient if they—the names, I mean—happen to be unknown to
her." To make clear his meaning, Freud gives an example of what it is to name
with "technical" precision: "*J'appelle un chat un chat*" (48; emphasis in original).
Yet, this cunning double entendre could not—or so it seems to me—be further

25

from Freud's stated aim, which is to be "dry," "direct," and "technical." Just after calling a pussy a pussy, Freud turns to French—again—to stress what he considered the "right attitude" for a physician to strike when undertaking treatment of an hysteric: "*pour faire une omelette il faut casser des œufs*" (49; emphasis in original).[23] In other words, just say it.

Freud himself does not, or at least not in so many words. Rather, he conceals the identity of his analysand, Ida Bauer, by renaming her "Dora." Yet Freud reveals—by putting off—the Jewish associations of Ida Bauer's hysteria. In the *Psychopathology of Everyday Life* (1901), a text written after Dora's case but published before it, Freud describes the thought processes which consciously and unconsciously determined Ida's renaming as Dora:

> With a view to preparing the case history of one of my women patients for publication I considered what first name I should give her in my account. There appeared to be a very wide choice; some names, it is true, were ruled out from the start—the real name in the first place, then the names of members of my own family, to which I should object, and perhaps some other women's names with an especially peculiar sound. It might have been expected—and I myself expected—that a whole host of women's names would be at my disposal. Instead, one name and one name only occurred to me—the name "Dora." (240–41)

Freud situates this recollection in the midst of a discussion concerning the extent to which mental ideas are determined. He is attempting to demonstrate that "certain seemingly unintentional performances prove, if psycho-analytic methods of investigation are applied to them, to have valid motives and to be determined by motives unknown to consciousness" (1901, 239).

Applying the methods of psychoanalysis to himself, Freud traces a chain of associations from the only apparently arbitrary choice of the name "Dora" back to his sister Rosa's nursemaid, also called Dora. As it happens, "the girl [Freud] knew as Dora was really called Rosa, but had had to give up her real name when she took up employment in the house," to prevent any confusion with Rosa Freud (1901, 241). Freud solves the riddle: when "looking for a name for someone *who could not keep her own*," namely the analysand Ida Bauer, he settled upon "Dora"—a name which already signaled lost identity (241, emphasis in original).

Feminist critics have discerned displaced aggression in Freud's renaming of Ida Bauer after a nursemaid. To get even with her for stopping analysis, Freud reduces the middle-class Bauer to the level of a household employee. He also fills out his characterization of her as having acted "just like a governess" at the moment when she served him notice that she was discontinuing analysis (Freud 1905a, 107). In so renaming Dora, Freud has also, inadvertently, put himself into the role of Herr K., who—Freud suggests—had aroused Dora's wrath by "[daring] to treat [her] like a governess, like a servant." Thus, the transference of aggression from patient to analyst, which Freud diagnoses in

the case study (Freud 1905a, 116–22), is at the same time an example of *counter*transference.

Freud's paternalism and misogyny are among the factors regulating the transaction whereby Ida Bauer becomes Dora. However, the unsettling proximity of femininity to Jewishness also exerts unconscious force. In this respect, both Freud's self-analysis and those feminist analyses of the case that focus exclusively on gender do not recognize the relay between gender and race in Freud's "seemingly unintentional performances." Freud indicates there were three classes of names from which he could not choose a pseudonym for his woman patient: the actual name; the names of his family members—presumably those of his female relatives—to which he would object; and names with *an especially peculiar sound*. Within fin de siècle Austria, the "especially peculiar sound" Freud wants to avoid broadly invokes the stigmatizing "hidden language" of the Eastern Jew, *Mauscheln*—a topic Gilman discusses in *The Jew's Body* (1991, 10-37) and *Freud, Race, and Gender* (1993a, 140, 190). Was the deflection of Jewishness from the site of Ida Bauer's analysis also one of the "seemingly unintentional performances" enacted in her renaming by Freud? And what connection might be established between Ida Bauer's new name and that of another person who could not keep *his* own, Freud himself?

Perhaps the "especially peculiar sound" Freud does not or cannot further specify is the foreign sound of Freud's given name, Sigismund. Jakob Freud named his son "Sigismund" after a sixteenth-century Polish monarch, whom the elder Freud admired for his policy of toleration to the Jews (Klein 1981, 46). From mid-century, the name "Sigismund" featured prominently in anti-Semitic jokes and comic literature (Gilman 1993a, 70; Klein 1981, 46). Freud formally changed his own name on the records of his gymnasium from Sigismund to its German variation, Sigmund, in 1869 or 1870.[24] In his rejection out of hand of the names of family members, Freud also rejects his own name—again—and puts personal distance between Jewishness and his analysis of a case of hysteria.

Freud locates the developmental seat of Ida Bauer's hysteria not in her Jewishness, which disappears from the case study along with her name, but in the requirements of femininity. In his *Three Essays on the Theory of Sexuality*, published in the same year as "Dora," he views hysteria as intimately related to the achievement of femininity:

> The fact that women change their leading erotogenic zone in this way [from clitoris to vagina], together with the wave of repression at puberty, which, as it were, puts aside their childish masculinity, are the chief determinants of the greater proneness of women to neurosis and especially to hysteria. These determinants, therefore, are intimately related to the essence of femininity. (1905b, 221)

27

It is during puberty, Freud hastens to remind us, that "the sharp distinction is established between the masculine and feminine characters" (1905b, 219). Prior to the onset of puberty, "the sexuality of little girls is of a wholly masculine character" (219). But, the achievement of feminine sexuality is by no means a foregone conclusion. Indeed, the double burden Freud identifies as the switchpoints in a young girl's sexual maturation—namely, changing eroto-genic zones and undergoing repression—is also responsible for the "greater proneness of women to neurosis and especially hysteria." In this respect, hysteria, far from being a deviation from normal femininity is actually part of the "essence of femininity."

In sharp contrast to the insistence with which contemporary medical discourse linked the Jewish male to the feminine and from there to "womanly" diseases like hysteria and narcissism, Freud has represented femininity as a cultural and psychic project which puts *women* at heightened risk for hysteria. By emphasizing the distinction between masculinity and femininity as the signal difference in the aetiology of hysteria, Freud effectively displaces the mise-en-scène of hysteria from race *and* gender wholly to gender. Ida Bauer's Jewish female body has faded into the figure of a "whitened" femininity. From this figure, femininity emerges as a form of racial passing. The Jewish woman passes for—is posed as—the feminine *tout court*, and Jewish men are thereby relocated on the side of the universal term: the masculine.[25]

In my view, Gilman's analysis of Dora's case (1991, 81-96), as well as his over-arching interpretation of Freud's transmutation of race into gender, falters on the question of Jewish female difference; he leaves out of consideration what and how race, gender, and Jewishness might mean in the construction of the Jewish female. Gilman indicates how Freud sought to set the hypervisible Jewish male body—including Freud's own—outside the scope of psychoanalysis. However, not only does Gilman sometimes imply that masculinity has no gender and femininity no race, but he treats "race" and "gender" as discrete, rather than mutually informing structures. One consequence of this separation of masculinity and race, on the one side, and femininity and gender, on the other, is that the Jewish woman cannot appear in Gilman's analysis except in drag: as a Jewish man *or* as a "whitened," presumptively Gentile, woman.[26] *All Jews are womanly, but no women are Jews.*

But Jewish women are more than screens through whom might be detected the hidden figures of threatened and threatening Jewish masculinity. Freud continually links hysteria to puberty, the period of a young woman's life when she must leave behind "her childish masculinity" and embrace femininity. Freud's third essay in *Three Essays*, "The Transformations of Puberty," pivots on the transformation from masculine to feminine. This transformation is the *telos* of female sexual development. It is also the linchpin in masculinity's presumption to universality. However, by representing femininity as a derivative

of masculinity, Freud also reveals "being" a woman as a passing performance. In his "General Remarks on Hysterical Attacks" (1909a), for example, Freud implies that "woman" is a precarious performative accomplishment, not a brute fact: "In a whole series of cases the hysterical neurosis is nothing but an excessive over-accentuation of the typical wave of repression through which the masculine type of sexuality is removed and the woman emerges" (234). *The woman emerges.* Freud oddly anticipates Simone de Beauvoir's "One is not born, but becomes a woman."

Men too are made (and remade), not born. Gilman offers a stunning piece of evidence on this point: Freud's identification of the clitoris—the "girl's piece"—with the masculine. In Viennese slang of the time, the clitoris was called the *Jud*, or "Jew" (1993a, 39). Female masturbation was known as "playing with the Jew." Gilman argues that the nickname *Jud* pejoratively synthesizes the bodies of Jewish men and all women and reflects "the fin de siècle Viennese definition of the essential male as the antithesis of the female and the Jewish male" (1993a, 38–39). Both the clitoris and the Jewish male's circumcised penis, then, were "lesser" organs, truncated versions of the "real" thing.

Gilman convincingly demonstrates how the masculinization of the clitoris recuperates the Jewish male's "defective" part. Within the homologics of Freud's analysis, the girl's passage from boyish activity to "properly" passive femininity—though by no means a foregone conclusion—may tip off the recomposition or redirection of Jewish manhood. But what does it mean for Jewish women or for stereotypes of Jewish women?

The girl's passage from active, preadolescent masculinity to passive, mature femininity—which Freud presents as the normative and normalizing path of female development—also recalls the historical movement of Jews from Eastern Europe into the urban centers of Western Europe and the United States. Is it possible to see in Freud's insistence on the transition from active masculinity to passive femininity not only his own ambivalence about Eastern Jewry, but the ambivalent position occupied by Jewish women as they and their families moved from east to west? I suggest a structural analogy between the more dominant household role played by Jewish women in Eastern Europe (as compared to the "angel in the house model" of Victorian, Christian womanhood), on the one hand, and the masculinization of early childhood femininity, on the other. The achievement of properly passive and vaginal female sexuality would then be structurally analogous to the "westernization" of Jewish household dynamics, in which the male publicly assumes the normative role of head of household, and the female recedes to the background.[27]

In Freud's subterranean geography of Jewishness, gender, and race, East is to West as phallic women are to angels in the house; as the young girl's childish masculinity is to the woman's mature and passive femininity; as a woman's fully achieved femininity is to a man's overachieving masculinity. In Freud's

own "case history," East was to West as his Galician mother, Amalie Nathansohn Freud, was to his German wife, Martha Bernays Freud.

Interpreting the achievement of a "mature" and only wishfully stable femininity in relation to patterns of Jewish immigration from east to west has especial significance for Jewish women. In the closing decades of the nineteenth century, the period of the greatest migration of Eastern Jews into Germany, Jews comprised just over one percent of the German population (Kaplan 1991, 5). The embourgeoisement of German Jewry was one of the cornerstones of Jewish assimilation; it was also the central task and responsibility of Jewish women. Like their Gentile counterparts, German Jewish women were expected to ensure and direct the smooth operation of domestic culture. Their highest task was marriage and family. Yet, Eastern European Jewish women also comprised a share of the Jewish female work force in Germany greater than their proportion of the total Jewish population. Their occupational profile also differed from that of German-Jewish women; at a time when German Jewish women were entering what Marion Kaplan calls the "New Woman" careers (such as secretaries, stenotypists, and salesclerks), the Eastern immigrants were more likely to be concentrated in industry (160). Many immigrant women also found employ as family helpers or domestic servants in the homes of German Jews (161).

Because newly arrived Eastern Jews were generally poorer than their German Jewish counterparts, they could not so easily emulate the sharp sexual division of labor which characterized the new middle-class ideal. Nonetheless, even, or perhaps especially, for the Eastern Jew, the project of assimilation was importantly, if impossibly, linked to embourgeoisement. The sexual division of labor, first point of entry into middle-class respectability, was probably of greater consequence for Jewish women and men than for Gentiles (Mosse 1985, 12; Kaplan 1991, 168). In their struggle to acculturate to the norms of polite society and to gain acceptance on German terms, Jews had to be more German than Germans. Kaplan describes the subterfuge to which some aspiring bourgeoisie would go in order to emulate the emerging middle-class ideal: "So deeply was middle-class status signified by the non-wage-earning and leisured women, and so deeply was Jewish acculturation identified with the bourgeoisie, that even those Jewish women who continued to work in family businesses or around the house often hid from public view while performing their chores" (1991, 26). But this was not, she reminds us, an option open either to poorer Jews in the countryside or to Jewish immigrants from Eastern Europe, who were generally clustered in urban centers.

The idealization of her domestic role over and against participation in a paid work force placed the Jewish female in a double bind. Her new role as leisured lady would symbolize her husband's new status and, through him, Jewish acculturation to German social norms. Yet, at the same moment that

she was being called back to the house, to the domestic chores of marriage, family, and household, there was an "oversupply" of German Jewish women. The imperative to marry and have children was at odds with the absolute numbers of marriageable women versus marriageable men. Only among Eastern European Jews did men outnumber women, and it was these women in particular whose financial contributions to their families were most essential. When Freud describes the difficult and risky passage whose final destination is femininity, he is describing a developmental trajectory that demands of its subject *assimilation* to gendered, racialized, and class-stratified norms.

As socially and psychically regulated identities, "gender" and "race" are always approximations; neither is ever fully or perfectly achieved, but is always only impossibly realizable. Thus, "having" gender and "having" race are always to some degree marked out as the failure of "proper" identification. For Jewish women—especially Eastern Jewish women—in the historical period in which Freud wrote *The Psychopathology of Everyday Life, Three Essays*, and Dora's case study, the project of femininity might seem bound on all sides by the spectre of imminent failure.[28] The shared ideal of womanhood was white, Christian, reproductive, and hidden from view. To supplement or redirect Gilman's account: Freud's description of the difficult passage from girlhood into womanhood is never fully "de-raced." Where Gilman sees only the spectral presence of the Jewish male, I mark also the trace of Jewish female difference.

A Jewish female difference makes an interesting, if unanalyzed, appearance in Freud's essay on "The Taboo of Virginity" (1918). This essay also marks Freud's first discussion of the narcissism of minor differences, a key concept he will return to in *Group Psychology* (1921) and *Civilization and Its Discontents* (1930).[29] Freud introduces the narcissism of minor differences in order to make sense of man's "generalized dread of women" (1918, 198). Perhaps, suggests Freud:

> [T]his dread is based on the fact that woman is different from man, for ever incomprehensible and mysterious, strange therefore apparently hostile. The man is afraid of being weakened by the woman, infected with her femininity and of showing himself incapable. (198–99)

So, woman's difference provokes man's performance anxieties. Yet, on closer examination, things really seem the other way round: "the practice of the taboos [on female virginity] we have described testifies to the existence of a force which opposes love by rejecting women as strange and hostile" (1918, 199). It is man's performance anxieties that demand and construct woman's difference, that demand and construct woman as difference. This demand is the narcissism of minor differences.

Freud's exposition of this unconscious demand crucially hinges on a 1902 anthropological study of "primitive" marriage; in thus joining the authority of

31

psychoanalysis to the authority of anthropology, Freud also exposes the complicity of both discourses in the project of colonization. In *The Mystic Rose: A Study in Primitive Marriage*, E. Crawley postulated that each person is separated from each and every other person by a "taboo of personal isolation" (qtd. in Freud 1918, 199). Freud takes Crawley to mean that "it is precisely the minor differences in people who are otherwise alike that form the basis of feelings of strangeness and hostility between them" (1918, 199). This "narcissism of minor differences" opens up new perspectives onto Freud's woman question:

> Psycho-analysis believes that it has uncovered a large part of what underlies the narcissistic rejection of women by men, which is so mixed up with despising them, in drawing attention to the castration complex and its influence on the opinion in which women are held. (199)

The clear implication is that men are making mountains out of molehills when they seek so sharply to differentiate themselves from "strange and hostile" women.

Yet, Freud quickly closes down the new line of inquiry. He apologizes for straying so far afield: "…the general taboo of women throws no light on the particular rules concerning the first sexual act with a virgin" (199)—the ostensible focus of his essay. *Throws no light* because, as it was, so shall it be. Woman is "for ever incomprehensible and mysterious, strange and … hostile." She is the "dark continent," neither admitting nor returning man's/Freud's penetrating gaze.[30]

By the time Freud returns to the narcissism of minor differences in 1921 and again in 1930, the couple man/woman has dropped from sight. Its place has been taken by other exemplary, and less transparently gendered, couples: Spaniards and Portuguese, South Germans and North Germans, Britons and Scots, Aryans and Jews.[31] In each case, Freud argues, "minor differences" between adjoining communities have been exaggerated and embellished to satisfy the narcissism of each; oppositions us/them and insider/outsider have been produced where there is, in reality, nothing or very little to choose between. (Of course, as Freud himself was all too aware, even if the differences separating "self" from "other" and "us" from "them" are more imaginary than real, they may also be, for this very reason, all the more intractable.)

If the ostensible focus of Freud's first discussion of the narcissism of minor differences, in "The Taboo on Virginity," was the management of sexual difference, in both *Group Psychology* and *Civilization and Its Discontents* his concern has shifted to the national and cultural borders. Yet, there is also a strong sense in which the 1918 exposition anticipates the final direction Freud's analyses of the narcissism of minor differences will take. After all, the diagnosis Freud offers in "The Taboo of Virginity," of a masculinity contaminated by

feminine difference, was one in which male Jews, within Freud's own histor-
ical experience, were dangerously implicated. To the extent, then, that the
alleged atavism of the Jews made them Europe's interior representatives of
those whom Freud calls "primitive races living to-day" (1918, 199), once again
Freud's diagnosis is too close to where he lives. Perhaps it is this possibility, that
femininity's debilitating effects are too much "alive among ourselves" (199),
that inflamed Freud's own sense of dread and brought him to turn his atten-
tion somewhere else. Not only is woman's difference from man superseded by
the male Jew's difference, but, on this reading, his difference has been there all
along. Accordingly, "The Taboo on Virginity," an essay ostensibly concerned
with the management of sexual difference, is really and *only* about the bound-
ary crisis Aryan/Semite or Christian/Jew.[32]

Yet, who or what goes missing, again, in this hermeneutic of supersession?
Although the difference man/woman is readable as a figure for the "problem"
of the male Jew's difference, the Jewish difference Freud does name in the 1918
essay is a Jewish woman's. "The taboo of virginity," Freud writes, "and some-
thing of its motivation has been depicted most powerfully of all in a well-
known dramatic character, that of Judith in Hebbel's tragedy *Judith und
Holofernes*" (207). Following Hebbel, Freud recasts the Biblical heroine as a
femme fatale who beheaded Holofernes not as an act of Jewish patriotism, but
of sexual refusal. In unveiling the hidden sexual motives—decapitation as
symbolic castration—behind Judith's apparently patriotic act, Freud unwit-
tingly replays one of the most persistent anti-Semitic tropes concerning Jewish
women: the *belle juive*. He also brings together two trends in the stereotyping
of "the Jewess," joining a "positive" image of moral virtue to a "negative"
image of sensuality and deceit.[33] This fusion of the virgin and the whore
(another minor difference?) is inflected by a racialized difference, even if it is
sometimes difficult to tell the difference between stereotypes of the *belle juive*
and stereotypes of a "generic" femininity.

What especially fascinates me in all this is the way that Freud's ability to
minimize difference or rather *some* differences (of "race" and Jewishness, for
example) is itself dependent upon his reproduction and maximization of other
differences. In other words, his analysis of the narcissism of minor differences
is caught (up) in the act of recapitulating it. The cultural and psychical tasks
Freud ascribes to the narcissism of minor differences—displacing the burden
of difference onto another individual or group of individuals, thereby chan-
neling fear and aggression into safer and culturally recognized territories—
seems to me to describe the work Freud does in the course of developing and
delimiting the range and objects of this theory. Between "The Taboo of
Virginity" and *Civilization and Its Discontents*, Freud's attention has shifted from
one category of exemplary difference to another. He resolves the problem of
Jewish male difference by pointing to narcissism's tendencies to inflate and

33

exaggerate the space between. To shore up the *indifference* of his own body in relation to the Aryan's or Christian's, however, Freud clings to and ambivalently promotes the difference man/woman. He thus maximizes one relatively minor difference ("sex"), so as to minimize another ("race"). The anxieties provoked by Freud's own experiences of difference haunt and distort his account of sexual (in)difference. For me, at any rate, this best explains and modulates Freud's ultimate failure to extend to sexual difference (and "woman") the same clear-eyed recognition of the way that narcissism, ambivalent compound of me and not-me, so often makes something out of nothing. In the end, Freud's failure might even symptomatize the necessary failure of identification: that is, narcissistic recognition of the same in the other and aggressive disavowal of the other in the same.[34]

NOTES

1 See Gilman 1993a for his important exposition of Jewishness as gender.

2 Butler describes identity categories, such as gender and race, as "vectors of power" which "require and deploy each other for the purpose of their own articulation" (1993a, 18). There is a rich and growing explicitly feminist literature on the interarticulations of Jewishness, gender, and race. See, for example, Laura Levitt's forthcoming *Ambivalent Embraces: Jews Feminists, and Home* and the contributions to Peskowitz and Levitt (1996).

3 For literature examining stereotyped associations between Jewish men and effeminacy, see Gilman 1991 and 1993a, Boyarin 1995, Geller 1992c, Garber 1992, Briggs 1985.

4 Daniel Boyarin has proposed a novel reworking of Gayle Rubin's famous, and nearly canonical, feminist formulation, the "sex/gender system" (Rubin 1975). In his work-in-progress, he calls for thinking Jewishness in terms of a "race/gender system." Private communication with Daniel Boyarin.

5 See Bhabha 1994, 66–84 and 85–92. In thinking about the relation between stereotypical discourse and "the Jewess," I have benefitted from conversations with Carol Ockman and Laura Levitt.

6 Analogously, Elizabeth V. Spelman has pointed out how such pairings as "women and blacks," which ostensibly aim at inclusion, either vacate any position for black women to occupy or suggest that black women's position is a composite of white women's and black men's experiences (1988, 14–15, 193n32).

7 All references to *Sex and Character* are from the 1906 English translation of *Geschlect und Charakter: Eine prinzipielle Untersuchung.* For Weininger on "the Jewess," see 1906, 319-20. For Harrowitz and Hyams' brief comment on this passage, see their introduction to *Jews and Gender: The Case of Otto Weininger* (1995, 4–5).

34

8 For a study where Gilman does try, though with mixed results, to center the Jewish female body, see 1993b.

9 The relation of Freud's Jewishness to the history and development of psychoanalysis has been amply documented. The stigmatization of psychoanalysis as the "Jewish science" and Freud's own concern that the psychoanalytic movement not be perceived as a "Jewish national affair" have also been much commented upon (Klein 1981, Yerushalmi 1991, Gilman 1991 and 1993a, Bakan 1990, Geller 1992b and 1992c, Gay 1987). For "Jewish national affair," see Freud's letter of 3 May 1908 to Karl Abraham (qtd. in Yerushalmi 1991, 42).

10 The term "thought-collective" is Ludwick Fleck's (qtd. in Gilman 1991).

11 For a detailed historical study of the relationship between linguistics and the biology of race, see Olender 1992.

12 For one representative study of the Jewish "essence," see Otto Rank, "Das Wesen des Judentums." An English translation of this 1905 manuscript appears as Appendix C in Klein 1981, 170-73.

13 Boyarin develops this claim in a forthcoming essay, "What Does a Jew Want?: The Phallus as White Mask" (1994b).

14 My understanding of the provocations "third terms" may represent to systems of binary logic has itself been informed and provoked by Marjorie Garber's studies of transvestism and bisexuality. See Garber's *Vested Interests: Cross-Dressing and Cultural Anxiety* (1992) and her *Vice Versa: Bisexuality and the Eroticism of Everyday Life* (1995).

35

15 This paradox has also engaged the attention of Daniel Boyarin, conversations with whom have sharpened my own thinking on this point.

16 Charcot, the pioneering French theorist of hysteria and an early mentor to Freud, identified the "especially marked predisposition of the Jewish race for hysteria," citing inbreeding as the likely cause of Jews' heightened risk (qtd. in Garber 1992, 225). Syphilis too was strongly associated with Jews.

17 Garber (1992) offers a useful summary of some of these stereotypes. See also Gilman on the Jewish foot (1991) and voice (1991 and 1993a).

18 Cf. Freud 1985, 61 and 181.

19 Geller details the course of this upwards displacement in 1992b and 1992c. For Freud's description of his own "nasal secretions," see 1985, 63, 130, 181, 285.

20 This is a point Harrowitz and Hyams also make in 1995, 4.

21 In addition to Franz Kafka, Weininger's well-known readers included Ludwig Wittgenstein, James Joyce, August Strindberg, Elias Canetti, Gertrude Stein, Charlotte Perkins Gilman, and Sigmund Freud.

22 For other contemporary or near-contemporary attacks on *Verjudung*, or "Judaization," see F. Roderich-Stoltheim (1912) and Alfred Rosenberg ([1925] 1970). See also Steven E. Ascheim's historical analysis of the myth of Judaization in Germany (1985).

23 For other turns into French phrasing in *Fragment of a Case of Hysteria*, see, e.g., 1905a, 40, 41. For other readings of this turn, see Marcus 1985 and Gallop 1985.

24 In a close reading of the Hebrew and German inscriptions that Jakob Freud entered into the Freud family bible, Yosef Hayim Yerushalmi has shown that it was Jakob Freud, and not Sigmund, who first used the German variation of "Sigismund" (1991, 132n19).

25 Freud's realignment of the Jewish male body with the universal term is most clearly represented in *Moses and Monotheism*, Freud's longest sustained meditation on the character of Jewishness. This point has also been made, though with different emphases, by Van Herik (1982), Gilman (1993a), and Eilberg-Schwartz (1994).

26 In his essay on "Salome, Syphilis, Sarah Bernhardt and the Modern 'Jewess,'" Gilman describes the problem of identifying the Jewish woman's difference thus: "When Jewish women are represented in the culture of the turn of the century, the qualities ascribed to the Jew and to the woman seem to exist simultaneously and yet seem mutually exclusive.... When we focus on the one, the other seems to vanish" (1993b, 195). At times, it appears that Gilman's own representations of Jewishness, race, and gender become one such case in point.

27 The pivotal and dominant figure here would be Freud's own mother, Amalie Nathansohn Freud. One grandchild called her "shrill and domineering" (qtd. in Appignanesi and Forrester 1992, 14). In the memoirs of another grandchild, Martin Freud, Amalie Freud's "eastern" origins are prominently mentioned. She was typically Galician, he says, "not what we would call a 'lady,' had a lively temper and was impatient, self-willed, sharp-witted, and highly intelligent" (ibid.).

28 For a wonderful reading of the intertextual relations that obtain between *Fragment of an Analysis of a Case of Hysteria* and *Psychopathology of Everyday Life*, see Mary Gossy 1995, 75–93. Among other things, Gossy suggests that the *Fragment* might be counted among the "Freudian slips" at the interpretive heart of *Psychopathology*. It would be interesting to put Gossy's suggestion together with Judith Roof's pairing of Dora and *Three Essays* and so to expand the intertextual scene of Dora's writing. See Roof 1991, esp. 174–201.

29 For Freud on the narcissism of minor differences, see "The Taboo of Virginity" (1918), *SE* 11: 199; *Group Psychology* (1921), *SE* 18: 101; and *Civilization and Its Discontents* (1930), *SE* 21: 114–15.

30 Freud's description of "the sexual life of adult women" as "a dark continent," beyond the ken of "psychology" (Freud's term) occurs in "The Question of Lay Analysis: Conversations with an Impartial Person" (1926), *SE* 20: 212. For a helpful discussion of the metonymic links the

trope of the dark continent forges among "infantile sexuality, female sexuality, and racial otherness," see Mary Ann Doane, "Dark Continents: Epistemologies of Racial and Sexual Difference in Psychoanalysis and the Cinema," in 1991, 209–48, 293–98.

31 I am here collapsing the terms of Freud's two later treatments of the narcissism of minor differences. In *Group Psychology*, Freud's final pair is Aryan and Semite (1921, 101); in *Civilization and Its Discontents*, he refers to the differences between Christian and Jew (1930, 114). Moreover, in *Group Psychology*, the division Aryan/Semite is classed among other insider/outsider, us/them distinctions whose "greater differences ... lead to an almost insuperable repugnance, such as the Gallic people feel for the German, the Aryan for the Semite, and the white races for the colored." In *Civilization and Its Discontents*, by contrast, Freud nowhere suggests that Jews and Christians are separated by "greater" differences than distinguish any other traditional antagonists.

32 This is an interpretation Sander Gilman also offers (1991, 176). Although I agree with Gilman as to the critical place Jewish male difference occupies between the lines of Freud's 1918 essay, I am troubled by the way Gilman seems to read through the opposition man/woman to see *only* Aryan/Jew. I wish that I had been more able to make clear this objection and this difference in the version of this essay written for *Jews and Other Differences: The New Jewish Cultural Studies*, ed. Daniel Boyarin and Jonathan Boyarin.

33 See Ockman 1991 for a nuanced reading of stereotypes of the *belle juive* in nineteenth-century French portraiture. See Bhabha for the way the "chain of sterotypical signification" wavers between positive and negative (1994, 82).

34 Again, I am much indebted to Bhabha's analysis of the stereotype and colonial discourse (1994, 66–84, esp. 77).

ENTR' ACTE
Portrait d'une Autre Dora

I have never seen a funnier figure than Sarah Bernhardt in
Scene II, where she appears in a simple dress, I am really
not exaggerating. And yet one was compelled to stop
laughing, for every inch of this little figure was alive and
bewitching. As for her caressing and pleading and embrac-
ing, the postures she assumes, the way she wraps herself
round a man, the way she acts with every limb, every
joint—it's incredible.

—Sigmund Freud,
Letter to Martha Bernays (8 Nov. 1885)

Charcot, who is one of the greatest of physicians and a
man whose common sense borders on genius, is simply
wrecking all my aims and opinions. I sometimes come out
of his lectures as from out of Nôtre Dame, with an entire-
ly new idea about perfection. But he exhausts me; when I
come away from him I no longer have any desire to work
at my own silly things; it is three whole days since I have
done any work, and I have no feelings of guilt. My brain is
sated as after an evening at the theatre.

—Sigmund Freud,
Letter to Martha Bernays (24 Nov. 1885)

AM I making something out of nothing, if I spy, behind the scenes of Ida
Bauer's re-naming, the figure of another woman? Or if I read between the
lines of Freud's exculpatory French declamations—*J'appelle un chat un chat* or
pour faire une omelette il faut casser des œufs—to uncover *le portrait d'une autre
Dora*?

In a November 1885 letter to his then-fiancée Martha Bernays, Freud
begins by apologizing for not having written to her "for ages" (1960, 178). He
explains: "Yesterday my failure to write had another cause. My head was reel-
ing; I had been to the Porte St. Martin theater to see Sarah Bernhardt" (179).
He proceeds to name the conditions which made his head reel: the "excruci-
ating heat of the theater" and the "wretched megalomania of the French" for
prolonging a two and one-half hour play by two hours of entr'acte (179). Yet,
in his later rapturous descriptions of Bernhardt's acting skills, Freud implies

that it was not the unbearable heat of the theater nor the duration of the play, but Bernhardt herself who sent his head reeling:

> I cannot really praise the play, Victorien Sardou's *Theodora* (he has already written a *Dora* and a *Feodora* [*sic*] and is said to be busy on a *Thermidora, Ecuadora, and Torreadora*!). A pompous trifle, magnificent Byzantine palaces and costumes, a conflagration, pageants of armed warriors and so on, but hardly a word anyone would want to commit to memory, and as for char-acterization, it leaves one completely cold.... But how this Sarah can act! After the first words uttered in an intimate, endearing voice, I felt I had known her all my life. I have never seen an actress who surprised me so little; I at once believed everything about her. (179–80)

Freud gazes at and is bewitched by Bernhardt's bodily acts. The "way she acts with every limb, every joint," her body so "alive and bewitching," her ser-pentine ability to "[wrap] herself round a man" captivate and hold Freud's rapt attention. Her staged gestures lead him to the woman "herself." Collapsing the distance between staged representation and "real" life, Freud calls Bernhardt "a remarkable creature" and imagines that "she is no different in life from what she is on the stage" (1960, 181). Freud loses all track of time and (bodily) space.

The eroticized spectacle of Sarah Bernhardt anticipates another specular object: the hystericized female body, whose vocal cues (as in: the "talking cure") and surface signs (as in: "somatic compliance") are the privileged mechanisms and symptomatic center of psychoanalysis. The women (and men) who people Freud's case histories are, as it were, characters in search of an author/auteur. It is Freud who makes their inner life available to directed view. In all this, Bernhardt plays actress-heroine for the psychoanalyst turned dramaturge. And Jean-Martin Charcot is dramaturge *père*, demonstrating before the rapt gaze of his students—Freud included—not just the theatrical-ity of hysteria, but the showmanship of clinical mastery.

In his 1886 report to the Faculty of Medicine at Vienna University, which funded Freud's studies in Paris from October 1885 to February 1886, Freud retrospectively describes how Charcot's public lectures on topics in neu-ropathology "delighted [their] hearers by the perfection of [their] form," but "produced their effect primarily by their constant references to the patients who were being demonstrated" (9).[1] What's more, in another November 1885 letter to Martha Bernays, written some three weeks after Bernhardt so bedaz-zled Freud, he analogized the effect of Charcot's command performances first to religious experience ("I sometimes come out of his lectures as from out of Nôtre Dame, with an entirely new idea about perfection.") and then to the-ater's ability to disturb mental life ("My brain is sated as after an evening at the theatre."). Charcot's star turn, like Bernhardt's, unsettles the distance between theater hall and clinician's office, perhaps also between performance and performativity, to suggest how much acts of witness in the theater hall

may have to tell about those other and unconscious acts of identification in everyday life. (Perhaps the eruption of French phrases into Dora's case history spells the continued ability of both Bernhardt and Charcot to disturb Freud's attentions?)

Unlike the "other" female hysterics Freud watched by day in that "other" theater, namely, Charcot's, Bernhardt could tell her own story. "Esperance," the actress-heroine of Bernhardt's 1922 autobiographical novel *The Idol of Paris*, and a thinly disguised figure for La Divine Sarah *elle-même*, represents acting as a form of self-defense. If she does not act, "neurasthenia and madness await her" (qtd. in Shattuck 1991, 34). Act or go mad: performance is the enabling condition of Esperance's (Bernhardt's) life. In turn, decoding and deciphering the other's bodily performances is the self-authorizing gesture of psycho-analysis.

Years later, in a 1931 letter to Yvette Guilbert (a French chanteuse and mimic who numbered Bernhardt/"Bernhardt" among her repertoire of onstage impersonations), Freud recalibrates the "distance" between performer and per-formed thus:

> The idea of the surrender of one's own person and its replacement by an imagined one has never satisfied me very much.... I would rather believe … not that the actor's own person is eliminated but rather that elements of it—for instance, undeveloped dispositions and suppressed wishes—are used for the representation of intended characters. (qtd. in Shattuck 1991, 37)

41

Enter the unconscious. Like the dreamwork, then, acting is the expression of a repressed wish. On this reading, acting does not so much erase the distance between representation and the real as it does provide a partial window onto unconscious phenomena and influences.

In her day (and to mark the end of it), Bernhardt's dramatics on the boards and off were critically praised and appraised for what they might reveal of the woman behind the mask. In a *London Times* obituary, dated 28 March 1923, and evocatively captioned "The Idol-Woman and the Other," the obituary's unnamed author says of Bernhardt:

> … the actress did create, with Sardou's help, a new type—the embodiment of Oriental exoticism: the strange, chimaeric idol-woman: something not in nature, a nightmarish exaggeration, the supreme of artifice. This type and Sarah became one. She wandered all over the world with it, and no wonder that it became in the end somewhat travel-stained. (n. pag.)

As in Freud's collapse of Bernhardt's onstage and offstage personae ("she is no different in life from what she is on the stage"), the *London Times* obituary maintains no distance between the unnatural, Oriental "type" Bernhardt por-

trayed and Bernhardt herself. Ultimately, this type does not travel well, because it travels too much.

"Sardou's help" elliptically nominates the scene of Bernhardt's greatest success, as the Empress Théodora in Sardou's play of the same name. Indeed, the *London Times*'s description of Bernhardt as "strange, chimaeric idol-woman" echoes an appreciative 1885 review of her performance in this role. At that time, the critic Jules Lemaître called Bernhardt's Théodora "a Salomé, a Salammbô: a distant chimerical creature, sacred and serpentine with a fascination both mystical and sensual" (qtd. in Gold and Fizdale 1991, 215).

So, Bernhardt's "Oriental exoticism" points eastward to Istanbul and beyond—to Judaea, Herod's court, and the figure of Salome. Salome: she of the seven veils and John the Baptist's severed head. Salome: the role set aside for Bernhardt in the London premiere that wasn't of Oscar Wilde's *Salome*.[2] If Salome was the greatest role Bernhardt never played, she did not have to. It was a role Bernhardt was always already (imagined as) playing.

If "Oriental exoticism" stops off in Judaea, it also circles back to include an "East" closer to home, bringing into view the "atavistic" landscapes of Eastern Europe and Eastern Jewry. Eastern Europe was even the explicit locale of Bernhardt's first collaboration with Sardou, *Fédora*. Sardou's description of the play's titular heroine, a part explicitly written for Bernhardt, conjures a figure capable of making one's head reel: "A combination of masculine mind and childish superstition. Eyes so deep they make one dizzy. A voice that stirs unknown vibrations in us; the languor of the oriental linked indissolubly with the grace of the Parisian" (qtd. in Gold and Fizdale 1991, 201). East and West, infantilism and masculinity, converge in Sarah Bernhardt.

Bernhardt's Jewishness forms a critical backdrop to her public reception. The image of the wandering Jew surfaces in the obituary's stage directions: *she wandered all over the world....* Bernhardt had attracted this stereotype before. An 1880 biography, which was explicitly intended to introduce Bernhardt to an American audience on the eve of her first American tour, resourcefully turned the stereotype of the wandering Jew into a myth of origins:

> Of Jewish origin and Dutch nationality, she was one out of the eleven children of a wandering beauty of Israel. The future tragedienne was born in Holland about thirty years since, on the road, her mother being at the moment of Sarah's nativity in the act of moving her Lares and Penates to fresh fields and pastures new. Possibly the nomadic conditions under which, as a puling infant, this strange woman drew her first breath, had an all-powerful influence on her after life. (Griffith and Marrin 1880, 8)

Bernhardt's Jewishness somehow "explains" her dazzling theatrical success. Yet, in a period when the Jew was noted and feared for his (and, in Bernhardt's case, decidedly *her*) mimetic talent to represent or pass himself off as someone

or something else (Geller 1992a, 30), attributing Bernhardt's acting abilities to her putative birthright reiterates dangerous associations between Jewishness and artifice.[3]

Despite the assurance with which Griffith and Marrin note Bernhardt's "Jewish origin and Dutch nationality," her nationality, as the *Boston Herald* put it in a November 1880 article, "seems to be one of those abstruse problems which no one can satisfactorily solve." "Is she a Frenchwoman or is she a Dutchwoman?" the article worried. In a news account appearing the day after Bernhardt's death, another *London Times* article would resolve the problem of Bernhardt's national affiliation; replaying the Franco-Prussian War, it aligned France and Holland against Germany: "Few things made the Dutch-French Jewess more angry than to be taken for a German Jewess." Moreover, the same 1880 *Boston Herald* article which worried whether she was a Frenchwoman or a Dutchwoman could elsewhere comfortably assert Bernhardt's "Dutch-Jewish" lineage. If Bernhardt's nationality was in doubt, her underlying identity "as" a "Jewess" never was.

In an intriguing passage in her autobiography, Bernhardt herself suggests that her chosen profession and Jewish lineage are inextricably linked. But here the link is not an essential one; that is, her "being" Jewish is not the necessary and sufficient condition of her "being" a great actress. Rather, Bernhardt seems to represent anti-Semitic constructions of Jewishness as propelling Jewish women into the stereotyped roles of temptress and exotic other. For Bernhardt, the positions "Jewess" and "actress" are both staged identities. One difference between them is who does the staging. Arguably, Bernhardt reinvents herself on stage and off in response and reaction to being named and identified from without.

In her autobiography, she recalls the decision upon which her entire destiny hinged: should she be an actress (Jewish) or a nun (not Jewish)? She claims initially to have inclined towards the latter vocation and remembers an occasion when the other great figure from the nineteenth-century French stage, Rachel, visited the convent at which the girl Bernhardt was being educated:

> She went all over the convent and into the garden, and she had to sit down because she could not get her breath. They fetched her something to bring her round, and she was so pale, oh, so pale. I was very sorry for her, and Sister St. Appoline told me what she did was killing her, for she was an actress; and so I won't be an actress—I won't. (Bernhardt 1907, 53)

Additionally, Bernhardt remembered "that when Rachel had gone out of the garden, looking very pale, and holding a lady's arm for support, a little girl had put her tongue out at her. I did not want people to put out their tongues at me when I was grown up" (53). In this anecdote, Rachel is represented as Bernhardt's negative image, that which she would least like to become.

43

In Bernhardt's melodramatic retelling of this girlhood scene, however, the occupational category "actress" is readable as the identity "Jew." Perhaps, the child's fear of being ridiculed as an actress may register the adult's anxious awareness of what it means to be stigmatized and marked as a Jew. In the mise-en-scène of the Catholic convent, the other girl's gesture of scorn at Rachel may target her as much for her "essence" (Jewishness) as for her occupation (actress). Bernhardt did not want to become another Rachel, a woman whose tuberculosis—a disease to which Jews were thought to be more susceptible—the Sister St. Appoline officially put down to her immoral life as an actress. Of course, if it is true—as Gold and Fizdale assert—that Bernhardt *l'actresse* always kept a portrait of Rachel with her backstage to inspire her performances (1991, 38), then it seems that Rachel would continue, for better or worse, to be a point of identification for Bernhardt.

Although Bernhardt's autobiographical emphases on her girlhood conversion to Christianity and the vocational path quite nearly chosen were themes repeated in newspaper accounts of her life, she never finally succeeded in redefining her Jewishness as a strictly religious identity, which she could take on or put off at will. In the newspaper accounts which appeared at the time of Bernhardt's death in March 1923, the same articles citing her baptism in the next sentence speak of her as the "Jewess." As in the 1880 biography, then, Jewishness as irreducible "essence" in the final analysis explained, conditioned, and delimited Bernhardt's theatrical appeal.

Nor could Bernhardt escape explicitly anti-Semitic characterizations. Marie Colombier's thinly disguised *Memoirs of Sarah Barnum* portrayed Bernhardt as greedy, sexually promiscuous, and talentless. Among other slurs, Colombier said "Madame Barnum possessed to the full the characteristics of her race—the love of money, but without the skill to obtain it" (1884, 29).

Similar accusations—of "Jewish" avarice and sexual promiscuity—were also made against Rachel (Gold and Fizdale 1991, 36–38). Even in a sympathetic 1911 biography, wondrously entitled *Rachel: Her Stage Life and Her Real Life*, "race," business acumen, and stagecraft come together: "Rachel was of the race that was business-like as well as artistic" (Gribble 1911, 105). For Bernhardt, then, comparisons to Rachel were a backhanded compliment: at the same time that they favorably measured Bernhardt's talents against Rachel's, they also placed Bernhardt in an extended "family" relationship: the family of "race."

Anti-Semitic slurs followed Bernhardt on her Russian tour. Moreover, around the time Colombier's pamphlet was circulating in France, there appeared in Germany a collection written by the Viennese playwright Ottokar Franz Ebersberg, but purporting to be the "authentic" correspondence of Bernhardt and her admirers (see Gilman 1993b). In one letter, written by "Bernhardt" to "Benjamin Disraeli," she happily compares "herself" to "the Misses Esther and Herodias 'of the Persian and Jewish ballet,'" and she asks, rhetorically, "was it

not Jewesses who accomplished everything and forced themselves into the tent of the enemy, and if flattery did not succeed, killed them as Judith did the stupid Holofernes" (qtd. in Gilman 1993b, 204). Judith again.

On two of the very infrequent occasions when Freud mentions a stageplay in his psychoanalytic works proper, he names Hebbel's tragedy *Judith und Holofernes*.[4] So, in these rare passages where the female character and her name are identifiably Jewish, Freud cites not a "real" woman, but a mythic figure whose exploits in defense of her "people" were taken up into an anti-Semitic sterotype of the Jewess as deadly seductress.

Certainly, this stereotype surfaced in connection with Bernhardt's "notorious" sexual life. Doubtless, rumors of her sexual exploits were overdetermined by her occupation; actresses were popularly thought to be little more than prostitutes. But, even more than that, the gossip was powered by the stereotype of the *belle juive*, a stock figure in the nineteenth-century imagination of Jewish femininity.[5] The *belle juive* was a deceptively feminine figure, "deceptive" because her beauty concealed her powers of destruction. She was the ultimate femme fatale, drawing Gentile men in to their doom. Nineteenth-century stereotypes of the *belle juive* not only cross in places stereotyped images of "other" black women—hypersexual, exotic, dangerous—but also anticipate Freud's later description of femininity *tout court* as the "dark continent" (Freud 1926, 212). The hyperbolic femininity of the *belle juive* conceals her perverse masculinity.

This powerful, and destructive, image of the manly and far too emancipated Jewess, her sexual tastes run wild, can be seen in the way Bernhardt's private life became a matter of very public speculation. Not only were her "countless" affairs with men known and much discussed, but rumors of affairs with women, most prominently with the painter Louise Abbéma, were also widely circulated. Fictionalized accounts of Bernhardt's alleged affairs with women appeared in such pulp novels as Félicien Champsaur's undated *Dinah Samuel* and Jean Lorrain's 1906 *Le Tréteau* (Gold and Fizdale 1991, 134). In their recent biography of Bernhardt, Gold and Fizdale are at pains to describe her bisexuality as the expression of her mixed nature, "for with all her seductive femininity, Sarah liked to play the man off-stage and on" (134). Bernhardt's celebrated (and hotly marketed) crossdressing is among the evidence they cite for her bisexuality. Her bisexuality, in their account, depends less on whether or not she ever "did it" with Louise Abbéma (or with any other woman) than on her "mixture" of feminine and masculine qualities.[6] The *belle juive* again.

In saying that Bernhardt "liked to play the man off-stage and on," Gold and Fizdale—like Freud before them—vacate any and all space between performance and performer. Yet, the claim that there was finally no difference between Bernhardt on stage and Bernhardt in the flesh is true only in the limited sense that the anti-Semitic spectacle of Jewish femininity was always

45

already staged and unnatural. This is no less true of Freud's spellbound attentions to her than of the anti-Semitic insinuations of Colombier and Chekhov against her.

"In life" Bernhardt's image followed Freud. For years—"for ages"—a portrait of her greeted Freud's patients as they arrived at his Viennese office. I like to imagine that the portrait adorning Freud's waiting room depicted Bernhardt in the celebrated role in which Freud had seen her, Sardou's "Théodora." I like to imagine also that the Jewish woman Freud would famously rename "Dora" confronted the image of this other Jewish woman, Sarah Bernhardt, playing this other Dora (Théo-Dora), whenever she (Ida Bauer) entered Freud's office for analysis. However, the fantasy of this uncanny meeting need have no reality outside this text, even if the phantom of Sarah Bernhardt—Freud's "remarkable creature" and the *belle juive* of her generation—may well haunt the scene of Ida Bauer's renaming.[7]

NOTES

1 For Freud's fullest descriptions of Charcot's clinical practice, see "Report on My Studies in Paris and Berlin" (1886), *SE* 1: 5–15, and the 1893 obituary notice he wrote for Charcot, reprinted in *SE* 3: 11–23.

2 For another, and related, perspective on the Bernhardt-Wilde-Salome connection, see Garber 1992. See also Gilman's reading of this triangle (1993b).

3 Is it possible to catch in Rosenberg's vitriolic 1925 rantings against the degradations inflicted on German and, he extends, all European theater by "pseudo-French tragedy" and "Jewish commercial management … [with its] pursuit of the 'star'" an allusion to Bernhardt, whose death in 1923 did not put an end to her influence (1970, 166–67)? Bernhardt, after all, was not only the most celebrated star of her era, but she had cut her theatrical teeth on Racine—a synechdoche for the Greek-inspired French tragedies which so earned Rosenberg's scorn. Moreover, Bernhardt herself even qualified as "Jewish management." She owned and operated several theaters during her career, beginning with the Théâtre de la Renaissance and culminating in her establishment of, what else, the Théâtre Sarah Bernhardt (Gold and Fizdale 1991).

4 I have mentioned the first occasion above, "The Taboo of Virginity" (1918, 207–8); the second citation occurs in the midst of Freud's discussion of the army in *Group Psychology* (1921, 97).

5 For Gilman's reading of the *belle juive*, see his "Salome, Syphilis, Sarah Bernhardt, and the 'Modern Jewess,'" *German Quarterly* 66 (Spring 1993): 195–211. But compare the suggestions in John Hoberman, "Otto Weininger and the Critique of Jewish Masculinity," in Harrowitz and Hyams, 141–53, esp. 141–42; Carol Ockman, "'Two Large Eyebrows à l'ori-

entale': Ethnic Stereotyping in Ingres's *Baronne de Rothschild*," *Art History* 14:4 (December 1991): 521–39; and Carol Ockman, "When Is a Jewish Star Just a Star? Interpreting Images of Sarah Bernhardt," in *The Jew in the Text: Modernity and the Politics of Identity*, ed. Linda Nochlin and Tamar Garb (London and New York: Thames and Hudson, 1995).

6 Two views of bisexuality compete here: bisexuality as the universal coexistence of the masculine and the feminine in one desiring subject (Freud's or Fliess's model) and bisexuality as the direction of desire at objects both male and female. Interestingly, the popular caricature of the bisexual as someone who just cannot make up her mind (a caricature operative among some lesbians and gay men no less than among some heterosexuals) is still kissing cousin to the Fliess/Freud model, where the bisexual is literally "of two minds." See Marjorie Garber's discussion of these contradictory models in *Vice Versa: Bisexuality and the Eroticism of Everyday Life* (1995).

7 I am not alone in entertaining a fantasy whose prime players are Freud, Dora, and Sarah Bernhardt. George Dimock proposes Bernhardt as an iconic substitute for, or antidote to, the hysterical female patient (1994, 243).

YOU MAKE ME FEEL (MIGHTY REAL)
Sandra Bernhard's Whiteface

A particularly favourable occasion for tendentious jokes is presented when the intended rebellious criticism is direct-ed against the subject himself or, to put it more cautious-ly, against someone in whom the subject has a share—a collective person, that is (the subject's own nation, for instance). The occurrence of self-criticism as a determinant may explain how it is that a number of the most apt jokes have grown up on the soil of Jewish popular life.... Incidentally, I do not know whether there are many other instances of a people making fun to such a degree of its own character.

—Sigmund Freud,
Jokes and their Relation to the Unconscious

WITHOUT YOU *I'm Nothing*, the cinematic conversion of Sandra Bernhard's "smash hit one-woman show" (as she so frequently reminds us), represents a fascinating and offbeat interpretation of the Jewish female body as "perfor-mative accomplishment."[1] The film restages Bernhard's successful 1989 off-Broadway show of the same name in predominantly black supper clubs in Los Angeles. Despite the fact that in the stage show within the film Bernhard repeats much of the "original" material, the film is not a literal record of the stage show. However, the film does employ some of the conventions of con-cert film and documentary, intercutting Bernhard's onstage performances with interviews with "real people"—except all the "real people" are per-formed by actors.

The operative conceit of the film is that Bernhard has gotten too big for her own good. The smashing success of her New York play has spoiled her;

she is "way out of hand." Bernhard needs to return to her roots, to her *black* roots as it turns out, in order to rediscover and recenter herself. So, she goes "home," back to where it all began, back to Los Angeles and the Parisian Room. In moving from east coast to west coast, the play has also shifted audiences: from white to black and, perhaps, from Jew to Gentile. The reactions of the black audience to Bernhard's onstage antics vary from bewilderment, to boredom, to hostility.

Without You *I'm Nothing* functions as a parodic send-up of the conditions of spectatorship and spectatorial (dis)identification by signaling them so brazenly. By explicitly representing what Laura Mulvey has termed the "unpleasure" of the audience within the film (1989, 21), as it watches Bernhard's performances, the film, by accident or intent, interrogates the terms of spectatorial pleasure and identification. The film may also interrogate and challenge the terms through which Mulvey advanced her interpretation of the male gaze, visual pleasure, and narrative cinema. Mulvey locates the "unpleasure" of the male spectator in the threat of castration woman-as-lack represents (21). But the "unpleasure" of Bernhard's audience should not be understood as operating through the framework of sexual difference alone. To the extent that Bernhard may be seen to pose a threat to her audience's pleasure, that threat must be conceptualized as the anxious site/sighting of sexual *and* racial difference. Moreover, *Without* You *I'm Nothing* is not finally readable through a male gaze.

Without You *I'm Nothing* simultaneously teases and frustrates identifications.[2] The film forecloses an identification between its represented and "real" audience. Paradoxically, this foreclosure—what I am calling identifications found, then lost—reflexively calls attention to the misrecognitions which condition pleasure and subjectivity. It is the cinematic spectators—the audience "outside" the film—catching the audience within the film in the act of watching Bernhard, who have the opportunity for recognition, self-recognition as it turns out. True to its name, then, *Without* You *I'm Nothing* plays on the dialectic of within and without, self and other, present and absent. In its movement within and without, the film seems to evacuate any possibility of deciding, once and for all, on which side "realness" lies: hetero/homo, white/black, male/female, Christian/Jew, culture/camp.

Who is the *You* without whom Bernhard would be nothing? The film stages a number of (are they inclusive?) possibilities. First, and most visibly, *You* is a collective person; it refers to the predominantly black audience, whom the film depicts disinterestedly watching Bernhard perform at the Parisian Room. At the film's close, Bernhard, draped in an American flag, apologizes to her audience for lying to them. The critics were right, she admits, she is "a petty, bilious girl." She wishes she could refund the price of admission to each and every one of them, because "without me—without *you*, I'm nothing." If

Bernhard's near miss is "just" a joke, the joke is on Bernhard as it reveals her narcissistic self-involvement. "Without *me*, you're nothing," she nearly said. Yet, the indifference of the depicted black audience has made clear that Bernhard means nothing to them. As Bernhard bumps and grinds her way through Prince's "Little Red Corvette," stripping away the Stars and Stripes to reveal patriotic pasties and g-string, the audience gets up and—one by one—takes leave of Bernhard. Only one woman, a black woman whose spectral presence haunts and even frames the length of the film, remains. (I will return, by way of concluding this chapter, to this black woman's "framing" function.) This lone black woman, then, is also an over-determined site and citational point of reference for Bernhard's directed address, *You.*

Bernhard wraps her verbal slip from *me* to *you* in the star-spangled spectacle and fantasy of a more perfect union—whether (only) with the black woman, within the national body politic, or between Bernhard and her collective audience is an open question.[3] In so doing, she gestures towards the wished-for containment and commodification of diffuse American cultural capitals—of which blackness is the film's most *visibly* represented term. These are processes of appropriation *Without* You *I'm Nothing* will both deliriously represent and ambivalently subvert.

In their contribution to the anthology *Fear of a Queer Planet*, Lauren Berlant and Elizabeth Freeman have interpreted Bernhard's American striptease thus: "Bernhard flags her body to mark a fantasy of erotic identification with someone present, in the intimate room: it is a national fantasy, displayed as a spectacle of desire, and a fantasy, apparently external to the official national frame, of communion with a black-woman-as-audience whose appearance personifies 'authenticity'" (1993, 194). Although I agree with much of their analysis, I want to unsettle the presumption of Bernhard's "whiteness"—an identification which seems, after a fashion, to ground their critique.

Bernhard's hyperbolic attempts to be black, as she impersonates Nina Simone, Diana Ross, Cardilla DeMarlo (in a wickedly lesbotic reinterpretation of "Me and Mrs. Jones"), Prince, and Sylvester, constitute an ambivalent acknowledgment of the conditions under which so-called "minority" cultures become visible to "mainstream"—which is to say: "white" and "straight"— America. A leading condition for the subaltern's visibility is reauthorization, via a commodifying exchange, by hegemonic culture. Expropriating the cultural products and even the "identities" of subaltern communities, majority culture transforms the historical particularities of racial, ethnic, or sexual identity/ies into the universal ground of "America" (hooks 1992, 31).

The issue here is not to adjudicate "origins" and "ownership," but to ask on whose terms and to what effects subcultural capital gets exchanged and differentially evaluated.[4] The multiple fortunes of hybridization are, of course, implicated in a postmodern (read: "late-capitalist") public-sphere-turned-

51

shopping-mall. Nor is blackness the only term charged to and in consumer economy. For, if recent mass market (and even high theory) trends are to be taken seriously, queerness too has a certain exchange value. Madonna herself may be only the most celebrated instance of the "straight queer," the hetero-sexual who self-consciously takes on the signifiers of high-fashion queerness. The aestheticization of queerness, its reduction to a look and a manner of dress one can take on or put off at will, picks up the popular cant of homo-sexuality as a "lifestyle" choice and thereby contains the threatening difference of queerness. In this respect, then, the "straight" answer to Bernhard-as-Sylvester's question—*Do you wanna funk with me?*—is yes.[5]

On one level, then, Bernhard repeats a history of "white" appropriation of "blackness." Not only does she perform songs popularized by and even identified with black divas, but a woman playing Bernhard's manager claims that "Ross, Nina Simone, Whoopi Goldberg—they've all stolen from her."[6] Moreover, Bernhard seeks to produce her body as black. The first song she performs in *Without You I'm Nothing* is Nina Simone's "Four Women." Costumed in Africa, in a dashiki, Bernhard sings: "My skin is black, my arms are long, my hair is woolly, my back is strong....What do they call me? They call me Aunt Sarah.... My skin is tan, my hair is fine (whichever way I fix it), my hips invite you, Daddy, my mouth, like wine.... What do they call me? They call me sweet thing."

As the second woman, "sweet thing," Bernhard invites both comparison and contradiction between her "black" body and the "authentically" black bodies of her band. In a visual citation of earlier closeups of her male band members' lips, the camera closes in on Bernhard's mouth at the very moment she sings "my mouth, like wine." Has she displaced the sexual difference of her "feminine" lips upwards and into an apparent "racial" similarity? Bernhard herself notes the "racialized" terms of her synecdochical identification with her (upper) lips: "They used to call me nigger-lips in high school" (qtd. in "Funny Face" 1992, 44).[7]

Bernhard is all mouth as she ventriloquizes the black. Yet her ventriloquism should not, I suggest, be understood as an attempt to speak *for* blacks. Rather, she represents herself as trying—and flamboyantly failing—to speak *to* blacks *from* the place of blackness. Bernhard's inability to translate and communicate herself denaturalizes "Black-Jewish solidarity," an alliance which has never been inevitable or finally achieved.

How might the contested history and meanings of Black-Jewish solidarity be thought through blackface? Michael Rogin has argued that one Jewish response to nativist sentiments in early twentieth-century America was to see Jewishness in relation to other "monstrously alien" minority identities (1992, 438). Likening their own experience of anti-Jewish violence to lynchings and other forms of anti-black violence, Jews not only made common cause with

African Americans in the struggle for civil rights, but came in some instances to identify *as* black. Interethnic solidarity was most dramatically represented in the Jewish attraction to blackface entertainment. Jewish vaudeville performers like George Burns, Eddie Cantor, George Jessel, and Al Jolsen absorbed and revised blackface minstrelsy (Rogin 1992, 430).

Rogin suggests that Jewish blackface in the Jazz Age may also be viewed as a mechanism of assimilation. Blackface simultaneously posited a relation to black America and promised that blackness could be left behind, transcended in the process of becoming American. Blackness as masquerade had exchange value; it was a switchpoint through which Jewish identity could be made to appear someplace else. Rogin argues that Jewishness passes through blackness into whiteness only by "wiping out all difference *except* black and white" (447; emphasis added). Jewishness, on Rogin's reading, does not transcend or unravel the fundamental binary opposition between black and white, but assimilates itself to the latter term.

Bernhard's blackface performances bear a different relation to the opposition black/white and to the history of Black/Jewish relations in the United States. Parodically reiterating white appropriations of blackness, she destabilizes the binary operations of exclusion and denial whereby whiteness presumes to speak for blackness. Bernhard's blackface thus enacts a kind of whiteface; she imitates and parodies whites impersonating blacks. Seeking to deconstruct and reflexively critique white appropriations of blackness, Bernhard must perform that appropriation. As bell hooks observes, Bernhard "walks a critical tightrope" between criticizing "white appropriation of black culture" and repeat performance (1992, 38). Ultimately, the shifting positions occupied by the black audience in *Without You I'm Nothing* indicate the ambivalent fortunes of (re)appropriation and subversion. Simultaneously the screen against which Bernhard projects herself as transgressive spectacle and the silent register of her inability to translate herself across racial boundaries, the black audience within the film remains the voiceless measure of Bernhard's grand success (or still more grand failure). In this regard, *Without You I'm Nothing* seems to present its critique of white appropriation from the standpoint of whiteness—a whiteness masquerading, unsuccessfully as it turns out, as blackness.

However, what prevents Bernhard's impersonation from being a "simple" act of appropriation is its open failure to forge an identification between her black audience of address and herself. The audience withholds its belief, refusing to authorize Bernhard's vision of herself. Moreover, Bernhard sets herself up as an object of ridicule for that audience, conspicuously dramatizing the distance between her audience's and her own self-understandings. Bernhard's performance is self-ironizing. The audience does not "get" Bernhard; Bernhard does not "get" her audience. But the very misrecognition is to some degree what compels the performance.

Bernhard's failure may also disrupt the pleasure the cinematic audience takes in watching *Without You I'm Nothing*. Bernhard's theatricalization of herself as black is the occasion of extreme displeasure for the black audience within the film.[8] The visible displeasure of the textual audience renders explicit the identificatory fictions which produce and sustain whatever pleasure the cinematic audience takes. In this way, the film potentially challenges the illusions of self-identity which not only determine the pleasure of narrative film, but also condition subjectivity. By showcasing the misidentifications between Bernhard and her audience, the film thus permits the cinematic spectators to gain some distance on themselves.

Nonetheless, the self-critique the film enables may also return to business as usual, reconstituting the self/other dichotomy. For the spectatorial pleasure of the "white" spectators, who comprise the vast majority of Bernhard's following, is founded in part on the represented discomfort or unpleasure of the "black" audience within the film. Yet, so obnoxious is much of Bernhard's performance, so arcane many of her jokes, that the film ultimately frustrates any lasting identification between even its (phantasmatically) white audience and Bernhard, thereby leaving no place to "fix" identity within or through the film. Moreover, the startling and discomforting discrepancy between the laughter of the white or "whitened" spectators, on the one side, and the incredulity of the black audience (whether within or without the film), on the other, may literally represent the appropriations and resistances which condition all identifications.[9]

Throughout the film, it is Bernhard who is the preeminent site of mis-, dis-, and *dissed* identification. Twice, the emcee at the supper club where she is performing introduces her as "Sarah Bernhardt." Such a misidentification punningly installs Bernhard within a theatrical tradition, whose lineage begins with the Divine Sarah, arguably the first truly international star.[10] The name "Sarah Bernhardt" has also come to be identified with histrionics and "over-the-top" self-theatricalization. As a latter-day Sarah Bernhardt, Sandra Bernhard can point to the Jewishness, considerable talent for self-invention, and "notorious" sexual life of her predecessor with an assumed family resemblance.

If the emcee twice confuses Bernhard with her much more celebrated soundalike, neither can Bernhard herself seem to get her own identity straight. She refers to "me and my Jewish piano player," saying "we people get along so well." Bernhard's sardonic "we people get along so well" sends up claims of interethnic solidarity, for the visible gulf between Bernhard and her black audience, who do not respond to the joke, dramatizes exactly the reverse. "We people" also ironically undercuts claims to *intra*ethnic solidarity among Jews. Despite the resistance of her black audience within the film, who are not in on the joke, Bernhard persists in identifying herself as black, even to the point of intercutting scenes of her onstage performances with the figure of a young

54

black woman, never named by the film, but identified in the closing credits as "Roxanne" (Cynthia Bailey). "Roxanne": most famously, the name of another object of ventriloquized desire, Cyrano's.

It is not always clear whether the black woman appears as counterpoint to or confirmation of Bernhard's blackness. Is she Bernhard's mirror image or her mirror opposite? Bernhard's explicit response to this question is that "Roxanne" represents a reality check on her film persona's presumption to blackness:

> We [director John Boskovitch and Bernhard] just thought it was really funny to have this deluded white performer, who thought she was a black diva, perform for a black audience. It was like letting her know that she not only was *not* a black diva, but she had no idea what it was like to suffer, you know in that skin. And of course, at the end, the black woman—the *beautiful* black woman—has the final word, which is "Fuck you, bitch. You may *think* you're black, but I'm the one who's paid the dues." (qtd. in "Sandra's Blackness" 1992, 116; emphases in original)

But, who are "we" and why the emphasis on the black woman's beauty, as if—in the end—(only) the black female's *body* really matters? As Berlant and Freeman suggest, the symbolic function Bernhard assigns to the black woman "perpetuates the historic burden black women in cinema have borne to represent embodiment, desire, and the dignity of suffering on behalf of white women.... " (1993, 218). The black woman signifies, but will not, does not, or cannot speak for herself. But is this the only way to see the black woman's symbolic role in the film or, to put the question another way, is this the only way to understand Bernhard's relationship to her?

In *Black Looks*, bell hooks asks whether the black woman is "the fantasy Other Bernhard desires to become ... or the fantasy Other Bernhard desires?" (1992, 38). Answering the former, hooks claims that the black woman functions as a critical "yardstick Bernhard uses to measure herself" (38). But are identification and desire only thinkable as mutually exclusive possibilities? What if identification is one of the ruses through and by which transgressive desires are rerouted?[11]

Identification and desire link Bernhard and the black woman throughout the film. Often, what mediates this transfer between identification and desire, Bernhard and the black woman, is a series of overlapping cultural references. The first time we see Bernhard, for example, she is sitting in front of a make-up mirror, concentrating all her attention on a strand of hair she is fussily trimming. Here *Without You I'm Nothing* and Bernhard wink at their audience as they conjure the image of Nico cutting her hair in Andy Warhol's *Chelsea Girls*. As Bernhard comes into closer view, the background music shifts from high European culture, signaled by Bach's first *Partita*, to the uniquely "American" sounds of jazz. Piling citation upon citation, this scene will later

55

be cited by the black woman. The black woman stands before a bathroom mirror, listening to Ice Cube, and carefully cuts a strand of hair. At other moments also the black woman appears either to retrace Bernhard's movements or give form to Bernhard's onstage monologues. During Bernhard's riff on Sonny and Cher's "The Beat Goes On," for example, the camera cuts from Bernhard's knowingly solemn intonation "And history has turned the page, uh-huh" to the black woman, in a chemistry laboratory, turning the page of a large textbook. Later, in a scene which registers the unstable border between identification and desire, we see Bernhard, on the bottom, being fucked by her black boyfriend, Joe the hairdresser. Bernhard seems to have usurped the black woman's position in a heterosexual economy of exchange, which posits sexual difference and racial "sameness" as normative criteria.[12] However, what if it is the black man who has taken the black woman's place? Perhaps, as Elspeth Probyn suggests, Joe substitutes for Bernhard's "real" object of desire and identification, the black woman (1993, 156). After all, the scene of heterosexual coupling was from the first a case of mistaken identity. Bernhard's insistent identification of Joe as a hairdresser, that redolent signifier of the homosexual and the effeminate, already promiscuously implied his "unmanning." Moreover, her complaint that Joe spent so much time in the bathroom "getting his look together" that she thought she was with a woman—"and from the size of [his] dick, I might as well have been," Bernhard quips—recasts the hypervirile, hypersexual black "stud," long a stock figure in a white racist imaginary, as not much more than a woman. That such a move, toppling the black man from his position "on top," is not necessarily a liberation hardly needs comment.

However, it is not just Bernhard who crosses over into the black woman's territory by becoming, or seeking to become, black. In one scene, the black woman puts herself, or is put, in Bernhard's "place." The black woman is seen leaning against what appears to be a kosher butcher shop. As Jean Walton notes in her lucid reading of this film, Bernhard's black stand-in holds a copy of Harold Bloom's *The Kabbalah and Criticism* in her hand.[13] This scene signals the possibility (or wish) that Bernhard's identification with blackness and the black woman might, as it were, go both ways. The book title, which passes fleetingly into and out of the viewer's gaze, may also represent a teasing challenge to the filmic audience to subject the film and Bernhard to critical scrutiny.

The film's final, critical words belong to the black woman. As Bernhard stands before the now-empty supper club, gazing plaintively into the space her audience used to occupy, the camera's gaze and Bernhard's become unified, focusing intently on her last best hope, the black woman, who has materialized as if from nowhere. The black woman wears a flowing evening dress, her hair piled high on her head. She seems to return Bernhard's gaze, but with contempt (is this halfway to desire?), going so far as to mark that contempt in

lipstick, femininity's signature. "Fuck Sandra Bernhard," she scrawls.[14] As the camera lingers over the black woman's parting statement, it also foregrounds a full glass of Remy Martin, the liquor to which Bernhard—in the persona of a black lounge singer—has earlier pledged her fealty. In high-culture contrast to Bernhard's bump and grind version of Prince's "Little Red Corvette," the black woman fairly floats out of the scene to the reprise of Bach's first *Partita*. The black woman is consumed by whiteness, as both she and the screen literally fade into white (Probyn 1993, 151).

In her analysis of the film, hooks argues that "all the white women strip, flaunt their sexuality, and appear to be directing their attention to a black male gaze" (1992, 38). But who are *all* these white women? There are only three "white" women in the film: Bernhard; her cigar-smoking manager; and Shoshana, an obvious parody of Madonna. Now, Bernhard's "butch" manager hardly seems the type to be flaunting her sexuality and performing for *any* male gaze—at least not in the straightforwardly heterosexualized manner hooks ushers into (our) view. By "all the white women," then, hooks must mean "Shoshana" and *multiple* "Bernhards." Evidently, performance and cinematic spectacle only go so far. Hooks allows that Bernhard may be fragmented into pieces, but seems to rule out the possibility that any of these performing "pieces" might be other than white. Hooks also insists that all the white women perform for a black male gaze. Yet, who or where is the agency of that gaze? Does hooks mean the audience within the film (which includes both men and women), the boyfriend "Joe," or a hypothetical black male gaze towards which white women in general direct themselves? The black male gaze within the film—if that is what it is—is textual, and it is *not* unified with the extra-textual gaze of *Without You I'm Nothing*'s cinematic audience.

Hooks introduces, but quickly drops the possibility that Bernhard might be performing for a black female gaze (1992, 38). Black women are Bernhard's "yardstick," not her objects of desire. Hooks chooses to read the interracial trajectory of Bernhard's desire heterosexually. This is, in my view, a telling misreading. The closing scene of the film, where Bernhard strips for the sole remaining audience member, suggests that it is black womanhood Bernhard desires and black women whose gaze she seeks to meet. Recoding lesbian desire through racial difference, rather than through the terms of sexual difference, stages the non-identity of "same-sex" love. The "same" is restaged as and in the difference "between" white and black. All the same, this does not answer to the concern that it is the black female body that bears the burden of signifying the "white" woman's difference—a point also made by Probyn (1993, 158) and Berlant and Freeman (1993, 218). It does, however, queerly complicate the relations between "racial difference" and "sexual difference," identification and desire.

57

Blackness is not the only performative term the film tries to make visible. Does the black woman's disappearance into a screen of white light at the film's close represent only the territorialization of blackness by whiteness or/and does it destabilize the claims of either side—"whiteness" or "blackness"—to represent or incorporate "realness"? I want to suggest that this destabilization occurs through the introduction of an excluded middle term, which resembles both sides, but is identical to neither: Jewishness. This is a point hooks, Probyn, Walton, and Berlant and Freeman overlook. Although hooks and Probyn at least cite Bernhard's Jewishness, neither fully addresses what the historical associations between blackness and Jewishness might mean in the context of Bernhard's will to blackness.

For hooks, Bernhard's "Jewish heritage as well as her sexually ambiguous erotic practices are experiences that place her outside of the mainstream" (1992, 37). Jewishness and unnamed, but sexually ambiguous (*because* unnamed?) erotic practices together place Bernhard at the cultural margins. But what does Bernhard's Jewish heritage have to do with her queer erotic practices? Has hooks inadvertently defined that heritage in erotic terms? The representations of Jewish women, not unlike the representations of (other?) women of color, have themselves been overburdened *as well as* over-identified with "sexually ambiguous erotic practices." Hooks insinuates, but does not finally clarify connections between Bernhard's assumed blackness, on the one side, and her Jewishness and queerness, on the other. She locates Bernhard's "outside" in an "alternative white culture" whose "standpoint" and "impetus" the film traces to "black culture" (37). Yet, in Bernhard's pulsating tributes to (and as) Sylvester, "You Make Me Feel (Mighty Real)" and "Do You Wanna Funk," as well as in her knowing reference to *Chelsea Girls* and her later rhapsodic eulogy for Andy Warhol, she makes it clear that *queer* cultures, black and white, are also among the resources and expropriated sites of American (sub)cultural capital.

Similarly, when Probyn refers to Bernhard as a "white Jewish woman" (1993, 156), it is not obvious to me what work "Jewish" is doing here. On this, the first and last occasion Probyn will cite Bernhard's Jewishness, she qualifies it as "white." However, isn't the relation of Jewishness and "race" one of the things *Without You I'm Nothing* contests? Berlant and Freeman too seem to lose sight of Bernhard's "racial" specificity. They (mis)identify the film's and Bernhard's "aesthetic distance" as working through the "straightness of the *generic* white woman-identified-woman" (1993, 218; emphasis added). But what does generic whiteness—or generic blackness, for that matter—even look like? And does it look like Bernhard?

At the very least, Bernhard does not identify herself as white. Asked in a 1992 interview whether she "[related] to the world as a white person," Bernhard responded, "I never relate myself as a white person because I'm not

a gentile; I'm a Jew. I feel like, culturally, I've gleaned from other cultures, but I also have a very rich one myself" (qtd. in "Sandra's Blackness" 1992, 116). In a 1993 interview (the too perfectly captioned "Egos and Ids"), Bernhard signals also the comparative *in*significance of her sexualized and gendered differences—as a woman-loving-woman—when measured against the historical meanings of the Jew's "racial" difference:

> I feel more concerned about being a Jew than I do about equating myself with being gay. I feel like there's more anti-Semitism than there is anti-homosexual feelings. It's like if the Nazis come marching through, they'll come after me as a Jew before they do as a chic lesbian. (1993, 4)

When pressed on the same point in another interview, Bernhard speaks even more directly of the inescapability of her Jewishness: "If I am going to defend any minority part of myself, it is going to be Judaism. It's something that has formed my personality much more than my sexuality has.... You are born Jewish. It is not something you can deny or run away from. You can pretend you're not. You can get your nose fixed and play all kinds of games, but ..." (qtd. in Sessums 1994, 126). Bernhard's Jewishness is not a "chosen" identity—even if accepting it or rejecting it is her choice. In contrast, she says, "you develop your sexuality" (127).

Whether or not Bernhard is right that the Nazis, or their contemporary equivalents, would come for her first as a Jew and only secondarily as a "chic lesbian" seems to me beside the point. What interests me here is the way Bernhard conceptualizes her Jewishness, on the one side, and her sexual "identity," on the other. In representing herself as born Jewish, but become queer, she aligns Jewishness with nature, and sexuality with nurture. Another way to express this division would be "essentialism" versus "constructionism."

In posing herself *as* the question of race, Bernhard appears to align herself with blackness not so much over and against whiteness as conceived through it. Her passage from blackness to Jewishness takes place through a caricatured whiteness. This transmutation through whiteness is dramatized in one of the film's early sequences. First, a "black" Bernhard performs Simone's "Four Women." After she completes the song, the black emcee encourages an incredulous audience: "Sarah Bernhardt, ladies and gentlemen. The lady came here all the way from New York City, so let's give her our support." Following Bernhard to the stage is "our very own lucky, lucky, lucky star, the original Sho-shanaaaaaa," the Jewish name "Shoshana" rhymingly replacing the Catholic "Madonna." As Shoshana wriggles her way through a performance whose bad taste is exceeded only by its poor execution, the camera cuts away from Shoshana's dancing fool to the anonymous black woman walking in front of the Watts Tower, then cuts back to Shoshana. Finally, Bernhard, performing "Bernhard," returns to the stage, where she attempts, unsuccessfully,

59

to lead the audience in a round of Israeli folk songs. She talks about the joys of growing up in "a liberal, intellectual Jewish household," but also confesses to a Gentile family romance:

> I'd fantasize that I had an older brother named Chip and a little sister named Sally, and my name would either be Happy or Buffy or Babe....

It is the white imitation-Madonna and the buxom "Babe" who appear the most obviously "false" of any impersonation in the film. "Whiteness," then, is recast as always already an imitation—variously of blackness, of itself, of nothing. (This last possibility—"nothing"—recalibrates the distance and the difference between the subject-positions brokered in the film's title.) Bernhard also identifies whiteness with Christianity, concluding her rapturous "testimonial" to the joys of Gentile family values with the wish, "May all your Christmases be white."

It may be, as Mary Ann Doane has suggested, that "[t]o espouse a white racial identity at this particular historical moment is to align oneself with white supremacists" (1991, 246). Moreover, as Doane also argues, "... both whiteness and blackness cover and conceal a host of ethnicities, of cultural backgrounds whose differences are leveled by the very concepts of white and black. Whiteness and blackness are historically *real* categories only in their lengthy and problematic collision with each other in the context of systems of colonialism and slavery" (246). This, on my viewing, is one of the things *Without* You *I'm Nothing* achieves, or comes close to achieving: namely, the disruption of the totalizing logic either/or, white/black. Ultimately, however, it also seems to me that the film and Bernhard can only disrupt monolithic whiteness by reconsolidating blackness.

Nonetheless, Bernhard's *whiteface* performances, through which she mimes and parodies whiteness as the historical agent of colonization and cultural appropriation, complexify the relations Rogin traces in *The Jazz Singer*. Bernhard's blackface is not principally a mechanism whereby Jewishness transcends blackness and becomes white; her insistent equation of whiteness with Christianity troubles such a movement. Arguably, Bernhard's impersonation of whites impersonating blacks allows her to leave behind not blackness, but white guilt. In parodying the bald-faced failures of whiteness to speak for or even to blackness, Bernhard may be exculpating herself from any wrongdoings committed in the name of whiteness. This is a paradigmatically liberal gesture of disavowal and/as transcendence. It may also represent the reappearance of a political fantasy, Black-Jewish solidarity.

But, just as the gender performatives of *Paris is Burning* are not only about gender, the race performatives of *Without* You *I'm Nothing* are not only about race.[15] I believe Bernhard works "race," which she represents as blackness, as a way to situate and resituate also her Jewishness, queerness, and womanliness.

That Bernhard thematizes whiteness as "being," among its other attributions, a relation to Christianity acts to denaturalize the claims of "race." At the same time it indicates how Jewishness is articulated through multiple terms of difference: religion, race, gender, nationality, sexuality, class, *and* political affinity.

Blackness, arguably the constitutive elsewhere of American national identity, becomes a way of visibly re-marking and exteriorizing Bernhard's differences. Articulating her "otherness" through blackness reinscribes and potentially upends the historical terms of American "racial" definition.[16] Perhaps blackness is the performative term most often seen, or recognized, in *Without* You *I'm Nothing* because it "appears" to be the one identity category on display in the film Bernhard does not "really" embody, because Jewishness or queerness or womanliness are somehow facts about Bernhard. She just is those things, right? This is appearance as ontology.

In sum, Bernhard's open avowal of the co-implicating structure of identity categories illuminates what so often seems just a theoretical abstraction: gender and race performatives. Moreover, we are able more clearly to recognize and identify (with) those processes that constitute and are performed as subjectivity when Bernhard is acting up and acting them out, than when "we" are "ourselves" becoming subject(s) through them. Meanwhile, if I take pleasure from Bernhard's performances at (and as?) the crossroads gender, race, and sexuality, that pleasure is itself conditioned by the glimmer of recognition—I mean, self-recognition—provided in this occasion of spectatorship. It is prompted also by the prick of my desire, as if I were the phantasmatic *you* for whom Bernhard performs and without whom her "I" would be nothing.

Put otherwise, the *I*—whether mine, hers, or yours—is the intersubjective site, or citation, of the differentiating marks of desire and identification. Bernhard's self-referential performances succeed, in some small measure, in calling up and relocating something of the Jewish female subjects displaced by Freud's (and Gilman's) terms. However, to the extent that she articulates the specificities of her body by speaking through another other's terms, Bernhard is yet caught up in the endlessly repeating and repeated logic of identifications found, lost, and found again at someone else's address.

61

NOTES

1 The term "performative accomplishment" is Butler's (1990b, 271).

2 For another reading of Bernhard's "tease" and "refusal," see Berlant and Freeman 1993, 193–229.

3 Cf. Berlant and Freeman 1993, 193–94, 217.

4 It is worth considering, with Homi Bhabha, the ways in which commodification and economic objectification fold into colonial power/knowledge: "It [i.e. colonial power] is an apparatus that turns on the recognition and disavowal of racial/cultural/historical differences. Its predominant strategic function is the creation of a space for a 'subject peoples' through the production of knowledges in terms of which surveillance is exercised and a complex form of pleasure/unpleasure is incited. It seeks authorization for its strategies by the production of knowledges of colonizer and colonized which are stereotypical but antithetically evaluated" (1994, 70).

5 See, in this regard, the spate of 1993 articles on "straight" passing as "queer" in the *Village Voice* (Powers), *GQ* (Kamp), and *Esquire* ("Viva Straight Camp!").

6 The stage name "Whoopi Goldberg" indicates that blackness may also name itself through Jewishness. It also names a group whom this discussion occludes: African-American Jews.

7 Bernhard's "inflated" lips are a point of frequent and sometimes even anxious discussion (Green 1992, 42; cf. "Look at Me" 1992, 14 and "Hips, Lips, Tits, POWER" 1992, 8). Her mouth is cited as her most distinguishing feature. An extreme closeup of her mouth is even the full-page subject of a Herb Ritts photo in his 1992 "photo album" of the "stars," *Notorious*.

8 In a 1992 interview with *Vibe* magazine, in which the flattering representation of "Sandra's Blackness" is in sharp contrast to the companion piece dissing "whites who think they're black," Bernhard was asked how black audiences respond to her black characters. "The black audiences love me. It's kind of amazing. They really get it. They're very receptive to me, it's the highest honor, because if black people dig you, you must be doing something right" (116). The displeasure recorded by the camera is a staged displeasure, then. According to Bernhard "real" black audiences "really" do "dig" her act. It is an open question whether Bernhard has here accurately represented—or spoken for—her impossibly unified "black audiences."

9 I do not here want to oversimplify the reception of this film. I am not claiming that all white people or all Jewish people (many of whom are also "white") like, or must like, this film. Nor do I mean to suggest that all black spectators (who may also be Jewish) are put off by Bernhard's bodily impostures. In neither case would this be "true" to the anecdotal

evidence offered me by Jewish and African-American friends and colleagues whose reactions to *Without You I'm Nothing* do not so easily fall into "racial" and/or ethno-cultural line. Rather, I am trying to offer a schematic of the spectatorial positions idealized and produced by the film. At minimum, it seems to me that the very divergent reactions this film has prompted make amply clear how the scene of (dis)identitification is mediated through race, gender, sexuality, and class positions.

10 Jesse Green's 1992 *Mirabella* article on Bernhard is even knowingly titled, "The Divine Sandra."

11 Diana Fuss explores how identification simultaneously opens up and defends against the possibility of lesbian desire in the context of contemporary fashion photography (1992).

12 Butler has urged that feminist theory attend to the places where compulsory heterosexuality does not just prohibit homosexuality, but also regulates and demands racial "purity" (1993a, 18). In other words, how do miscegenation and homosexuality together mark the boundaries of a reproductive heterosexual economy? The incest taboo—which is to say, the prohibition on mother-son incest—represses a prior prohibition on homosexuality and incest between father and son or mother and daughter (Butler 1990a). But the prohibition on (heterosexual) incest, which generates the extra-familial exchange of women, produces an exogamy within limits, *racialized* limits. In this sense, the prohibition on miscegenation potentially preserves and incorporates the fantasy of incest by keeping reproduction within the bloodline and, thus, within the "family" of (or as) "race."

63

13 See Walton 1994, 255. Walton's fine essay on *Without You I'm Nothing* was published after the penultimate version of this chapter was written. As much as I am in agreement with and have learned from her reading of the film, Walton too fails to register the difference that Jewish difference might make for Bernhard's "whiteness."

14 Berlant and Freeman make a similar point (1993, 217).

15 For an analysis of the links between race and gender performatives in *Paris is Burning*, see Butler 1993a, 121–40. Compare hooks 1992, 145–56 and Phelan 1993, 93–111.

16 During the first decades of widescale (read: "visible") Italian, Irish, and Jewish immigration to the United States these marginalized "white" ethnicities—Irishness, Italianness, and Jewishness—were assimilated to blackness. For those whom historian David Roediger has called the "not-yet-white ethnic" (1994, 184), assimilation to the American ideal has historically meant assimilation to "whiteness." In his study of common features in the symbolization of blacks and Jews in the American white imaginary, Nathan Hurvitz cites, by way of just one example, the "street expression

and graffito" that "a nigger is a Jew turned inside out" (1974, 307). If this "joke" reverses the direction of Bernhard's performances and draws blackness through Jewishness, it yet arrives at the same "punchline." Neither the "nigger" nor the "Jew" is a subject *of* whiteness, but is rather subjectivated through its terms.

BLACKNESS

The words of
race are like
windows into
the most pri-
vate vulnera-
ble parts of
the self; the
world looks in
and the world
will know, by
the awesome,
horrific reve-
lation of a
name.

—Patricia J.
Williams,
*The Alchemy of
Race and
Rights*

CITING IDENTITY, SIGHTING IDENTIFICATION
The Mirror Stages of Anna Deavere Smith

Let me give you an analogy; analogies, it is true, decide
nothing, but they can make one feel more at home.

—Sigmund Freud,
"The Dissection of the Psychical Personality"

IDENTIFICATION IS appropriative, aggressive, and highly theatrical. To say this
is to state the obvious. (Sometimes, of course, it is precisely the "obvious" that
most needs restating.) But it is also to understate the unsettling implications
of identification for any theory or politics of identity that wrestles, as any such
theory or politics must, with (or in) the place of "the" subject. Poststructuralist
theory's death of the subject is a passing foretold in Freud's depiction of
identification as the shifting and ever uneven "ground" of desiring subjectivity.

In Freud's first public commentary on psychical processes of identification,
in *The Interpretation of Dreams*, Freud analogizes hysterics' ability to "express in
their symptoms not only their own experiences but those of a large number
of other people" to a talent, "as it were, to suffer on behalf of a whole crowd
of people and to act all the parts in a play single-handed" (1900, 149).[1] Freud
rejects the hypothesis that hysterical identification is no more than the

"familiar" (and apparently boundless) capacity of hysterics for imitation (149). Instead, he characterizes identification as "*assimilation* [*Aneignung*] on the basis of a similar aetiological pretension… " (150; emphasis in original). Identification, he continues, "expresses a resemblance and is derived from a common element which remains in the unconscious." Significantly, the two examples Freud brings before his readers' imagination are hysterical women. "Supposing a physician is treating a woman patient," Freud sets the scene, "Let us imagine that… " (149–50). Gendered female, hysterical identification is cast, "as it were," as a one-woman play.

In the three decades after this brief and diverting episode in *The Interpretation of Dreams*, Freud's initial focus on the pathology of identification—in cases of hysteria, melancholia, and homosexuality—gives way to an appreciation of "how common and how typical" identification is (1923, 28).[2] Although Freud will continue to pathologize some cases (homosexuality above all) where object-cathexis "regresses" to identification, he also comes to describe the introjection of lost objects and the alteration of the ego on their model as the normal and even necessary course of events. The replacement of object-cathexis by identification, Freud argues in *The Ego and the Id*, "makes an essential contribution towards building up what is called its [ego's] 'character'" (1923, 28). The ability of the ego to conserve its losses by transforming an erotic object-choice into an identification might even, he suggests, allow the ego to wrest some slim self-control from the id (albeit on desire's terms). Entering more fully into the theater of identification, Freud scripts an encounter between the ego and its id: "When the ego assumes the features of the object, it is forcing itself, so to speak, upon the id as a love-object and is trying to make good the id's losses by saying: 'Look, you can love me too—I am so like the object'" (30).[3] The theatricality of Freud's description of identification is exceeded only by the theatricality of the ego, whose capacity for assimilation, imitation, and transformation is as limitless as its range of real or imagined objects.

Not only does this substitution potentially strengthen and enrich the ego, but identification in the shadow of loss turns out to be the ego's constitutive condition: "… the character of the ego is a precipitate of abandoned object-cathexes and … contains the history of those object-choices" (29).[4] The character of the ego, what I am glossing as "identity," re-presents the history of a subject's identifications with and desires for others (real or imagined). But, and I take this to be the critical provocation of Freud's theory of identification, the subject so-called and identity as such do not "exist" prior to identification. If, as Elin Diamond suggests, it is "impossible to conceptualize a subject in the process of identification who would not be engaged, however unconsciously, with the history of her identifications, which is at least partly the history of her psychic life with others" (1992, 396), it is equally impossible to imagine

subjectivity, or to "be" a subject, except through identification. (I will address Lacan's gloss on identification later.)

Freud's assertion that identity is a precipitate of abandoned object-cathexes might seem to assign priority of place, in the psychic history of the subject, to desire. However, after a slight detour (which is really a return) to the matter of pathological identifications, he settles the issue what (and who) came "first" in favor of identification.[5] An individual's "identification with the father in his own personal prehistory," Freud argues, "is apparently not in the first instance the consequence or outcome of an object-cathexis; it is a direct and immediate identification and takes place earlier than any object-cathexis" (1923, 31).[6] Even as other objects come and go and are soldered into the ego, this "prehistorical" identification with the father will continue to impress itself on the character of the ego; the super-ego is heir to this first attachment.

The particular stress Freud sets on a "direct and immediate" identification with the father in the "personal prehistory" of the subject begs the question as it prefigures the answer why Freud's account of primary identification is always already gendered.[7] For, as Diana Fuss helpfully observes, the preoedipal prehistory of "primary" identification is produced and narrativized after the "fact" of a postoedipal "secondary" identification (1993, 53). In this retroaction of objects lost and subjects founded, son fathers parent(s); pre- is heir to post-; and "proper" gender identification and "appropriate" object-choices are secured backwards, in what Lee Edelman has playfully termed "(be)hindsight."[8] Indeed, it is only after raising the specter of identifications too much in the grip of former objects of desire that Freud asserts the prehistorical and foundational status of identification with the father (1923, 30-31).

Nonetheless, the careful distinction between identifying with the same and desiring it cannot hold—as Freud himself acknowledges ten years later when he returns to the terrain of ego, id, and super-ego, in his *New Introductory Lectures*.[9] Now identification is "probably" the earliest form of attachment to someone else, and identification and desire are "to a large extent independent of each other" (1933, 63)—qualifications that reveal the troubling tendency of identification and desire to cross and multiply in ways that do not admit of easy disentanglement or prioritization. To cite Fuss again: "... in the very attempt to prove that identification and desire are counterdirectional turns, Freud in fact demonstrates their necessary collusion and collapsibility, the ever-present potential for the one to metamorphose into, or turn back onto, the other" (1993, 54).

Whatever the inconsistencies and contradictions in Freud's various attempts to set out and set straight the relations of identification and desire, his richly complicated understanding of the way unconscious identifications form and are continually transforming the character of the ego on the model of an other unhinges self-identity to open up the space between. These "in-between

spaces"—to invoke Homi Bhabha's elegant phrase—offer the possibility of glimpsing the other in the same and the same in the other. It is important, however, not to romanticize this movement, this travel from self to other and back again. For the colonizing gesture which is identification is more than a metaphor. As both Fuss and Bhabha make clear in their readings of Frantz Fanon's politics of identification, not just psychoanalytic theories of identification, but identification "itself" may be and has been mobilized in the historical project of colonialism.[10] Certainly, Freud's likening of identification to *Aneignung*, a term his English editors translate as "assimilation," but which would more accurately be rendered "appropriation," is not innocent of this history—a colonial history that touches on without being reducible to Freud's own political and psychical predicament as an other within.[11] Both terms, "appropriation" and "assimilation," figure in the history and the rhetoric of colonialism; together they may even represent both sides of its unequal equation.

The appearance of assimilation in the place of appropriation introduces the specter of another difference ("race") and another identificatory process: identification not in the sense of identifying *with* some x (or with the image one has of some x), but of identifying or "hailing" some x as y. These identifications objectify; their most common expression is the stereotype; and their achievement is *dis*identification. What Jay Geller terms "apotropaic representations" ward off the terrifying specter of the other's difference from the self and "plaster over" the self's discomforting dependence on the other to reflect back—mirror—the self.[12] We have encountered a version of this phenomenon earlier, in the narcissism of minor differences. Another version may be observed in the elsewhere of the colonial imagination. To put a finer political point on the matter: the colonizer generates the fiction of his self-identity by displacing difference elsewhere, onto the colonized, who become the placeholder of absolute difference. The colonized do not have the same luxury of disidentification; even their inner kingdoms may be overrun by images of the colonizer in the double sense of images *of* the colonizer as measure of what it is to be human and images the colonizer *has* of them or of "their people."

The flip side of hailing some x as y, then, is that the one so hailed may find her or himself in that hailing, may, that is, come to identify not just with the other, but with the image the other has of her as the human's outer limits. The term "assimilation" thus casts too polite a notice on the violence that activates and impresses the subject of colonialism to identity with the subject of empire; it looks the other way (by gentlemen's agreement?) from the appropriations that underwrite the colonial encounter. I will return to these issues in the next chapter, when I take up the challenge of Fanon's *Black Skin, White Masks*. For now I want to pursue another way into the gap between self and other, same and different, identity and (dis)identification.

The relation of the subject to the Other is entirely produced in a process of gap ... from the subject called to the Other, to the subject of that which he has himself seen appear in the field of the Other, from the Other coming back. This process is circular, but, of its nature, without reciprocity.

—Jacques Lacan,
"The Subject and the Other: Alienation"

... I still have to make the trip to begin to see this from another person's point of view. From other people's points of view, to see this geography of race, just positioning myself a little bit differently, less from the heart, if you will, less from automatic response and more patient, more like stepping back, stepping back, stepping back, stepping back.

—Anna Deavere Smith, "Media Killers"

In a series of performance pieces, playwright, actress, and self-described "repeater" Anna Deavere Smith has attempted to step into and inhabit the space *between*. She performs the self called out from the other, but holds out hope of a reciprocal turn. Smith does not aim to efface or colonize the other.[13] Instead, her theater project—evocatively entitled *On the Road: A Search for American Character*—represents and, through Smith's person, literally enacts the possibility of recognizing the other in the self and the self in the other.

The performance pieces that make up *On the Road* are organized around communities (or communities manqué) in transition, persons and institutions in the process of negotiating contested claims of and to "identity" and belonging. In what are probably her best-known works, *Fires in the Mirror: Crown Heights, Brooklyn and Other Identities* and *Twilight: Los Angeles, 1992*, Smith portrays people and places coming apart at the seams—and "seems"—of race, class, gender, national origins, and generation. Each theater piece is assembled, word for word, out of interviews Smith conducts with women and men in some way, often in some very surprising and unexpected way, connected to the historical events and communities that are the occasion for the play. On stage, Smith performs all the parts and repeats the words spoken to her. She does not take sides, but attempts to "inhabit" every subject-position.[14] From these multiple vantage points emerges another story or stories, ones not reducible to simple cause and effect, us and them.

In stark contrast to Freud's "hysterical" mimic, then, whose suffering "on behalf of a whole crowd of people" and acting "all the parts in a play single-handed" demand a cure, Smith's one-woman play effects a cure. A *talking cure* for the terrifying risks and necessities of identification and disidentification.[15] (Remember: "Identity," the character of the ego, is effected not only through acts of *in*corporation and *in*clusion, but also through acts of *ex*clusion.)

71

I do not, however, want to overwork this analogy between theater and psychoanalysis. To be sure, the issues engaged in Smith's performance pieces, and the way she represents them, do illumine key words and concepts for psychoanalysis—for example, identification, the mirror stage, and the division of the subject in language. Smith's performances set in dramatic relief also terms that have achieved critical currency in theater and performance studies, literary criticism, and post-colonial, feminist, and lesbian and gay theories—for example, performativity, iterability, and identification (still and again). In making these connections, however, I do not mean to treat Smith's performances and their innovations like extended (and theatrical) metaphors for theory. Such a bracketing would too much follow Freud, and, in another way, J. L. Austin, who did not so much look at the theatrical, as look *through* it to see the psychical and the performative, respectively.[16] My ambition in reading Anna Deavere Smith's embodied performances "after" psychoanalytic accounts of identification is to open new angles of re-vision onto *both* the theatrical and the psychical, *both* performance and performativity. In this regard, then, the looking glass goes (at least) two ways to ask: Where do Smith's attempts to indicate that character abides where language fails cross, if they do, Lacan's account of the division of the subject in language? What new purchase on processes and politics of identification might be gained from reading Freud with and against Smith's *Fires in the Mirror*, the 1992 play on which I will focus this intertextual study? Do Smith's performances challenge the privileged place sexual difference occupies in psychoanalytic theory and in theories drawn through psychoanalysis? Do her hopeful evocations of individuals and communities coming together in their differences offer a way to connect individual and group psychology, psychoanalysis and culture, the psychical and the social in productive new ways? To go in the "other" direction, what happens in the performative space opened up between Smith ("Smith") and her spectators? What does this have to say to the relations among speech acts, interpretive communities, and identification? These are not, I want to stress, rhetorical questions, but are of some moment for politics as for theory.

History is backdrop and engine to Smith's performances; the "real-life" events which occurred before the curtain opens offer the audience (which quite frequently includes the interview subjects) and Smith too (the interviewer turned reiterator) points of entry and identification.[17] The story "behind" *Fires in the Mirror* is four days of unrest and rioting that engulfed the Crown Heights section of Brooklyn in August 1991. The rioting began the day after two deaths: Gavin Cato's, a seven-year-old Guyanese-American boy struck and killed by a car driving in Lubavitcher Grand Rebbe Schneerson's motorcade; and 29-year-old Yankel Rosenbaum's, an Hasidic scholar from Australia attacked and killed by a group of young black men. These deaths did not so much "cause" the riots as stoke preexisting misunderstandings and

tensions between black communities (plural) living in Crown Heights and a smaller community of Lubavitcher Hasidim. The historical identifications informing the play's reception(s) also include the violent disturbances that erupted in Los Angeles, and some other U.S. cities, after the acquittal of the police officers accused of beating Rodney King—events that overlapped exactly with the May 1992 preview performances of *Fires in the Mirror* in New York. In fact, the first preview, scheduled for the evening of May 1, was cancelled out of "concern," in the *New York Times*'s memorable words, "that the unrest would *spread*" to New York City (Wright 1992; my emphasis), a characterization which recasts the political response to the acquittal as a kind of psychical infection or epidemic of identification. Signifying on the past even as it is signified "in" it, *Fires in the Mirror* thus constitutes an historical intervention in this double sense: the intervention *of* history and an intervention *in* it.

In partnership with her audience, Smith potentially creates an "intermediate region" where experiences may be repeated and worked through to somewhere else. In the space of this remembering, repeating, and working through—as in the "definite field" of the psychoanalytic transference—is forged the opportunity to repeat with a difference, to identify with (a) difference.[18] This does not mean that all members of the audience will come to the play with the same relation to its background history—and this is not simply a question of whether they hail from Crown Heights or not. Nor does it imply that every member will leave with her or his "pre-curtain" identifications transformed in the same way (if they are transformed at all).

Whether these identifications other-wise are sustained beyond the length of Smith's performances must remain an open question. I can only cite, in the place of an answer, Freud's thoughtful commentary on the necessary provisionality of "constructions" (that is, *re*constructions of some forgotten piece of the patient's early history) offered in the course of analytic treatment: "The analyst finishes a piece of construction and communicates it to the subject of the analysis so that it may work upon him… " (1937, 260). "Only the further course of the analysis," he concludes, "enables us to decide whether our constructions are correct or unserviceable. We do not pretend that an individual construction is anything more than a conjecture which awaits examination, confirmation or rejection" (265). Neither a simple yes nor a simple no will suffice to corroborate or deny the correctness of a construction. The analyst rather looks for "indirect forms of confirmation which are in every respect trustworthy." As Marcia Ian makes clear in the wonderful re-uses to which she puts Freud's essay, the truth-value of a construction will be the degree to which it "touches" its recipients (Ian 1993, 232–33). Importantly, the analysand is not a passive recipient of the analyst's message but is an active participant in the exchange.[19]

So too do the members of Smith's audience actively shape and resist mean-
ing. Listening, giving witness—these are performative acts. On the one hand,
the gasps of laughter and of shock which meet Smith's performances indicate
that something is getting across to and working upon the audience.[20] On the
other, just what message or messages are being received by the audience, in all
its heterogeneity, and sent back *to* Smith as well as to *each other* is not clear.
Ratification? Renunciation? All and nothing? In the "space of reception," per-
formative utterances may be conducted elsewhere than intended.[21]

In her introduction to the published text of *Fires in the Mirror*, Smith
describes the political intervention she intends on stage as the "intervention of
listening" (1993a, xxxix).[22] And what she is listening for are the places "where
words fall away" and character struggles to make itself heard in all its awful
silence and speechfulness (1994a, 117). Her sense is that

> American character lives not in one place or the other, but in the gaps
> between the places, and in our struggle to be together in our differences.
> It lives not in what has been fully articulated, but in what is in the process
> of being articulated, not in the smooth-sounding words, but in the very
> moment that the smooth-sounding words fail us.... (1993a, xli)

Smith's procedure for revealing character may be helpfully analogized to the
technique of psychoanalysis. She too fastens on slips of the tongue, colorful
allusions, halting speech—the *uhs* and *ums* in consciousness. She is looking and
listening for evidence that the "unique" way individuals and groups of indi-
viduals inhabit (and are inhabited by?) speech says something about their "psy-
chological reality" (1993a, xxvii). This is not, I want to suggest, a retrieval of
the humanist subject, self-knowing, autonomous, whole. Nor is it the imposi-
tion of an ideal of community which admits nothing of difference.[23] Rather,
it seems to me a recognition that the subject-in-process always exceeds its own
intentions and never more so than when it speaks, when it struggles to step
across the gap separating self and other. This observation applies equally to
Smith's express statements concerning the intentions and commitments she
brings to her project. I do take seriously Smith's description of her perfor-
mance pieces, her performance method, and what motivates them; my own
ample citation of Smith would tell against me were I to assert otherwise. But
I am still more intrigued and provoked by the way her performances (neces-
sarily) do more than she says.

The mirror is the central image and strategy of *Fires in the Mirror*. Smith's
performances are animated by her concern "to mirror a community ... inter-
ested in looking at itself ... particularly communities where people were hav-
ing difficulty saying things to one another or where people felt silenced—the
people who felt that one group had more power than another group because
they were unable to speak, they were unable to be heard" (qtd. in Clines

1992, C1). Importantly, she portrays figures both famous and obscure (symbolized most poignantly in *Fires in the Mirror* by four anonymous characters). She wants to bring new voices into (the) conversation and so to upset the balance of margin and center. Smith turns herself into an *acoustic* mirror whose multiple "frame[s] of reference" provoke, invite, and goad her audience to different ways of hearing, sighting, and citing the other.[24] As we shall see, this is no ordinary mirror. Even when she does perform well-known figures, her wry juxtapositions of one character with another as well as the interposition of her body-voice may defamiliarize the known. Center and periphery. Self and other. Us and them. Smith's acts of de-centering are at the same time imaginative re-centerings—of community, identity, history, and the narratives that produce, sustain, and transform them.

Black and white are, historically and symbolically, the "master narrative" of American race relations. In *Fires in the Mirror* (and perhaps even more so in *Twilight: Los Angeles, 1992*) Smith's performances take aim at, in her words, the "authority of the black-white story" (qtd. in C. Smith 1994, 39). In the main, the events at Crown Heights were narrativized in popular accounts in black and white as a case of Blacks "versus" Jews.[25] Like other totalizing narratives, this one squeezes out other possibilities, other differences. It highlights differences *between* groups or individuals and de-emphasizes (if it recognizes at all) differences *within* groups or individuals. Contradictions are closed out. Such a narrowing of vision leaves out of view the multiform character of Crown Heights and its overlapping but distinct communities of Caribbean Americans and African Americans; such a narrowing of vision conflates Lubavitchers with all Jews, observant or secular. Its binary logic reduces complexity, diminishes historical understanding, and limits moral imagination. The oppositions black-white, Blacks–Jews, us–them, I–you take for granted what most requires explanation: what and how "we" (or "I") have in common.

For some, the bar fixed between Blacks and Jews—Blacks "versus" Jews—also becomes a site of loss: how and when did Black-Jewish solidarity come to *this*? This fantasy of Black-Jewish solidarity come to crisis in the streets of Crown Heights runs roughshod over some uncomfortable particulars. Lubavitcher Jews and Caribbean Americans cannot just be plugged into "the" history of Black-Jewish solidarity (if that is what it was) and so stand for *all* Jewish Americans and *all* black Americans.[26] More to my point, this nostalgic attachment to the way "we" never were begs the question; solidarity or coalition must be worked at, constructed, negotiated, not assumed in advance nor given in history once and for all. Differences internal to a group need not preclude the formation of "us-ness," of course, any more than differences internal to (and constitutive of) individuals block the achievement of "I-ness." But difference does intrude, rendering the hold of group- and self-identity always and only precariously approximate, transformable, in process, in history. Must

the dream of identity, whether of individuals or of groups, hinge on a demand for sameness, for identification without remainder? What happens to those placed outside the "magic circle" of "I" or "we"?[27]

Perhaps *Fires in the Mirror* indicates another direction. The play does not "just" show differences between groups and persons, it also stages the heterogeneity within groups and individuals. In this, the play potentially opens up and complicates the binarisms black–white, us–them, Blacks–Jews by unsettling the wishful sameness of each "side." It does this, in part, by putting the audience in Smith's place. The characters Smith portrays frequently address an unspecified "you." This second-person singular "originally" referred to Smith the interviewer, but now embraces a third term, the audience. There is thus a dizzying series of substitutions and displacements. Smith speaks from the place of the other, repeating words first spoken to her; the audience shifts into the open space of "you," ambiguously singular *and* plural. The reversibility of the positions "I" and "you" shifts the field of vision—as when the character "Minister Conrad Mohammed" makes "gradations" in blackness a visible sign of the *de*gradations experienced by black Africans during the middle passage: "Our women raped before our eyes, so that today some look like you, some look like me… " (1993a, 54). Now that a light-skinned black woman is appearing as a darker-skinned black man, the relations of "you" and "me" are disturbed, their referents confused. Hailed by Smith-as-Mohammed—"some look like you"—*my* whiteness, which can pass in the U.S. context as no race at all, is marked and remarked upon. Other members of the audience will be hailed and placed differently, the subject-positions they move and are moved into, as multiple, precarious, and richly varied as the history of identifications they bring to the performance and move out from. How much more unsettling it must be to be the "real-life" referent of the character Smith is performing on stage.

Smith becomes a floating signifier of difference. She is a black woman portraying men and women of different complexions and hues. She puts her own speaking style on hold in order to slide in and out of the verbal styles and speech patterns of different groups and to mark as well distinct individual styles. Her difference from the women and men she is portraying is at once there and not there—a tension that models a different way of conceiving the hard work of community and of identity. Something of this double vision may be seen in the back-to-back re-presentations of a well-known public figure, the Reverend Al Sharpton, and an unknown Lubavitcher woman, Rivkah Siegal. This exchange offers one particularly vivid example of the unexpected images and connections reflected in Smith-as-mirror.

Sharpton and Siegal are the second and third characters represented in the three-piece sequence on "Hair"; I will come back to the lead figure later. In a monologue subtitled "Me and James' Thing," Smith-as-Sharpton explains

that his signature hairstyle is not his own, but James Brown's: "James Brown took me to the beauty parlor one day and made my hair like his. And made me promise to wear it like that 'til I die.… [H]e wanted a kid to look like him and be like his son" (1993a, 19, 21). Neither man, this character emphasizes, is slavishly imitating white hair styles:

> It's, it's, *us*. I mean in the fifties it was a slick. It was acting like White folks. But today people don't wear their hair like that. James and I the only ones out there doing that. So it's certainlih not a reaction to Whites. It's me and James' thing. (1993a, 22; emphasis in original)

From this single, idiosyncratic detail of Sharpton's personal style—his hair—emerges a rich story of identification, attachment, their psychical and political stakes.

Of course, this scene does not give us Sharpton, but "Sharpton"—and not simply for the reason that it is not the "real" Al Sharpton up there on stage (though this would be reason enough), but also because the identificatory practices that build and rebuild the character of the ego are thinkable as a kind of citationality. Here racial identification crosses and is crossed by the axis of gender and its paternal function; Sharpton's hair daily cites the attachment formed between these two men, surrogate father to surrogate son. Perhaps the fact that Sharpton—better: "Sharpton"—is being mediated through Anna Deavere Smith's body and voice remarks this crossing. That it is a black *woman* standing for the Reverend Al Sharpton calls attention to the gendered, and not just racialized, politics of representation: who gets to stand in for whom; whose body and whose voice are put up as mirrors for a whole community or "people." Touching on in-group solidarity, the politics of representation, and the misinterpretations or misreadings to which performative utterances (Sharpton's fashion statement included) are susceptible—"Me and James' Thing" thus provides a metacommentary on the intersubjective and interlocutionary conditions of any "I" *or* any "we."

The next scene, "Wigs," also tropes on hairstyle as a way to get at the social and psychical scene of identity-formation. Additionally, it is one instance among many in *Fires in the Mirror* where the masculinist frame of Black-Jewish solidarity (real or imagined) and its late, lamented "we" is challenged by Smith's attention to the words and claims of women.[28] "Rivkah Siegal" (Smith portraying Rivkah Siegal) articulates what it means for her to follow Lubavitcher custom and cover her hair:

> But now that I'm wearing the wig, you see, with my hair I can keep it very simple and I can change it all the time.… But I, uh, I feel somehow like it's fake, I feel like it's not me. I try to be as much me as I can, and it just bothers me that I'm kind of fooling the world. (1993a, 25)

Her ability to change her hairstyle all the time—an ability she experiences, paradoxically, as a loss of individuality—resignifies the staying power of Sharpton's "thing." Caught between the comforting "us-ness" her wigs bring her and the loss of some measure of individual style, she worries that she is fooling the world by faking herself. This is the dramatic tension between "we" and "I" and within "we" and "I." Siegal, Sharpton, *and* Smith are all negotiating this tension. Smith negotiates this tension by performing it; her characterizations renegotiate and cite the difference between Sharpton and "Sharpton," Siegal and "Siegal," the "real-life" Sharpton and the "real-life" Siegal. In all this, *Fires in the Mirror* accomplishes onstage what never happened off: namely, individuals and communities who have probably never spoken to each other (or who have not heard each other if they have spoken) have the chance to speak through the gap—and Smith is its placeholder—which separates one from the other.

Smith places herself at and, I want to suggest, performs herself as the tensed "join" of me and not-me, us and them, then and now. In this, *Fires in the Mirror* and *On the Road* as a whole exemplify that "borderline work of culture" which, in Bhabha's words,

> demands an encounter with "newness" that is not part of the continuum of past and present. It creates a sense of the new as an insurgent act of cultural translation. Such art does not merely recall the past as social cause or aesthetic precedent; it renews the past, refiguring it as a contingent "in-between" space, that innovates and interrupts the performance of the present. The "past-present" becomes part of the necessity, not the nostalgia, of living. (1994, 7)

The performativity of history, as the performativity of identity, consists in the productive capacity of iterability. To reiterate is not, in any straightforward way, to mirror; it is to reflect back with a difference. Vision becomes a revisioning. The fires in the mirror Smith stages are not static reflections of self- and group-identity, but mobile and sometimes dangerous flashpoints for multiple and multiply fragmented identifications.

The play even offers its own sly commentary on the demand to mirror "truly." In the person of astrophysicist Aaron M. Bernstein, *Fires in the Mirror* ironizes spectators' demand for the same and winks at the audacity of Smith's attempts to "inhabit" the speech of another. "Bernstein" offers a lesson on the difference between commonsense understandings of what mirrors don't do— "So everyone understood that mirrors don't distort"—and physicists' recognition that the large reflecting mirrors they build to gaze at the stars may actually distort vision by surrounding the image in a "circle of confusion" (1993a, 14). For the punchline, Smith-as-Bernstein turns the commonsense view of mirrors and mirroring on their head: "If you're counting stars, for example, and two look like one, you've blown it" (15).

78

This way of looking at things could not be further from the dream of self-identity represented in the mirror stage, that fabled and phantasmatic moment when the infant catches sight of "himself" in the mirror, delights in "his" specular image, and makes one out of two. The coherence and autonomy the *imago* represents to and for the child are a fantasy (Lacan 1977, 1–7). But this misrecognition, in which the child mistakes the mirror image for itself, lays the basis for all future identifications. The subject will continue to seek reflections of itself in "objects" around it (read: in other subjects). But entry into the Symbolic, the order of language and the social in which every subject (to be a subject) must take up a position, also requires an ability to differentiate oneself from another. The subject inhabits—"is"—this push-pull between desire for wholeness and the demands of differentiation enjoined in the preexisting relations of language and the cultural field: "I"/"you"/"he-she-it" and "father"/"mother"/"son."²⁹

The two-ness of Smith's mirror images potentially models the splitting at the heart of subjectivity. Her mirror stagings also bring into view another symbolic splitting—along the axis of "race." In this, *Fires in the Mirror* offers a much-needed rejoinder to psychoanalytic theory's traditional focus on sexual difference, for Freud and Lacan both plot the drama of subjectivity along the axis of sexual difference alone. If Lacan "rescues" Freud from the biologism that sometimes creeps into the elder man's account of the difference sexual difference makes, Lacan's linguistic turn reasserts the primacy of sexual difference. (Perhaps the younger man thus inscribes his own primary identification—like father, like son—with Freud?)

To return, then, to the trilogy on "Hair" and the character who leads it off. The "Anonymous Girl" begins her segment by recounting her discovery, or realization, of her blackness:

> When I look in the mirror ... I don't know. How did I find out I was Black....When I grew up and I look in the mirror and saw I was Black. When I look at my parents, that's how I knew I was Black. (1993a, 16; ellipses in original)

The girl's parents were her conduit for self-recognition. Suggestively, the subtitle for this recognition scene is an imperative: "Look in the Mirror." This charge to look into the mirror—of "race"—challenges the central place of sexual difference in psychoanalytic accounts of an infant's early identification *of* her/his own bodily contours and *with* her/his parents.

In a 1992 interview, Smith provides a rich commentary on the testimony of her anonymous girl: "Somehow, we can't live outside the politics of race. There's something very deep in all of us, that is taught to us when we are very, very little. Which is the disrespect and fear of the other." Going on to describe the moment, or rather moment*s*, when all black children discover their black-

ness, she says, "usually they have this experience before they're two years old. And usually it's unpleasant." Smith also crucially "up-dates" the mirror stage by arguing that race is a lifelong process and training; the sense of oneself as racially "other" receives continual and often painful reinforcement from without:

> [The anonymous] girl … starts out by talking about how she found out she was black. She looked in a mirror, she said, or she looked at her parents. When she goes to Manhattan she knows she's black. Because she goes into stores and, compared to Crown Heights, it's all white people and it really frightens her. She doesn't like going there. (qtd. in Rothstein 1992, 7)

The girl's blackness is given back to her, but at what cost?

Racialization produces the black subject-in-process as a site of ambiguous meaning. The construction of what Patricia J. Williams calls "raciality" is at once self-affirming and self-negating:

> I think: my raciality is socially constructed, and I experience it as such. I feel my blackself as an eddy of conflicted meanings—and meaningless-ness—in which my self can get lost, in which agency and consent are tumbled in constant motion. This sense of motion, the constant windy sound of manipulation whistling in my ears, is a reminder of society's constant construction of my blackness. (1991, 168)

Williams racializes the Cartesian cogito—*I think*, she begins—and situates the drama of the self "outside-in," in the drama of intersubjective meaning-making. The "positive" self-image of blackness secured in early identifications with parental imagos contrasts sharply with the distortion-effects of racism and the white gaze.[30]

For Williams, for Smith, for the nameless girl, the self is *doubly* divided against itself. The fantasy of wholeness promised but ever deferred in the mirror image is twice removed from the black subject (female or male), whose body-self comes together and falls apart in the meeting of whiteness and blackness.[31] So Smith juxtaposes the anonymous girl's parental mirror with the very different sense of self which emerges from the girl's encounter with white shopkeepers and customers in Manhattan. So Williams describes the contradictory associations of her own blackness:

> I remember with great clarity the moment that I discovered I was "colored." I was three and already knew that I was a "Negro"; my parents had told me to be proud of that. But "colored" was something else; it was the totemic evil I had heard my little white friends talking about for several weeks before I finally realized that I was one of *them*. I still remember the crash of that devastating moment of union, the union of my joyful body and the terrible power of that devouring symbol of negritude. I have spent the rest of my life recovering from the degradation of being divided

against myself; I am still trying to overcome the polarity of my own vul-
nerability. (1991, 119–20; emphasis in original)

If it is the condition of "the" subject to be split, not every subject is equally
split. Some are split into pieces.[32] The watchful eye/I of the other reflects a
new and terrible sense of what blackness means. From this perspective, Smith's
stage direction, "Look in the mirror," is an ambiguous charge.

However tempting it might be to counter "negative" images of blackness
with "positive" images, this political and psychological response to the depri-
vations of being identified from without cannot go all the distance. We can no
more predict what actions or identifications "positive" representations will
give rise to than we can be certain to capture the all of us in "our" would-be
positive images. Can any campaign for "positive" images reckon with the
unconscious and its unpredictable uptake of "the" image? Will "our" images
be any less normalizing than "theirs"? Yet, there is no denying that, as Smith
starkly observes, "The mirrors of society do not reflect society" (1993a, xxvii),
and *Fires in the Mirror* does aim·at building better reflectors "to mirror a com-
munity … interested in looking at itself.… " However, and this is the point I
wish to reemphasize, the play and Smith's "multiple voicings" (Norma
Alarcón's term [1990, 365]) open into another optical field, where two does
not reduce to one. In this regard, *Fires in the Mirror* participates in what
Evelynn Hammonds calls a "politics of articulation," a project that does not
take representation for granted, but actively interrogates the political, histori-
cal, and psychical conditions for speaking and seeing, being heard and being
seen (1994, 141).

In order to give form to her interview subjects, Smith must always inter-
pose something of her own character and her own difference. To go back for
a moment to the speech of "Minister Conrad Mohammed." The bodily
dimensions of Smith's speech acts loosen the grip of the possessive pronouns
"our" and "their" and admits not just the "raced" inclusions but also the
"sexed" *exclusions* of the "we": "Not only were *we* killed and murdered, not
only were *our* women raped in front of *their* own children" (1993a, 56; empha-
sis added). When Smith returns her interviewees' words to flesh, it is a flesh
and a voice not their "own." Her body-voice comes between, to "unhome"
speech and undo the illusory hold of the signified.[33]

Although I have been stressing Smith's role as a transfer point of sorts,
through which identifications between audience members and her characters
are conducted, Smith is "herself" an object of (dis)identification. The interpo-
sition of Smith's body-voice, its uncanny likeness and its uncanny *un*likeness,
disturbs the smooth surface of that mirror in which two are seen as one.[34]
Some black and Jewish audience members have even accused *Fires in the Mirror*
and Smith of taking the "other" side, crossing from characterization into car-
icature, and providing unequal points of entry.[35] During one post-perfor-

81

mance discussion of *Fires in the Mirror*, for example, a young black man complained to Smith that the play offered him no strong black men he could identify with. Smith has speculated that the "source" of the young man's dissatisfaction lay elsewhere, with the difference her body represents: "Well, is his problem ultimately that it is a strong black man in a black woman's *body*?" A Jewish man participating in the same post-performance discussion countered with the suggestion that Smith's "play would be better if [she] had, you know, men doing the men" (Smith 1994b, 68; emphasis in original). Of course, the whole point of Smith's project is that she is doing all the roles, she is making the attempt to "be" somebody else, she is not afraid to show her unlikeness.

Fires in the Mirror can no more assure a perfect fit between Smith's characters and her spectators, in all their diversity, than Smith can achieve a perfect match between herself and the women and men she is performing, than any "I" can close the gap between me and not-me. Can the same only speak for and to the same? What does the same look or sound like? Smith has to make the same effort to "be" the anonymous girl or Rivkah Siegal as she does to "be" the Minister Conrad Mohammed or Aaron Bernstein (1994b, 68). No one is any easier to represent than any other, including Smith "herself."[36]

Perhaps the resistances—a term I intend in both its psychoanalytic and political registers—to Smith's performances derive, in part, from a frustrated desire for the same. The nearness of Smith's near-image is not near enough.[37] Nor ever finally far enough. Discomfort also arises from how close Smith does come to closing the space between. This unease, on either side of Smith's near equation, may even lie behind some of the accusations made against *Fires in the Mirror* and Smith. This is in no way to imply that the provocations of Smith's uncanny crossings from self to other and back again will touch every member of the audience in the same way. It does matter—to the one who speaks and the ones who listen—whose body is the sight, and not just the reciter, of speech. To schematize: what one person or group of persons witnesses as the uncanny image of the other in the self, another might experience as the self in the other. These are related, but not identical vantage points.

The non-identity of the subject-positions from which the audience listens is as crucial to the work of *Fires in the Mirror* as the non-identity of the subject-positions from which Smith speaks. Smith's thought experiment, in which she imagines performing *Fires in the Mirror* on alternate nights with another actor, rearticulates the citational crossings of the other in the self and the self in the other:

> ... I think that it would be exactly shocking, and exactly dangerous, and
> exactly right to have a Sandra Bernhard, or a kind of Sandra Bernhard,
> do my show one night. It would be difficult for black people to watch
> her do black people, and maybe even more difficult for white people to
> watch her do black people.[38]

Fires in the Mirror's characters and their words would mean differently and be placed differently if performed by a Sandra Bernhard. Respoken through another other's body-voice, the "same" starts out from and lands somewhere else again. I do not know whether or not white—Jewish? Gentile? both?—spectators would have *more* difficulty watching Bernhard (or "a kind" of Bernhard) perform black people than would black spectators; Bernhard's very different performance piece, *Without You I'm Nothing*, and its uneven reception throw this question open. It is enough to acknowledge, with Smith, that they would have *different* difficulties and see where this awareness takes us.

Smith's hypothetical playbill calls renewed attention to the (dis)identifications, real and imagined, that underwrite and condition reception. On the "other" side of performance, that of the audience, what is performed constructs and is constructed neither once for all nor all for one. The relations that hold together or pull apart *Fires in the Mirror*'s audience demand as much notice as the identificatory claims joining or failing to join the audience to particular characters.[39] The audience is as fractious and multiple a lot as the characters Smith (or Bernhard on alternate nights) is speaking from. This contestatory scene of interpretation is not to be bemoaned, but multiplied and learned from. Smith "want[s] people to experience the length of the differences of our perspectives... " (1994a, 119). Her express "desire is that the audience should be so diverse that in fact people will laugh at things the person next to them thinks are horrible" (1994a, 120). The discomforting distance *Fires in the Mirror* opens up on the other side of Smith's speech acts, between "our" take and "theirs," is a crash course in seeing the "same" with a difference. Although "seeing simultaneously yet differently is more easily done" in company, as Patricia J. Williams urges, "one person can get the hang of it with time and effort" (1991, 150).

What does it mean and what does it risk to see one as two? To sight the other in the same, or the same in the other, without flinching, without closing down the space between—this is the challenge of *Fires in the Mirror*. Smith's performances express a yearning for something that might be held in common even as Smith "herself" is grasped by the particular. The nerve of this double vision—to look in the mirror and behold at once difference and common humanity—is worlds away from the fetishist's solution, who cannot or will not believe his eyes: "I see but all the same... " It is closer to Pat Parker's marvelous turn: "The first thing you do is forget that i'm Black. / Second, you must never forget that i'm Black."[40] And it is the dream and the dare of another optic. This dream, ephemeral as the length of Smith's performances or/and as haunting as their after-image, gestures defiantly and hopefully towards what will have been but which is not yet.[41]

83

NOTES

1 As Freud's editors note (151n1), Freud had earlier broached the topic of hysterical identification in an 8 February 1897 letter to Wilhelm Fliess. (This letter is reprinted in Freud 1985, 229–31.) But *The Interpretation of Dreams* marks Freud's first published treatment of the issue.

2 Freud's psychoanalytic investigations and theories depend on a movement (is it "progressive" or "regressive"?) from the "pathological" to the "normal." In his 1933 [1932] lecture on "Femininity," Freud describes this analytic method thus: "[W]e study the residues and consequences of this emotional world [of childhood] in retrospect, in people in whom these processes of development had attained a specially clear and even excessive degree of expansion. Pathology has always done us the service of making discernible by isolation and exaggeration conditions which would remain concealed in normal people" (1933, 121). See Teresa de Lauretis's provocative reading (1992) of the way this dependency, of the "normal" on the "abnormal," organizes Freud's *Three Essays on the Theory of Sexuality*. For identification as the "mechanism of hysterical symptoms," see 1900, 149–50. For a clinical picture of a "regression" from object-cathexis to narcissistic identification in the "aetiology" of melancholia, homosexuality, and paranoia, see 1914b, 88–90; 1915, 269–70; 1916–17, 426–27; 1917A, 250–51; 1922, 230–32.

3 Freud's playful dialogue also catches the attention of Elin Diamond, who picks up and extends Freud's theatrical metaphor to describe the ego as "a theatrical fiction, permeable, transformable, a precipitate of the subject's psychic history with others" (1992, 396). My attempt to think Freud's theory/ies of identification in relation to theatrical scenes of identification leans heavily on (imitates with a difference?) Diamond's feminist investigations into some keywords common to feminism, psychoanalysis, and theater: imitation, mimicry, and identification. See especially "The Violence of 'We': Politicizing Identification" (1992) and "Mimesis, Mimicry, and the 'True-Real'" (1989).

4 In his final substantive remarks on identification, Freud says that "identifications of this kind as precipitates of object-cathexes that have been given up will be repeated often enough later in the child's life" (1937, 64).

5 In a "digression from [his] main aim," Freud shifts his attention briefly to the matter of pathological identifications, asking into but not resolving the difference between object-identifications that benefit the ego and object-identifications that "obtain the upper hand over the ego and become too numerous, unduly powerful and incompatible with one another, [in consequence of which] a pathological outcome will not be far off" (1923, 30).

6 Freud's most detailed treatments of the disorderly relations of identification and desire occur in *Group Psychology and The Analysis of the Ego*

(1921) and *The Ego and the Id* (1923). In both these essays he characterizes identification as "the original form of emotional tie with an object," effectively placing identification "before" object-choice, wanting to be out in front of wanting to have (1921, 107; cf. 1923, 31 and 1933, 63). To be sure, this is not a point Freud consistently held. In "Mourning and Melancholia," by contrast, he sets desire prior to identification, or at least elides the difference, when he holds that "identification is a preliminary stage of object-choice, ... the first way—and one that is expressed in an ambivalent fashion—in which the ego picks out an object" (1917, 249). See my discussion in main text. For a terrific analysis of the twists and turns taken by Freud in his various attempts to assign narrative priority to identification *or* desire, see Diana Fuss's "Freud's Fallen Women: Identification, Desire, and 'A Case of Homosexuality in a Woman'" (1993). See also Marcia Ian (1993, 3–5).

7 In an important essay that bears on the question of identification, Daniel Boyarin historicizes Freud's "discovery" of Oedipus. Boyarin makes a persuasive case for reconceptualizing Freud's fin de siècle shift away from a concern with hysteria and infantile trauma and to the theory of Oedipus in relation to contemporary anti-Semitic representations of male Jews as hysterical, effeminate, "queer" (1995). Although Boyarin does not specifically engage the topic of identification, his discussion of the rising fortunes of the "positive" Oedipus complex in Freud's sexual theory points the way towards registering the "raced" dimensions of Freud's theory of "primary" identification with the father as well as towards recognizing the "raced" dimensions of identification in general.

8 Edelman 1991, 101. See Fuss's wry redirection of Edelman's reading (1993, 64n2).

9 If much of the energy of Freud's later investigations into the relations between identification and desire will be given over to their enforced and always only precarious separation, Freud's first consideration of this vexed topic already admits the possibility that identification takes place on the verge of desire and vice versa (1900, 150). The relevant passage from *The Interpretation of Dreams* reads: "A hysterical woman identifies in her symptoms most readily—though not exclusively—with people with whom she has had sexual relations or with people who have had sexual relations with the same people as herself" (1900, 150). Although Freud's focus is *hysterical* identification, his brief and very preliminary analysis of it outlines (and informs) many of the claims he will later make for identification in general. See note above and discussion in main text. For Freud's later discussions of simultaneous object-cathexis and identification, see 1923, 29 and 1933, 63.

10 See Fuss (1994) and Bhabha (1994, esp. 44–45). The term "in-between spaces" is borrowed from Bhabha (1994, 1).

11 For another passage where this suggestive (mis)translation appears, see 1933, 63. I am grateful to Jay Geller for tracking down and explicating the German term used by Freud.

12 Private communication with Jay Geller.

13 For Smith's description of herself as a "repeater," see 1993a, xxv. For her wish that this travel might be experienced and seen as something other than "spying or colonialism or anything like that," see 1994a, 113.

14 In a 1993 interview with the *New York Times*'s Bernard Weinraub, Smith says: "The bottom line of my project is not to take sides. The bottom line is to speak to people and try to evoke from them performance and poetry" (C21).

15 For an analysis of theater's talking cures which has energized my own second thoughts concerning *Fires in the Mirror*, see Peggy Phelan, "Performing Talking Cures: Theater, Lies, and Audiotape" (1995). For Chris Smith's allusion to the "talking cure" in connection with *Fires in the Mirror*, see 1994, 39.

16 For two different considerations of what is at stake in Austin's curious evocation and disavowal of the theatrical in his account of performative speech acts, see Phelan (1995) and Sedgwick and Parker's introduction to *Performance and Performativity* (1995).

17 My argument in this paragraph draws on Elin Diamond's critique of the coercions of dramatic realism and her call for narrative forms that recognize (so as to politicize) the intrusive, disruptive presence of historical identifications (1990, esp. 94).

18 The topographics are Freud's; I borrow the phrases "intermediate region" and "definite field" from his elaboration of what repetition might accomplish when conducted in and through the safe space of analytic treatment (1914a, 154).

19 Freud: "But at this point we are reminded that the work of analysis consists of two quite different portions, that it is carried on in two separate localities, that it involves two people, to each of whom a distinct task is assigned" (1937, 258).

20 See Smith's discussion of the very different comments sung out during her performances of *Fires in the Mirror*—and after (1993a, xxxviii).

21 See Sedgwick and Parker's discussion of the way performative utterances take for granted a consensus of meaning between speaker and hearer. But this consensus may come to crisis in the "interlocutory (I-you-they) space of [the] encounter" (1995).

22 I am struck by the overlap between Smith's stress on listening as a form of political intervention and David M. Halperin's description of Michel Foucault's political work: "Rather than intervene directly in a situation affecting others, and propose reforms in institutions, or improvements in

material conditions, on their behalf, Foucault typically used his intellectual skills and his prestigious social location to create specific opportunities for the voices of the disempowered to be heard, recorded, published, and circulated" (Halperin 1995, 52).

23 See Iris Marion Young's very helpful discussion of the coercions of community and the denial on which it depends: the denial of difference between and within subjects (1990).

24 The term "acoustic mirror" is borrowed from Kaja Silverman's influential study of the female voice in psychoanalysis and cinema (1988). The phrase "frame[s] of reference" is Smith's (qtd. in Clines 1992).

25 The title of Melissa Beck's *Newsweek* article exemplifies the binary logic I am critiquing here: "Bonfire in Crown Heights: Blacks and Jews Clash Violently in Brooklyn" (9 September 1991). This way of framing the conflicts was the rule, not the exception. Compare, for example, Allis (1991) and Evanier (1991).

26 For an important discussion of the way ahistorical elisions like these obstructed understanding the Crown Heights riots, see Patricia J. Williams (1995, 31–34). I am grateful to her for sharpening my thinking about these issues.

27 The phrase "magic circle" is borrowed from Fuss's discussion of essentialism in the classroom (1989, 115). Fuss credits Edward Said for her circle metaphor.

28 See Cornel West's foreword to the printed text of *Fires in the Mirror* (1993a, esp. xviii–xix).

87

29 This summary of Lacan is a necessary oversimplification. In preparing it, I have drawn on essays gathered together in Lacan (1977, esp. "The mirror stage as formative of the I in psychoanalysis," "The function and field of speech and language in psychoanalysis," and "The signification of the Phallus") as well as the very helpful overviews offered in Fuss (1989), Gallop (1982 and 1985), Mitchell and Rose (1982), and Selden (1985).

30 In his final discussion of identification, Freud observes that the early influences of parents (plural) on a child's character undergo modification, reappraisal, and even displacement as the child becomes subject to (and subjectivated by) other identifications (1937, 64).

31 For a detailed treatment of this double splitting, see Spillers (1987). See also Fuss (1989, 94).

32 These self-portraits of the splittings which "are" race converge in places with Fanon's account of racial disidentification, the subject of my next chapter. They also join Hortense Spillers's important observations concerning the impossibility of the "black woman," whose over-presence as racial difference un-genders "her" as it re-genders "him," that is, the "black man" (1987).

33 See Diamond's analysis of a mimesis "excessive to itself, spilling into a mimicry that undermines the referent's authority; [this] suggests that the interposition of the performer's body signals an interruption of signification itself" (1989, 62).

34 "Character," Smith writes, "lives in the obvious gap between the real person and my attempt to seem like them. I try to close the gap between us, but I applaud the gap between us. I am willing to display my own *unlikeness*" (1993a, xxxvii–viii; emphasis in original).

35 For accusations of stereotyping, see Smith (1993a, xxxvii). For suggestions that *Fires in the Mirror* took sides, see Smith (1994b, 65). See also Smith's discussion of stereotypes in *Twilight: Los Angeles, 1992* (1994a, 111–12, 118–19).

36 I find myself provoked by a series of photographs, and their captions, which underwrite a 1994 article on Smith and *Fires in the Mirror*. Four black and white stills from *Fires in the Mirror* are tagged, from left to right and top to bottom, "Smith as Minister Conrad Mohammed," "As Monique 'Big Mo' Matthews," "As Rabbi Shea Hecht," "[A]s Henry Rice (below)." A fifth photo, a head shot of Smith, is captioned, plainly, "Anna Deavere Smith, *herself* (above)" (C. Smith 1994, 34–35; emphasis added). Where or who is Smith? Evidently, one can never be too sure.

37 For a related discussion of near-images, see Richards (1993); I have borrowed the term "near-image" from that essay.

38 Smith offers this tantalizing scenario during a 1992 interview with Thulani Davis (Smith 1992c, 42). I am grateful to Jean Walton for drawing my attention to this interview and this delightful exchange above all.

39 This is a point made by Sedgwick and Parker in their call for an interrogation of the "quality and structuration of the bonds that unite auditors or link them to speakers" (1995).

40 Pat Parker, "For the white person who wants to be my friend," reprinted in Anzaldúa (1990, 297).

41 I am borrowing the term "after-image" from Peggy Phelan's important study *Unmarked: The Politics of Performance* (1993, 14). See Alice Jardine's commentary on the future perfect, that modality which "implies neither that we are helpless before some inevitable destiny nor that we can somehow, given enough time and thought, engineer an ultimately perfect future" (1981, 5).

THROUGH THE LOOKING GLASS
Fanon's Double Vision

But just as I reached the other side, I stumbled, and the
movements, the attitudes, the glances of the other fixed me
there, in the sense in which a chemical solution is fixed by
a dye. I was indignant; I demanded an explanation.
Nothing happened. I burst apart. Now the fragments have
been put together again by another self.

—Frantz Fanon,
Black Skin, White Masks

This book, it is hoped, will be a mirror....

—Frantz Fanon,
Black Skin, White Masks

IT IS Smith's express desire in *Fires in the Mirror* to display the "relationships
of the *unlikely*, these connections of things that don't fit together" without
losing "hold on ... contradictions or opposition" (Smith 1993a, xxix; empha-
sis in original). With her example before me, it is my ambition in this chap-
ter and the one that follows to see what unlikely connections—between the
political and the psychical, racial difference and sexual difference—might be
sparked by working Frantz Fanon with and against Freud and, in the next
chapter, with and against Albert Memmi. The anachronism of these engage-
ments, with Smith's *Fires in the Mirror* set in front of texts chronologically
prior to her own, is an attempt to foreground who and what goes missing
from Fanon's (as well as Freud's and Memmi's) politics of identification. Where
the two figures brought together in this chapter are concerned, reading Freud
and Fanon with and against each other on the topic of group psychology may

also have the effect of lifting up convergences and divergences in their strategies for managing their own membership in racially "othered" groups. Briefly, Freud's general focus in his case studies and in his theoretical papers on the world of the family, in relative isolation from the larger social universe buffeting and shaping that family, may have been a way of tactically containing and then expelling racial difference from the drama of psychoanalysis. As I have argued in chapter one, the racial uncannily returns in the guise of Freud's female analysands. Fanon, by contrast, constantly foregrounds racial difference and the subjection of colonial man to another's terms.[1]

Look in the Mirror. This is the double dare of Anna Deavere Smith's *Fires in the Mirror.* It also expresses something of the hope and the terror of Fanon's analysis of the (dis)identificatory crossings of race and gender, colonizer and colonized in *Black Skin, White Masks.* Fanon's "socio diagnostic" (his term) of the high costs of identification across difference sharply contrast Smith's generally optimistic presentation of what "travel from the self to the other" might accomplish and effect.[2] Although Fanon expresses the hope that his book might be "a mirror with a progressive infrastructure, in which it will be possible to discern the Negro on the road to disalienation" (1967, 184), he also and perhaps more insistently stresses the unstable currents and terrifying edge of racialized (dis)identifications. The comma separating *Black Skin* from *White Masks* marks the socio-psychical looking glass through which racialized subjects see reflected in the white gaze their own alterity, radical otherness, inferiority. Writing against a backdrop of colonialism and domination, Fanon thematizes identification as a facet of the colonial encounter.[3]

First published in France in 1952 as *Peau Noire, Masques Blancs* and translated into English only after Fanon's death, *Black Skin, White Masks* represents one of the few thoroughgoing attempts to offer a psychoanalytic accounting of "race."[4] It also constitutes a signal effort to hold psychoanalysis ethically and politically accountable to the experiences and demands of racialized others. Fanon mobilizes psychoanalysis, makes it work on behalf of those whose subjection under structures of domination has been visibly marked out under the sign "race." In so doing Fanon not only broadens the individualistic focus of psychoanalysis, but also, as Homi Bhabha has observed, conceptually challenges and enlarges the sphere of the political (1987, 118).

Fanon's application of psychoanalytic concepts and insights to the task of racial liberation and decolonization remains the path less taken. With rare exceptions, psychoanalysis has not entered the vocabulary of revolutionary change as a term of praise. Nor has psychoanalysis generally been viewed as providing an orientation for revolutionary praxis—unless that orientation be one of reaction *against* psychoanalysis. Yet, for Fanon—at least, for the Fanon

of *Black Skin, White Masks*—psychoanalysis was not a luxury, but a vital tool through which the oppressed might come to understand not only themselves, but their position as "other."[5]

In *Black Skin, White Masks*, Fanon attempts a "sociodiagnostic" of race and racism (11). Refusing the either/or of the political "versus" the psychical, society "versus" individual, in brief, Marx "versus" Freud, he instead describes a "double process" of inferiorization: "primarily, economic; subsequently, the internalization—or, better, the epidermalization—of this inferiority" (11). In Fanon's view, the liberation of black men (and black women?) must be carried out on two fronts: within and without, the psychical and the socio-economic.[6] "As a psychoanalyst," Fanon writes, "I should help my patient to become *conscious* of his unconscious and to abandon his attempts at hallucinatory whitening, but also to act in the direction of change in the social structure" (100; emphasis in original). The task of the psychoanalyst too must be doubled, meeting "the need for combined action on the individual and on the group." Fanon does not calibrate a precise relation between the social and the psychical, group and individual. He does, however, warn against the hope that liberation from the psychopathology of racism might be achieved unilaterally, that is, on one level only. "[H]istorically they influence each other," he says. But Fanon also asserts that "the gravest mistake would be to believe in their automatic interdependence" (11).

Subject-formation occurs in history, where social and cultural conditions do matter. As Fanon says in another context, a timeless Freud is of no use: "What must be done is to restore this dream [read: phantasmatics of race] *to its proper time* ... and *to its proper place*" (104; emphasis in original). Fanon is trying to bring the unconscious into history even while recognizing that it is not co-extensive with history, hence his caution against believing in the *automatic*— that is, the predictable and systematic—interdependence of the social and the psychical. Although the social and the psychical are implicated in each other, the precise forms this relation or relations will take cannot be specified in advance nor "fixed" on either side. But Fanon is equivocal on this score. As Bhabha and Gates also observe, Fanon's attempts to identify a close correspondence between the social and the psychical sometimes reduce the latter to a determined and closed effect of the former.[7] The dream of full and mutual recognition with which Fanon ends *Black Skin, White Masks*—"At the conclusion of this study I want the world to recognize, with me, the open door of every consciousness" (232)—aches for a world where race no longer signifies. In the end, Fanon's *dis*alienating mirror will reflect racial difference so as to do away with it; in the free encounter of one self with another, the point of difference fades to naught. It is necessary to return Fanon's dream to his proper time and place and to recall, with Fanon, the social and historical coordinates informing his desire to leave race behind:

91

> The memory of Nazism, the common wretchedness of different men, the common enslavement of extensive social groups, the apparition of "European colonies," in other words the institution of a colonial system in the very heart of Europe, the growing awareness of workers in the colonizing and racist countries, the evolution of techniques, all this has deeply modified the problem [of racism] and the manner of approaching it.[8]

In the after-time of World War II, Fanon's wish to get "beyond" racial difference is not a denial of difference, but the horrified recognition of all that has been done in the name of "solving" difference.

Within the terms of Fanon's this-worldly psychological analysis, race and the identifications that would hold it in place border on pathology; race symbolizes humanity's disalienation from itself. In a world gone mad, whiteness and blackness are relational terms, blackness being the constitutive outside of whiteness. But these two terms are not on equal footing. Whiteness dissimulates its own race relations; white men and, in another way, white women can strike the pose of realness, of individuality. Whiteness produces itself as the unmarked, universal term by projecting the burden of difference onto other bodies. The racist creates his/her inferior, displacing the burden of being marked wholly onto the racialized other (93). Caught in the white gaze, a gaze which is most successful when it is internalized, the black is always *only* a race-woman or a race-man, always *only* a representative type of her or his group. The individual-as-such does not exist. Or, in the words of Albert Memmi, whose range of interests and subjects is very close to Fanon's: "... a collective drama will never be settled through individual solutions. The individual disappears in his lineage and the group drama goes on" (1965, 126).

Fanon is attempting to diagnose the conditions under which collective consciousness or group identity overwhelms the achievement of an I-ness, however tentative. As he says, the governing fiction of the Antillean's inferiority complex is not personal, but social (1967, 215)—a claim Fanon ultimately extrapolates to the situation of all oppressed peoples. To Freud's much-discussed couple, ontogeny and phylogeny, Fanon adds a third term, "sociogeny" (11). Fanon's "sociogeny" extends and complicates Freud's compact study of group psychology. Like Freud, Fanon is interested in tracing individual case histories. Unlike Freud, however, Fanon's individual psychology explicitly addresses the larger, extra-familial social context in which an individual's conscious and unconscious mental life takes shape. For Fanon, this "taking shape" quite literally means taking shape as black, embodying blackness and alterity for whiteness. Stationed between ontogeny and phylogeny, individual and "species," sociogeny works in two directions at once. Through it, Fanon attempts to elucidate how group membership ineluctably informs and inscribes the consciousness of the oppressed. This inscription surfaces on and as the racialized body; the oppressed loses all claim to individual "being" and becomes instead a representative type.

Part of the innovation and critical force of Fanon's application of group psychology is that he advances (or, rather, seeks to advance) a general theory of collective consciousness that remains attentive to historical and cultural particularities. In identifying commonalities in the experience of oppressed groups, Fanon does not mean to override differences between them. Nonetheless, from the opening moves of *Black Skin, White Masks*, when Fanon lays out the geographical compass of his study, there will be a provocative tension between, on the one hand, his express methodological commitment to remaining local, specific and, on the other, his politico-philosophical commitments to outlining the existential crisis of the black (man) wherever he may be. Could this tension be redescribed as the impasse of constructionism/essentialism, theory/politics? This double vision, I want to suggest, is the ambition and genius of Fanon's sociogeny.

This double vision can also be a stumbling point. For example, in order to lay bare the socio-psychical dynamics of oppression, Fanon identifies parallels between the historical uses and symbolic operations of anti-Semitism and Negrophobia.[9] This interpretive move carries considerable risks—among them, the closure of difference instead of the expansion of political possibilities. Fanon is cognizant of this danger: "Seeing only one type of Negro, assimilating anti-Semitism to Negrophobia, these seem to be the errors of analysis being committed here" (183). In the end, Fanon cannot sustain the double vision of difference and sameness. Despite his stated commitment to heterogeneity, *Black Skin, White Masks* sometimes replicates a hom(m)ologics of the same. This is especially apparent in the case of women, black women in particular, who represent Fanon's extended blind spot. Moreover, to the extent that Fanon's conceptualization of the symbolic work "Negro" and "Jew" perform in common ends up reiterating long-standing stereotypes of Jewish men as effeminate, homosexual, queer, Fanon's blind spot of gender may also be "seen" to include the position "Jew." I will take up Fanon's Jewish question more fully in chapter six. For now, I will only suggest that the ambivalence of Fanon's own identifications with Jewishness and Jewish men holds out, as it turns its back on, the spare promise of speaking across difference.

Fanon's attempts to uphold heterogeneity within are most successful when he takes aim at the ways blackness, positioned as difference from whiteness, comes to deny difference: "… Negro experience is not a whole, for there is not merely *one* Negro, there are *Negroes*" (136; emphasis in original).[10] Fanon also rejects "negritude," a politico-literary movement to identify and celebrate distinct "Negro values" (229). Fanon wants no part in what he elsewhere dismisses as the "black mirage" of negritude (1964, 27). He implies that the wishful project of locating a separate black culture and civilization is of a piece with the operations of white racism (1967, 134-35). Both engage processes of abstraction and homogenization in order to produce the phantasmatic whole the "Negro people."[11]

93

In Fanon's view, the logical inscription of negritude in the very structures of meaning it seeks to overcome means that negritude cannot succeed as a long-term political strategy. It might, however, serve short-term psychological ends. In *Black Skin, White Masks* (a text in which Fanon is considerably less sympathetic to the cause of negritude than he is in *Wretched of the Earth*) he does allow that the process of naming and valorizing the signs and symbols of blackness might enable the black subject's psychical reintegration.[12] He qualifies this admission, however, by insisting that it is only a first step in the "internal revolution" (Aimé Césaire's term) of the oppressed (qtd. in Fanon 1967, 197–98). To achieve full personhood, Fanon says, black subjects must transcend not only their self-hating identification with whiteness, but also their newly born "positive" identification with blackness; "the two terms are equally unacceptable" (197).

But if negritude—with its ecstatic abandonment of individual identity—is caught up in the logic of white, European thought, so too is the willful staking out of its contrary, isolated individualism. In *Wretched of the Earth*, Fanon implies that categories of Western culture—such as individuality, egoism, and selfhood—do not mean in the context of "underdeveloped communities" (1963, 55). It is the colonialist who has taught the colonized to chase after the white man's dream of "a society of individuals where each person shuts himself up in his own subjectivity… " (47).[13]

If I have paused to trace the directions and detours Fanon's thinking on such topics as negritude and collective consciousness takes after *Black Skin, White Masks*, I have done so in the hopes of better specifying the revolution in thought that Fanonian sociogeny may represent for psychoanalysis:

> Reacting against the constitutionalist tendency of the late nineteenth century, Freud insisted that the individual factor be taken into account through psychoanalysis. He substituted for a phylogenetic theory the ontogenetic perspective. It will be seen that the black man's alienation is not an individual question. Beside phylogeny and ontogeny stands sociogeny. (Fanon 1967, 11)

Like Freud in his day, Fanon in his works to overcome the "tendencies" holding back knowledge and truth. Freud's are among the tendencies Fanon must overcome. If Freud "substituted for a phylogenetic theory the ontogenetic perspective," now Fanon makes a substitution of his own. This is not a wholesale break with Freud. Fanon builds on his predecessor, seeking to strike a different balance between individual and group factors. Fanon's sociogenetic approach makes group identity the leading, rather than the trailing, edge of analysis and thereby subtly shifts the terms of Freud's distinction between individual and group psychology. Arguably, *Black Skin, White Masks* is readable as Fanon's dialogical engagement with Freud, among others. Although Freud's

name is not so often mentioned as Césaire's or Sartre's, the two men who represent the Francophone poles of *Black Skin, White Masks*, Freud's shadow is cast over much of the text.

Individual psychology is the methodological center of Freud's research. This is the case even in his 1921 essay *Group Psychology*, in which he painstakingly builds up a theory of group formation by extrapolating from discoveries in the field of individual psychology. Freud himself allowed that the separation between individual psychology and group psychology was in many ways an artificial one: "In the individual's mental life someone else is invariably involved, as a model, as an object, as a helper, as an opponent; and so from the very first individual psychology, in this extended but entirely justifiable sense of the words, is at the same time social psychology as well" (1921, 70). Freud's exposition, in *Group Psychology* and elsewhere, of the rivalries, jealousies, passionate desires, and no less passionate identifications at work in the constitution of subjectivity suggests that the roles outlined above—"as a model, as an object, as a helper, as an opponent"—are not stably assigned. One person might play all of these roles simultaneously or consecutively. Or two or more persons might compete for a role, as both the mother and father, in Freud's Oedipal scheme, are simultaneously objects of desire and points of identification for a young child.

Individual psychology takes as its central subject the individual as a member of a triangulated family unit: father, mother, and baby makes three.[14] Group psychology, by contrast, focuses on extra-familial, essentially public memberships: "of a race, of a nation, of a caste, of a profession, of an institution, or as a component part of a crowd of people who have been organized into a group at some particular time for some definite purpose" (Freud 1921, 70). Later Freud will refer also to the "numerous group minds" in which each individual has a share, in this instance naming "race … class … creed … nationality, etc." (129).

An individual's membership in a particular group may be voluntary, compulsory, or some combination thereof. Or, to use Freud's own language, groups may be "natural" or "artificial" (93). Freud does offer other ways of describing what he calls the "morphology" of groups—such as duration and organizational structure. However, these characteristics do not receive much further elaboration from Freud. (He will end up developing his group psychology by attending to another distinction: namely, that "between leaderless groups and those with leaders," focusing on two highly organized groups, the church and the army.) Nor does Freud ever explicitly say which groups are "natural"—as if this is so obvious as to demand no further comment. Presumably, race and nation qualify for Freud as "natural" groups, although his definition of artificial groups as those requiring "a certain external force … to prevent them from disintegrating and to check alterations in their structure" might seem to unset-

tle the claims of race and nation to the "natural." What Freud says of his two paradigmatic organized, artificial groups, the church and the army, might equally be said of racial(ized) groups:

> As a rule a person is not consulted, or is given no choice, as to whether he wants to enter such a group; any attempt at leaving it is usually met with persecution or severe punishment, or has quite definite conditions attached to it. (1921, 93)

Perhaps the process of being racialized is thinkable as a kind of conscription or enforced calling. An individual who attempts to leave the "unit" to which s/he has been assigned and to pass herself off as someone or something else opens herself to the full weight of the law. S/he faces a range of punitive sanctions, designed to police and sort out "legitimate" from "illegitimate" claims to membership in a group. But passing out and over may attract censure from both "sides." What one group calls usurpation, the other may decry as a betrayal of one's own and a denial and erasure of one's proper name.[15] These accusations do not come down with equal force.

Just what characteristics, qualities, or features successfully qualify an individual for "proper" membership and full citizenship is a complicated question. One way to answer this question is to return to the "narcissism of minor differences." In my previous discussion of this phenomenon and Freud's analysis of it, I suggested that difference (or rather *some* differences) are manufactured and amplified as a way to solidify in-group identity and to provide outlets for ventilating aggression. These outlets take the bodily form of identifiable or identified groups of other(ed) people: "them," "those" people, not-us. Freud names and discusses differences between nations, regions, and "races" precisely in order to show how little there really is between them; there are, at most, "minor" differences only. Of course, as I suggested in chapter one, Freud's analysis of this phenomenon leaves other differences—of gender and sexuality, for example—relatively uncontested. This is a criticism that could also be charged to Fanon's application of the narcissism of minor differences in *Black Skin, White Masks*, as I will argue in the next chapter.

Freud's explanation of how the narcissism of minor differences operates to mark "us" out from "them" constitutes a critical backdrop for Fanon's own study of the interdependence of blackness and whiteness. Fanon points, for example, to the anxiety Antilleans experience in the presence of black Africans; Antilleans want at all cost to avoid being mistaken for a "nigger" (1967, 25-26). In their identification with Europe, "many Antilles Negroes" put off any and all associations with Africa: "That would be all we need, to be taken for Niggers!" (26). The tone of Fanon's analysis in this passage is one of surprised regret: "And yet many Antilles Negroes see nothing to upset them in such European identifications; on the contrary, they find it altogether nor-

mal" (26).[16] In his 1955 essay "West Indians and Africans," Fanon describes the forced separation between these two positions in terms that even more starkly recall Freud's analysis of the narcissism of minor differences:

> But inasmuch as externally the West Indian was just a little bit African, since, say what you will, he was black, he was obliged—as a normal reaction in psychological economy—to harden his frontiers in order to be protected against any misapprehension.... This was because, between whites and Africans, there was no need of a reminder; the difference stared one in the face. But what a catastrophe if the West Indian should suddenly be taken for an African! (rpt. in 1964, 20)

The "catastrophe" of being mistaken for a black African suggests the arbitrariness of racial classifications even as it acknowledges the force with which these categories invest their subjects.

Fanon devotes considerable energy and attention in *Black Skin, White Masks* to laying out the capriciousness and binding force of racial classifications. One of the ways Fanon demonstrates this paradoxical construction of race is by attending to what I will term racial "gateways," entry points through which members of socially subordinated and racialized groups might pass over to the other side. The signal example here may be language. Again and again, Fanon returns to the role of language and linguistic mastery in codifying racial boundaries: "To speak a language is to take on a world, a culture. The Antilles Negro who wants to be white will be the whiter as he gains mastery of the cultural tool that language is" (1967, 38). The greater the Antillean's command of French, the greater the likelihood s/he will be cited approvingly, by whites and blacks, as a role model for the race entire. Through the virtuosity of his or her verbal performance, the black speaking-subject makes himself over into the image—"complete replica," Fanon says (36)—of the white.

To speak French like a "true" citizen of France, where "true" means "white," is to cross over. The question and the anxiety for Fanon, as for other virtuoso performers, is whether the "honorary citizenship" (which is revocable to the last) extends dual citizenship or bespeaks an absolute "rupture" with his or her homeland (36–38).[17] For, if talking the white man's talk signals an identification with the colonial subject and his cultural standards, it may also and in the same breath express a corollary contempt for "native" dialect:

> In every country in the world there are climbers, "the ones who forget who they are," and, in contrast to them, "the ones who remember where they came from." The Antilles Negro who goes home from France expresses himself in dialect if he wants to make it plain that nothing has changed. (37)

97

Sometimes, however, the Antillean has so forgotten himself that even his own mother can no longer recognize him (36). An Antillean went to France, but a European returns (37).

The ambivalent operations of language Fanon so powerfully diagnoses in *Black Skin, White Masks* marked him as well. *Black Skin, White Masks* exposes this constitutive ambivalence by performing it—and him. In its command of the French intellectual scene, of the French language, the book does as Fanon says. *Black Skin, White Masks* consolidates his identification with the literature and language of the post-war French left, as represented by Jean-Paul Sartre. Addressing himself to Sartre, Fanon does not withdraw his love or his identification from his "adopted" country, but writes through it, chastising France for making its love so conditional, criticizing even Sartre for underestimating the material effects of racism (133–40). In a sense, Fanon's mastery of French was one way for France to master Fanon. "At bottom you are a white man," Fanon is told on the occasion of his own savant performance in and of the French language (38).[18] But Fanon also resists this assimilation into and by the language of the other. His ample citation of Aimé Césaire (the poet-hero of Martinique and, like Fanon, a "spokesman" for "the" race) throughout *Black Skin, White Masks* potentially signs Fanon's will to re-member who *he* is and where he came from.[19] Césaire: caesura. This name proleptically marks the rupture "before and after… "[20]

Language and speech, to use Fanon's own terms, "incarnate" the one who speaks (36). Speech does not "naturally" express or record the "essence" of the speaking subject, but rather marks and constitutes the one who speaks within a network of raced, sexed, and "classed" meanings. It is because language plays such a crucial social and psychical role in demarcating racial boundaries that one and the same act of speaking may attract qualified praise from one quarter and accusations of ventriloquism or betrayal from another (Harper 1991; Appiah 1992, 47–72).

"Race" is thus thinkable as a kind of speech act. As such, "race" is not an effect of biological truths, but is one of the ways that hegemonic social fictions are produced and maintained as "natural" facts about the world and its inhabitants. That race is not "true" in any natural or objective sense does not diminish the impact or brute force of its assignations, however. To extend the sense of race and racialization as speech act somewhat further: the artifactuality of race, its organizing and constraining fictions, generates a pattern of "call and response." But this is no game, and "pattern" is perhaps too benign a term to designate the fact that individuals once called and named can then name themselves as an effect of (and response to) this hailing. Sometimes, the response might itself be made in the name of liberation, as a way, that is, to establish a "positive" or self-affirming identity over and against hegemonic, negative associations.[21] These new and newly reclaimed "identities" require

public affirmation and recognition from others. As Carol-Anne Tyler observes with respect to the spectacle of passing, "our narcissistic investment in [our desires and identities] binds us deeply to others who have the power to alienate us from ourselves" by denying our demand for recognition (1994, 215). The double bind of the colonized is that s/he must seek recognition of herself from those most resistant to recognizing her as a subject in the first place.

Moreover, attempts to reclaim identity, where reclamation is not so much a discovery of what (one) has always been as a re-membering what (one) never was, may participate in the very structures they seek to undermine. Because the colonized subject has, as it were, been recut from the colonizer's cloth, even his/her attempts to locate and revalorize "native" customs, traditions, and beliefs are caught up in the circular logic of racism. But there is no place to speak nor to resist except from this "definite position" within the symbolic regime of race.

The phrase "definite position" is Freud's. It designates his response to being named from without: "... in the higher classes [in school] I began to understand for the first time what it meant to belong to an alien race, and anti-Semitic feelings among the other boys warned me that I must take up a definite position" (1900, 196). This definite position is that of the inferiorized other, scrapping for respect and recognition. For Freud, as for Fanon, mastering the other's language represented one possible (albeit unstable) route to the other side. Freud's passage from East to West, from Eastern Jew to acculturated German, was conditioned by his entry into and identification with the German language: "[My] language ... is German. I considered myself German intellectually, until I noticed the growth of anti-Semitic prejudices in Germany and German Austria. Since that time, I prefer to call myself a Jew."[22] Freud responds to being named from without by naming himself. But at what cost? In a 1938 letter to Saussure, composed after the annexation of Austria and written during the early days of Freud's English exile, he describes his "painful comprehension" of the "loss of the language in which one lived and thought and which one will never be able to replace with another, for all of one's efforts at empathy" (qtd. in Gilman 1993a, 186). If anti-Semitism was a point of resistance through which Freud could know himself as a particular kind of self—"Since that time, I prefer to call myself a Jew"—it could also shatter the symbolic signposts by which he recognized and ordered himself.

The psychic and bodily costs of being named from without and subsequently incorporating the other's name for oneself are also revealed in Fanon's howl of protest at being named from without—"Look, a Negro"—and its aftermath: "Then, assailed at various points, [my] corporeal schema crumbled, its place taken by a racial epidermal schema" (1967, 112). Fanon is no longer an individual; he stands in for an entire people, for his "race":

99

> I was responsible at the same time for my body, for my race, for my ances-
> tors. I subjected myself to an objective examination, I discovered my
> blackness, my ethnic characteristics; and I was battered down by tom-
> toms, cannibalism, intellectual deficiency, fetishism [sic], racial defects,
> slave-ships, and above else, above all: "Sho' good eatin'." (112)

Inscribing the black body as irreducibly different, other, secures the "truth" of
race and allows whiteness to masquerade as the real. As Fanon powerfully
argues, "with the Negro, the cycle of the *biological* begins" (161; emphasis in
original).

This scene of social interpellation—"Look, a Negro"—in which the black
body is called to order and incorporated into a system of racialized meanings
is a key to understanding more fully what Fanon intends by "epidermaliza-
tion." In laying out the double-process of inferiorization, Fanon refers to "the
internalization—or, better, the epidermalization—of this inferiority" (11). At
first glance (and this scene/seen of naming is all about the glance), Fanon's
apparent equation of internalization and epidermalization is puzzling. How
can internalization be equal to epidermalization, when epidermalization nom-
inates the most visible or conventional external sign of "racial" difference?
Perhaps it is all a matter of perspective. From the position of the one being
named, the "black" subject, interpellation proceeds as if through a mirror. The
black subject sees in the other's eyes a reflection of him or herself. S/he inter-
nalizes, or incorporates, the other's representation of his body, of her soul, as
the whole "truth." In *The Souls of Black Folk,* Du Bois called this way of look-
ing at things "double consciousness":

> ... the Negro is a sort of seventh son, born with a veil, and gifted with
> second sight in this American world,—a world which yields him no self-
> consciousness, but only lets him see himself through the revelation of the
> other world. It is a peculiar sensation, this double consciousness, this sense
> of always looking at one's self through the eyes of others, of measuring
> one's soul by the tape of a world that looks on in amused contempt and
> pity. One ever feels his two-ness.... (1994 [1903], 2)

Freud too has a name for this division of the ego against itself. Du Bois's and
Fanon's haunting representations of double consciousness and epidermaliza-
tion strikingly recall Freud's account of the generation and performative force
of the super-ego.

Freud offers his most detailed presentation of the super-ego's range of
influence in his 1923 essay *The Ego and the Id.* The super-ego or ego ideal (and
Freud seems to use these two terms interchangeably) is the "heir of the
Oedipus complex" (36). It is what remains of a subject's earliest objects of
desire—his or her parents—whom the child has been compelled under threat
of force to abandon. But these forbidden objects can come to life again in the

form of intense, and intensely *reactive* identifications (34). The forbidden object-choices of the id are taken up into the ego, where they are transformed into the internal agent of the father's law: "You *ought to be* like this (like your father).... You *may not be* like this (like your father)—that is, you may not do all that he does" (34; emphasis in original). In the field of acts, this is the familiar refrain *do as I say, not as I do.*

Freud does grant that transformed object-ties with *both* parents come together "in some way" to precipitate the ego ideal out of the ego (1923, 34, 36; cf. 1933, 64). Yet, in pressing his argument, Freud returns again and again to the foundational role paternal authority plays in the constitution of the super-ego (1921, 122–28, 135–36; 1923, 34, 37). Freud thus appears to make the father into the "real world" model for the ego ideal. The analogical and wishful relation Freud implies seems to go like this: Just as the father presides over the family, as the embodiment of the public sphere of law and reason, so the super-ego rules the ego and patrols the borderlands between "what is real and what is psychical" (1923, 36). To the extent, however, that the super-ego enjoins that the subject be "like" the father, it might be more accurate to say that the father is "himself" only an idealized figure for the "real world" of law's empire.

This, at least, is the meaning I take from Freud's assertion that:

> ... the super-ego retains the character of the father, while the more pow-
> erful the Oedipus complex was and the more rapidly it succumbed to
> repression (under the influence of authority, religious teaching, schooling
> and reading), the stricter will be the dominance of the super-ego over the
> ego later on—in the form of conscience or perhaps of an unconscious
> sense of guilt. (1923, 34–35)

101

The super-ego, then, does not speak *for* one voice, even if it may seem to speak *as* one. Rather, as Freud suggests in *Group Psychology*, it assembles multiple social influences, re-presents multiple social identifications (1921, 129). To take up and modify Freud's analogy, then: Just as there is a discrepancy between the normalizing picture of father as benevolent and sole familial representative of law's empire and the way things "really" are, so too is there an unbridgeable gap between what the subject demands of herself and what she actually achieves.

The subject forever tries, and just as often fails, to meet the demands of his inner kingdom. Yet, even these self-regulating failures have their use-value. According to Freud, the operations of self-judgment are what enable higher forms of sociality and group feeling. The "tension between the demands of conscience and the ego's actual performances" is experienced by the subject as a sense of guilt (1923, 37). Guilt, in turn, acts as a moral restraint by cajoling the subject to bring his or her behavior into line: *You* ought to be *like* ... fill in the blank.

Social feelings and the group mind develop when a number of individuals effectively fill in their blank with one and the same idealized object and identify themselves with one other in their ego (1921, 116; 1923, 37). Freud traces this circle of identification back to a "common quality" of their emotional life (1921, 108). More specifically, all the members of the group are intensely invested in the same unobtainable object, and this longing has similar affective consequences for each individual. The impossible object of desire scorches and consumes the ego, supplanting the (parental) ego ideal and demanding unconditional love from the adherent.

What object or objects are capable of generating such intense, "empathic" [Freud's term is *Einfühlung*] ego-identifications between subjects who, as Freud says, would otherwise regard each other as "inherently foreign" (108)? In *Group Psychology*, Freud ascribes this centripetal pull to three classes of unobtainable objects: a leader or leaders; an abstract idea in which all the members have some share; and a wish held in common (100). Is it possible to think of "race" as one such abstract idea and/or wish? This possibility, I urge, is precisely what Fanon's sociogenetic theory of racial (self-)consciousness and inferiorization diagnoses.

"Race," Fanon argues, is "but a superstructure, a mantle, an obscure ideological emanation," which both masks and, as it were, mass-produces other realities.[23] In *Black Skin, White Masks*, Fanon reveals how the discourse of "race" crosses, consolidates, and covers up national, cultural, linguistic, moral, and economic relations.[24] Racial thinking does not neutrally find and record the "truth" of race, but produces it. Moreover, as Fanon says, it produces and materializes its truth on the body; in other words, the discourse of race claims and incorporates the body as its truth-effect.[25]

In chapter five of *Black Skin, White Masks*—aptly entitled "The Fact of Blackness"—Fanon sketches a phenomenology of embodied self-consciousness:

> A slow composition of my *self* as a body in the middle of a spatial and temporal world—such seems to be the schema. It does not impose itself on me; it is, rather, a definitive structuring of the self and of the world—definitive because it creates a real dialectic between my body and the world. (111)

However, this process does *not* obtain for racially marked subjects, because "[i]n the white world the man of color encounters difficulties in the development of his bodily schema" (110). An "historico-racial schema" imposes itself e body. Thinking through his own bodily experiences, Fanon says:

> he elements that I used had been provided for me not by "residual sensions and perceptions primarily of a tactile, vestibular, kinesthetic, and al character," but by the other, the white man, who had woven me of a thousand details, anecdotes, stories. I thought that what I had in

hand was to construct a physiological self, to balance space, to localize sensations, and here I was called on for more. (112)

This "more" is the demand of racial difference: *Look, a Negro!*

White and black subjects alike form their body-selves intersubjectively, in a dialectic of inside/outside. As Fanon allows, all subjects experience a self-critical distance—"impurity" he calls it (110)—between their idealized image of themselves and the public face they present to the world. This allowance seems remarkably close to Freud's analysis of the guilt-provoking tension between the ego ideal and the "ego's actual performances." What starkly distinguishes "white" and "black" experiences of bodily self-consciousness, however, is their differential situation within the historico-psychical network of "race." To recall and extend Freud again: the push-pull between "what is real and what is psychical" is all the more jarring for subjects who must embody and signify the borderlands of dominant frames of reference. The phantasmatic promise (and threat) of racial solidarity transforms a number of individuals into a united front by displacing difference—what is "inherently foreign"—somewhere else. The racialized other is no longer a distinct personality and individual, but represents a group entire—a "genus," according to Fanon (1967, 116). This "new kind of man" appears alien even to himself; "dissected under white eyes, the only real eyes," he reassembles the fragments of his body by matching it to the other's images: "But just as I reached the other side, I stumbled, and the movements, the attitudes, the glances of the other fixed me there.... I burst apart. Now the fragments have been put together again by another self" (109).

This depiction of self-alienation crosses and complicates Freud's claim that the "ego is first and foremost a bodily ego; it is not merely a surface entity, but is itself the projection of a surface" (Freud 1923, 26). In a footnote added to the 1927 English edition of *The Ego and the Id*, Freud clarifies his meaning: "I.e. the ego is ultimately derived from bodily sensations, chiefly from those springing from the surface of the body. It may thus be regarded as a mental projection of the surface of the body ... " (26n1).[26] Fanon's harrowing account of his body in pieces, rent by the glances of the other, suggests that the bodily ego is edged and edged in by multiple projections and that one surface may impinge upon another's. Identifications with the other may be turned in on the self. Captured in the other's eyes, the black man "who has ... breathed and eaten the myths and prejudices of [racism] ... will be able, if he stands outside himself, to express only his hatred of the Negro" (1967, 188). In contrast to the later Freud's depiction of identification as necessary, transformative, the ground of resistance, in Fanon's view identification is pathogenic, self-destructive (cf. Fuss 1994, 29). In this, Fanon's account comes closer to the early Freud, who also treated identification as a pathological condition.

What sets Fanon's analysis apart, however, is his explicit engagement of the *political* scene of identification. This is the innovation of Fanonian sociogeny.

103

If, in the end, Fanon wants to believe that the aggressivity of the demand for recognition can be overcome or that political revolution will automatically and thoroughly transform the consciousness of the oppressed, this does not overrule Fanon's more sustained emphasis in *Black Skin, White Masks* on the necessary, albeit unpredictable, co-implication of the political and the psychical. The despair motivating Fanon's wish to get to a place beyond the reach of race deepens comprehension of the catastrophe of colonial identifications and reminds Fanon's readers that the travel from self to other and back again may as easily be filled with terror as with new possibility. Perhaps Fanon's final leap of faith—"the quite simple attempt to touch the other, to feel the other, to explain the other to myself" (231)—demands more, not fewer, leaps into the space between.

NOTES

1 For a lucid reading of Freud's and Fanon's very different strategies as "post-colonial" males, see Boyarin (1994b).

2 For "travel from the self to the other," see Smith (1993a, xxvi).

3 For two influential readings of Fanon and the colonial scene of identification, see Bhabha (1994) and Fuss (1994). For another, but related reading of the comma in *Black Skin, White Masks*, see Fuss (1989, 75).

4 The book developed out of a series of essays and speeches Fanon gave after 1948. Fanon edited them into a unified whole in 1951.

5 Something of Fanon's appreciation for psychoanalysis and its talking cure may be preserved in the reuses of Fanon in 1960s liberation movements in the United States. Within both women's and black nationalist movements, Fanon's version of what might be called political, or politicized, "therapy" was a vital current in the development of consciousness-raising as a tactic for the oppressed. The representative text for this development is not Fanon's *Black Skin, White Masks*, but his posthumously published *Wretched of the Earth*. The first French edition of *Les damnés de la terre* appeared in 1961; the first English edition, in 1963. The subheading for the 1991 English-language reissue reads: *The handbook for the black revolution that is changing the shape of the world*. In his study of Fanon's psychological and social theory, Jock McCulloch describes *Wretched* not as a guidebook for revolution but as "a panegyric to the inevitable failure of the African revolution" (1983, 4). For a brief overview of interpretative debates concerning the political status of psychoanalysis in earlier and later Fanon, see Fuss (1994, 38–39).

6 Fanon uses the term man/*homme* in both gender-neutral and gender-specific senses. As I will argue in chapter six, however, even Fanon's putatively gender-neutral invocations of "man" are always haunted by the specter of sexual difference. With rare exceptions in the text, "man" is

never race-neutral, but is almost always qualified—that is, "racialized"—by "black" or "white." In quoting or paraphrasing Fanon, I will forgo the customary *sic* and let "man" stand without further aid or comment.

7 In the *Wretched of the Earth*, Fanon asserts that "decolonization is quite simply the replacing of a certain 'species' of men by another 'species' of men. Without any period of transition, there is a total, complete, and absolute substitution" (1963, 35). Henry Louis Gates suggests that an older Fanon, witness and partisan of the Algerian Revolution, ultimately failed to reconcile his "political vision of emancipation" with his psychoanalytically rich account of subjectivation (Gates 1991, 467). Cf. Fanon (1967, 223–32). For Bhabha's discussion of this ambivalence, see 1994, 60–61.

8 Fanon made these remarks in a 1956 address before the First Congress of Negro Writers and Artists, in Paris. The speech is reprinted as "Racism and Culture" in Fanon (1964, 31–44).

9 See, for example, 1967, 160–67, 180–83; cf. 1964, 32–33, 36.

10 Compare Fanon (1964, 17). McCulloch too points out Fanon's stated commitment to heterogeneity (see esp. 1983, 38, 46), though he gives insufficient critical attention to Fanon's failure to meet this commitment.

11 In his later analysis of negritude in *Wretched*, Fanon is even more clear on the structural implication of negritude in racism and colonialism: "The efforts of the native to rehabilitate himself and to escape from the claws of colonialism are logically inscribed from the same point of view as that of colonialism.... And it is only too true that those who are most responsible for this racialization of thought, or at least for the first movement toward that thought, are and remain those Europeans who have never ceased to set up white culture to fill the gap left by the absence of other cultures" (1963, 212).

12 For a helpful consideration of the differences between Fanon's treatment of negritude in *Black Skin* and *Wretched*, see McCulloch (1983, 35–62).

13 According to Fanon, two factors come together to incline the colonized to group consciousness. First, the privileging of group over individual is a function of the revolutionary moment; the oppressed discover they must stand together or fall apart (1963, 47). Second, the intensity and impact of group identifications derive from the concrete historical and cultural situation of a particular community: "One of the characteristics of underdeveloped societies is in fact that the libido is first and foremost the concern of a group or the family" (55). As in *Black Skin, White Masks*, Fanon is arguing for the interstructuration of psychical and socioeconomic phenomena.

14 It is perhaps of more than passing interest that the physician—Freud's representative?—also gains entry to the family cell: "The relations of an individual to his parents and to his brothers and sisters, to the object of his

love, and to his physician—in fact all the relations which have hitherto been the chief subject of psycho-analytic research—may claim to be considered as social phenomena" (1921, 69).

15 See Carol-Anne Tyler's provocative discussion of passing and its contradictory public demand for recognition and disavowal at once (1994). See also Erving Goffman's still-timely study, *Stigma: Notes on the Management of Spoiled Identity* (1963).

16 For Fanon's attempts to put distance between himself and other blacks, see Geismar's biography (1971, 43).

17 For an account of another virtuoso performer—the ABC television anchorman Max Robinson—and the linguistic ruptures he experienced, see Harper (1991).

18 This "praise" is Fanon's reward for having drawn an "erudite" parallel between "Negro" and European poetry in the course of his lecture to a literary society in Lyons. See Geismar (1970, 53).

19 Ultimately, however, Fanon could call no place home. He neither returns to his "native" land nor remains in the "mother country," France. Rather, he goes to Algeria, there—as Albert Memmi observes—"to propose a completely novel man," himself (Memmi 1971, 5). The new "'species' of men" that Fanon says will be born of the Algerian Revolution heralds Fanon's own rebirth and re-membrance (1963, 35).

20 Fanon cites Césaire at great length and with great frequency throughout *Black Skin, White Masks* (e.g., 123–25, 130–31, 195–98). In "West Indians and Africans," Fanon places Césaire at the scene of the epistemic shift "before and after the war of 1939–1945" and identifies him as the principal author of the new collective consciousness of the oppressed (1964, 19, 21–27). Césaire's simple declaration—"'that it is fine and good to be a Negro'"—had scandalized pre-war Martinique, but also impelled Antilleans into their future (1964, 21). Fanon's approving citation of Césaire contrasts with his far less favorable "review" of Léopold Senghor and Alioune Diop (1967, 127, 185–86). For a concise summary of Fanon's divergent responses to these three exponents of negritude, see McCulloch (1983, 37–40).

21 The social and psychical phenomena I am here describing as "call and response" are not so far from what Foucault has termed, with slightly different emphasis, "reverse discourse" (1980, 101).

22 Qtd. in Gilman (1993a, 186). Gilman's sorce for the passage is George Sylvester Viereck, *Glimpses of the Great* (New York: Macaulay, 1930), 30.

23 In this particular passage, in "West Indians and Africans" (1964, 18), Fanon is briefly outlining how the "question of race" conceals "economic realties"—an issue which he also touches on in *Black Skin, White Masks* (1967, 11).

24 This is a point Diana Fuss also makes in her concise overview of Fanon's "tropological investigation" of race (1989, 74–6).

25 This, at least, is what Fanon seems to be arguing in his presentation of the very different ways that black and white subjects experience and demarcate their body (1967, 109–16; cf. 1964, 32–33).

26 Butler too has focused on this passage, although she puts it to different uses. She extends Freud's conceptualization of the ego as the projection of a surface in order to unsettle the privileged position some body parts occupy in both Freud's and Lacan's accounts of sexual difference. See "The Lesbian Phallus" (1993a, 57–91).

BETWEEN MEN
Fanon, Memmi, and the Colonial Encounter

Ontology—once it is finally admitted as leaving existence by the wayside—does not permit us to understand the being of the black man. For not only must the black man be black; he must be black in relation to the white man.... Overnight the Negro has been give two frames of reference within which he has to place himself.

—Frantz Fanon,
Black Skin, White Masks

The first attempt of the colonized is to change his condition by changing his skin. There is a tempting model very close at hand—the colonizer. The latter suffers from none of his deficiencies, has all rights, enjoys every possession and benefits from prestige. He is, moreover, the other part of the comparison, the one that crushes the colonized and keeps him in servitude. The first ambition of the colonized is to become equal to that splendid model and to resemble him to the point of disappearing in him.

—Albert Memmi,
The Colonizer and the Colonized

IDENTIFICATION IS not "simply" a political and psychical phenomenon Fanon subjects to analysis in *Black Skin, White Masks*. It is also, in no small degree, his method of proceeding. His study of race, racism, and racialization succeeds to the degree that his readers—black and white—can locate themselves, their mirror images, in it: "Many Negroes will not find themselves in what follows. This is equally true of many whites.... Those who recognize themselves in it, I think, will have made a step forward" (12). But, when it comes to women of color, it is Fanon who draws a blank; women of color do not break the horizon of his visible. To represent the predicament of the black (male) subject, Fanon turns repeatedly to the machinery of sexual difference. The femininity he does put into play is *white* femininity. (In this respect, Fanon's strategy for revealing "racial" difference may not really be so far from Freud's strategy for concealing it.) In order to lay bare the operations of the race/gender system

in *Black Skin, White Masks*, I want to draw Fanon in and through the terms of another post-colonial male subject, the Tunisian-Jewish writer Albert Memmi. Both members of this imaginary interracial male couple are committed to exploring and unraveling the dialectic that binds colonized subjects to their oppressors. Each of them attempts to forge new ties of sympathy, solidarity, and mutual recognition—between men. Indeed, to the extent that both Memmi and Fanon concentrate on forging bonds between men, and men only, the short caption for the politico-psychological remedies they offer might be "male bonding." My dialectical engagement of Fanon and Memmi will, I hope, at once revisit their colonial scene and, in a move faithful to Fanon's and Memmi's own examples, disrupt their terms.

In *Black Skin, White Masks*, Fanon takes up and recapitulates Freud's homology between family and nation, when he argues that the "family is an institution that prefigures a broader institution: the social or national group" (Fanon 1967, 149). Fanon even offers a brief synopsis of Freud on Oedipus, the ego ideal, and group feeling:

> In Europe and in every country characterized as civilized and civilizing, the family is a miniature of the nation. As the child emerges from the shadow of his parents he finds himself once more among the same laws, the same principles, the same values. A normal child that has grown up in a normal family will be a normal man. There is no disproportion between the life of the family and the life of the nation ... [T]he characteristics of the family are projected onto the social environment. (142)

110

In every case, Fanon says, the "sickness" or pathology of an adult may be traced back to family environment (48-49, 143). However, if Fanon is in some way rehearsing Freud's *Group Psychology*, he is about to make a striking change in the stage directions. *Exeat Oedipus.* Fanon categorically denies the presence of the Oedipus complex in Antilles (180n44).

Fanon might here be understood to be paring back the global aspirations of psychoanalytic categories by asserting that the Antillean's psychological economy is not commensurate with the white colonialist's (cf. 1963, 55). Whatever the actual merits of *this* case, however, Fanon has other motives for asserting that Oedipus does not mean in the Antillean context. He points to "the absence of the Oedipus complex in the Antilles" as the reason homosexuality is unknown to Martinique. Homosexuality is outside Fanon's direct acquaintance; he at least had "no opportunity to establish the overt presence of homosexuality in Martinique" (180n44). For Fanon, homosexuality is "culturally white" (Fuss 1994, 30).

Having dispatched Oedipus from the scene, Fanon turns to consider other precipitating conditions for the formation of neurotic symptoms in individual

black men and women. Their neuroses are reaction-formations to the unbearable whiteness of being beyond the family walls: "A normal Negro child, having grown up in a normal family, will become neurotic upon the slightest contact with the white world" (1967, 143; cf. 213–16). "As long as the black man is among his own," Fanon asserts, "he will have no occasion … to experience his being through others" (109). As Fuss observes, this passage is the "clearest statement of Fanon's view that identification itself is a pathological condition" (1994, 29n14). Once the Antillean goes to France, to the longed for "mother" country, he is forced to recognize himself through the other's eyes. The Antillean must choose between family and nation, between being black and being French. This is not a picture of Du Bois's potentially lifesaving "double consciousness," but of a dangerous splitting within the ego, a falling apart into self-hating idealization of the other.[1]

A child's earliest images and identifications are formed in relation not merely to a familiar inside world of parents, siblings, and extended clan, but always with reference to an outside. S/he participates in, and is formed by, shared cultural myths. Anticipating much of the recent debate around visibility politics and the relative impact of "positive" and "negative" images on the formation of self-image, Fanon argues that the black child, no less than the white, is raised on myths and fairy tales which represent and normalize the little white boy's point of view. Fanon's particular examples are Tarzan stories, Mickey Mouse and other cartoons and comic books, and folktales from the American south, such as the story of Uncle Remus and Br'er Rabbit. These stories discharge collective aggressions, Fanon argues, by displacing fears, anxieties, and hostilities onto objectified types: "[T]he Wolf, the Devil, the Evil Spirit, the Bad Man, the Savage are always symbolized by Negroes or Indians … " (146). If the colonizer assuages his/her guilt by feasting on the myth of the "bad Injun" or the "wicked Negroes," the colonized internalizes his/her symbolization as evil and, "quite as easily" as the white subject, identifies with "the victor" (146, cf. 188). However, the impact this symbolic incorporation has on the "little Negro," whose psychic (mis)fortunes are Fanon's central concern, is not quite so "easy." To use a metaphor which resonates throughout *Black Skin, White Masks*, the black child grows up cannibalizing her or himself.

Fanon is too quick to fix the meaning of these images, leaving out of consideration the ways that so-called negative images may be the site of subversive reappropriations.[2] In dissecting the self-destructive effects of internalization, Fanon seems to deny the foundational role misidentification and misrecognition play in the dialectic of self/other and eclipse the fundamentally ambivalent structure of all identifications. I am not sure how Fanon would reply to these criticisms, although I might counter by reasserting Fanon's earlier insight concerning the double process of inferiorization: a dialectic of inside/outside, interior/exterior. Attending to the world of representation is

one way to attend also to the unconscious, even if the potential re-significations of the symbolic cannot be predicted in advance nor ever be completely revealed to consciousness after the fact. What form or forms this attending will take also remains, quite literally, to be seen.

Whatever the shortcomings of Fanon's formulation of the relationship between representation and the unconscious, it nonetheless offers a glimpse of racialization as a process of symbolization and signification. Fanon unsettles what it means to "be" black or to "be" white, dislodging the meaning of race from the immutable realm of biology or metaphysics, loosening its claims on, or to, the body's edge. He shows how the boundaries between "being" white and "being" black are contestable, mobile, constructed. This dovetails well with Fanon's exposition of the way whiteness and blackness are articulated through and against each other, in and as language—an argument I have already set out at some length in the previous chapter. What Fanon calls a "retaining-wall between language and group" establishes an inside/outside mediated by speech. But this border falls heavily on those who must mark its limits—as the testimony of both Fanon and his contemporary Albert Memmi bears out.

Like Fanon, the Tunisian writer Albert Memmi offers a suggestive account of the psychical turbulence which may accompany acculturation in another's tongue. "In the colonial context," Memmi writes in *The Colonizer and the Colonized*, "bilingualism is necessary" (1965, 107). The ability to speak the language of the colonizer improves the material circumstances of the colonized, giving him (or her) access to greater economic opportunities, for example.[3] In a metaphor reminiscent of Fanon's "retaining-wall," Memmi says that the bilingual speaker is saved from being "walled in." But s/he is not saved from a "cultural catastrophe." For "possession of two languages is not merely a matter of having two tools, but actually means participation in two psychical and cultural realms" (107). Consequently, in a colonial context, bilingual "natives" are always split subjects, denying with every word they speak some part of themselves.[4]

Despite important differences between Fanon's and Memmi's definite positions, their analyses of language as a crucial index and instrument of racial othering do have significant overlap—as do their techniques for managing sexual difference. Both enact a double strategy of making women's bodies the signifying site of racial integrity (or its breach) and committing women to the outside of the colonial scene. For the moment, I want to trace the course this strategy takes in Memmi's *Colonizer and the Colonized* and indicate also its intersections with certain psychoanalytic currents influential in Memmi's day (and in our own).

Although Memmi refers to the "gift of French," he also makes amply clear at what cost to his "inner organization" this gift was finally accepted. In a passage describing the double-bind of the bilingual speaker, Memmi reveals the way language touches the body:

[T]he colonized's mother tongue, that which is sustained by his feelings, emotions and dreams, that in which his tenderness and wonder are expressed, thus that which holds the greatest emotional impact, is precisely the one which is the least valued. It has no stature in the country or in the concert of peoples. If he wants to obtain a job, make a place for himself, exist in the community and the world, he must first bow to the language of his masters. In the linguistic conflict within the colonized, his mother tongue is that which is crushed. He himself discards this infirm language, hiding it from the sight of strangers. In short, colonial bilingualism is neither a purely bilingual situation in which an indigenous tongue coexists with a purist's language (both belonging to the same world of feeling), nor a simple polyglot richness benefiting from an extra but a relatively neuter alphabet; it is a linguistic drama. (1965, 107–8)

Despite the nostalgic evocation of a mother tongue, that first language of "feelings, emotions and dreams," this is no naive call for a return to prelapsarian linguistic purity. Memmi explicitly rejects the call of nativism, considering the search for an untainted, pre-colonial "language of the people" anything but (1965, 106).[5]

The passage does, however, express a longing for prelinguistic *unity*, a desire forcibly repressed by the colonial regime. As Memmi wryly observes elsewhere, the colonized is "not the only [person] on earth not to know a perfect unity" (1966, 183). The political drama of cultural bilingualism Memmi stages thus recapitulates the psychic drama of differentiation and subjectivation *all* subjects undergo, for that is part of what it means to become (a) subject. Separation and loss are among the founding conditions of subjectivity. Nonetheless, as Memmi also insists, the colonized does not enter the Symbolic on the same political nor psychic terms as the colonizer. And it is this difference which may intensify and accentuate the shattering force of the colonized's interpellation into and by language.[6]

Memmi's account of the shock of learning how to speak French (described in his semi-autobiographical novel *Pillar of Salt* and cited in the 1991 "Afterword" to *The Colonizer and the Colonized*) is extraordinary for its depiction of language as physically rending and re-forming the body. He was, he says, forced to leave behind his "basic unity" and to reassemble his "scattered limbs" in the territory of the other (160). Torn between "two psychical and cultural realms," Memmi re-members his body by displacing his feelings, tenderness, and emotional ties wholly onto one of them: the mother tongue. If this retroaction of a time before, a time of wholeness and unity, is a fantasy, it is also a lifesaving one, offering some slim refuge from the dislocations of language.

Longing for the mother tongue—"that which is sustained by his feelings, emotions and dreams, that in which his tenderness and wonder are expressed"— suppresses another longing, for the figure of speech who has loomed always

behind it, the one who sustained his feelings and emotions, who occupied his dreams, who gave to and received from him tenderness and wonder. Repressed longing for the mother. Elsewhere, Memmi refers to the "old and never-forgotten anxiety ... which gripped [him] on [his] first day of school at the terrifying idea of confronting a teacher who would speak a different language from that of [his] mother" (1966, 184). Consequently, if Memmi may seem at times to romanticize and even naturalize the mother tongue, starkly contrasting it to the deprivations of "learned language" (183), his longing identification with the repressed mother tongue recalls and phantasmatically recuperates another lost object: his mother's body.

This fantasy is an ambivalent one, however. If "mother tongue" is metonymic for "mother," she in turn stands in for the feminine—and feminizing—space of family. Barred from citizenship, the colonized is forced back into his family confines. Family—which Memmi has previously eulogized, in the mother tongue, as tender and full of feeling—now represents an "internal catastrophe" for the young man (99). The warm embrace has become a stranglehold; the womblike interiority of family has mutated into a vagina with teeth: "He will remain glued to that family which offers him warmth and tenderness but which simultaneously absorbs, clutches and emasculates him" (99). The phantasmatic promise of the mother tongue has broken down into (another) fantasy cum nightmare of dismemberment.

Even within the family, the colonized cannot truly be a man. He waits his turn, "submit[ting] ... to his father's authority [as he] prepares to replace him" (100). Alas, his father does not model manhood, but soft effeminacy; he is, "by a curious paradox ... simultaneously weak and possessive" (100). Colonization feminizes the colonized; he is conditioned within his family—through *whose* agency: the mother's? the father's? the *colon's*—to accept the terms of his oppression.

Memmi's "portrait" of the colonized takes the son as its central subject, and the dualism of colonizer/colonized, which he lays bare with such thoroughness and insight (though this insight cannot penetrate the blind spot of gender), depends upon the dualism of masculine/feminine and man/wife. Indeed, women may only enter Memmi's narrative in a dependent relationship to some male subject; they are wives and mothers, complicit in colonization perhaps, but never really subject to it. In one particularly telling example, Memmi says that no matter how much the colonized might seek to separate himself from the values and image of his oppressor, he will yet resemble and mimic the colonizer. To bring his point home, as it were, Memmi analogizes the colonized's situation to that of the wife at divorce proceedings, whose gestures and movements still "strangely" recall her husband's:

> At the height of his revolt, the colonized still bears the traces and lessons
> of prolonged cohabitation (just as the smiles or movements of a wife,

even during divorce proceedings, remind one strangely of her husband).
(1965, 129)

A "feminine" and feminizing mimicry betrays the dependent status of the col-
onized. The analogy—colonizer is to colonized as husband is to wife—closes
down any space for either the female colonized *or* the female colonizer.
Memmi's metaphorization of woman effectively banishes women from the
colonial situation; the couple colonizer and colonized is a relationship solely
between men. Yet, one unintended effect of this argument by analogy is to
open the door to homosexual desire. The logic of Memmi's analysis, which is
also the logic he imputes to colonization, "homosexualizes" the bonds joining
colonized to colonizer. The "prolonged cohabitation" of this pair has put the
colonized in woman's place. The colonized male wishes to resemble the col-
onizer to "the point of disappearing in him" (120). The colonized's "[l]ove of
the colonizer is subtended by a complex of feelings ranging from shame to
hate" (1965, 129). *From shame to hate*: what are these but the barriers arranged
from within to police and dam(n) up homosexual desire?[7]

Memmi's "linguistic drama," in which the colonized is imperiled on the
one side by emasculation/castration and on the other, by the terrifying vicis-
situdes of language could have been a restaging of Freud's Oedipal drama—
as reconceived by Jacques Lacan. Reformulating Freud, Lacan argues that
the Oedipal complex is not a biological process, but a symbolic—let us even
say "linguistic"—drama. The father comes between the dyadic unity of
mother/child and subject/object characteristic of the Imaginary and its
Mirror Stage, forcibly propelling the child into the triangulated structure of
language. From this "new" position in the Symbolic, the subject continues
to be haunted by a repressed desire for the maternal body, for, that is, the
prelinguistic unity of mother-child. In a sense, this fantasy of preoedipal
unification is a way of holding the body together amidst the lacerations of
language.

Fanon and Memmi are both critically intervening in and upsetting the
terms of psychoanalytic theory.[8] By indicating that the colonized is subjecti-
vated through a racial economy of inside/outside, Memmi and Fanon join
Anna Deavere Smith in challenging the privileged status of sexual difference.
However, to make racial difference appear, Memmi and Fanon—unlike
Smith—effectively "disappear" black women. This is especially evident in the
similar uses to which both men put the trope of miscegenation, although their
ultimate appraisal of the symbolic and "moral" significance of loving and
desiring across racial lines could not be more divergent. It may be of more
than passing interest here that both Memmi and Fanon married white French
women.[9] (And it is of more than passing interest because, among other things,
it reveals that theory, both for its writer and for its reader, is always, consciously
or unconsciously, interested.)

In his own efforts to dissect and dislodge the social, cultural, and religious impediments to miscegenation, Memmi brilliantly turns the tables. "All marriages," he argues, "are necessarily a form of exogamy; otherwise they would be restricted to incest, to marriage between brother and sister." If "every marriage is mixed," he reasons, then mixed marriages, far from being perversions of the law, are actually its truest and fullest realization (1966, 99). Although he ultimately came to criticize "mixed marriages" as being a form of identification with the oppressor, Memmi also recognized their utopian aspirations. Until the revolution happened, however, mixed marriages were too private and personal a solution. They represented "an effort towards individual salvation within a conflict of groups. Instead of avoiding this conflict, partners in a mixed marriage are obliged to live as part of the dramatic laceration of these opposing groups which invade their union and the very individual" (1966, 105–6).[10]

The ambivalence of identification, as it wavers between longing to have and longing to be, takes a curiously racialized—and anxiously heterosexualized—turn in Fanon's text. Despite, or perhaps because of, his personal investment in the socio-psychical complex of mixed marriage, Fanon dissects and venomously denounces interracial desire in Black Skin, White Masks as constituting the grossest form of identification with whiteness.[11]

In "The Woman of Color and the White Man" and "The Man of Color and the White Woman" (chapters two and three of Black Skin, White Masks), Fanon argues that the desire to be white or "whitened" typically seeks its satisfaction in loving the other. Heterosexual object-choice becomes a conduit for interracial identification. In these two chapters, Fanon is considering interracial desire from the standpoint of the person of color. He does not, however, make miscegenation "mean" the same for black women as for black men. Nor does his recognition of this non-identity represent a recognition that, historically, the sexualities of black women and black men have not been policed in the same way, with the same meanings, or with the same consequences.

Taking Mayotte Capécia's autobiographical Je Suis Martiniquaise as his hard evidence, Fanon uncovers her "infantile" fantasy of whiteness. Her desire to marry a white man does not point to an identification with white women, in the way that Fanon says the man of color's desire for a white woman symptomatizes an identification with white men. In fact, at no point in Black Skin, White Masks does Fanon even admit identifications or attachments between women, whether within or across racial lines. What Fanon does give himself leave to imagine, repeatedly, are the infantile dimensions of Capécia's mental life. Her unfulfilled wish to marry a white man expresses her childish identification of whiteness with high society and material wealth (1967, 43–44). In marrying a white man, she would be moving up and into whiteness.

But what, I want to ask, makes this identification "childish"? After all, for Capécia (though not only for Capécia) whiteness represents a vehicle of

escape and self-transcendence.[12] Whiteness holds out the hallucinatory promise of material plenitude and social recognition. Consequently, Fanon might have usefully invoked Capécia's wishful thinking to illustrate and particularize his claim that race is coordinate with economic class (1967, 11, 43; cf. 1964, 18). In so doing, he would have been making a compelling case for the different social, economic, and psychic determinations of a woman's "marriage plot" versus a man's and could also have shown that the institution, ideology, and individual practice of marriage do not mean the same from one woman, or group of women, to the next. The answer a woman (or a man) supplies to the "marriage question" implicates larger questions of racial and economic positioning. And these, it need hardly be restated, are among the questions with which Fanon is grappling in *Black Skin, White Masks*. Fanon could have made these connections; but, he turns away. He transforms Capécia's desire to marry up into evidence for her—and every woman's?—"artificiality" and narcissistic attachment to a world of surfaces (1967, 44-5).

A little later Fanon will offer another reading of Capécia's "infantile fantasies," one which renders the "infantile" literally: "… what Mayotte wants is a kind of lactification. For, in a word, the race must be whitened; every woman in Martinique knows this, says it, repeats it. Whiten the race, save the race … " (47). *Lactification*: Capécia wants to turn the color of milk, brilliantly white. But she also desires to nurse at her breast a white man's child, making her mother's milk a purifying source for herself and her lineage. She is, Fanon says, after "delightful little genes with blue eyes, bicycling the whole length of the chromosome corridor" (52). Having the white man's child compensates her, in the form of future generations, for the whiteness she never had. In coupling with a white man, she can whiten the stock of future generations and dream of, or in, a future perfect. Is there an echo here of Freud's much-repeated tale of the consolation women receive by having a son, in whom they might relocate, at one generation removed, their missing and much-lamented penis?

In making the mother's breast at once an effect of pollution (race-mixing) and an instrument of purification (race-whitening), Fanon transforms the maternal body itself into the equivocal site of miscegenation. However, Fanon is ultimately unable to bear the tension he has himself introduced. In his final, vitriolic dismissal of Mayotte Capécia, he shudders: "May she add no more to the mass of her imbecilities" (53). Although he is ostensibly referring to her literary production, his wish also recalls the supremely chilling refrain of Oliver Wendell Holmes: "Three generations of imbeciles are enough."[13] In Fanon's final analysis, the woman of color's "transgressive" desires do not uplift, but dilute the race.

Yet, it is also an open question whether the woman of color and the white man are finally the linked subjects of the chapter that bears their name. Despite the vehemence with which he attacks Capécia and her "type," women

117

of color fail to hold Fanon's attention for long. Like Freud on femininity *tout court*, Fanon will at last plead ignorance on the subject of black femininity: "I know nothing about her [the woman of color]" (180).[14] Moreover, even before beginning his analysis proper of the man of color and the white woman in chapter three, Fanon has displaced the woman of color by introducing into his analysis of the woman of color and the white man another interracial (but same-sex) couple: the man of color and the white *man*. For example, in the midst of a discussion about black women's desire for the white man, Fanon abruptly changes focus to the drama of black men seeking white male approval:

> We must see whether it is possible for the black man to overcome his feelings of insignificance.... For him there is only one way out, and it leads into the white world. Whence his constant preoccupation with attracting the attention of the white man, his concern with being powerful like the white man, his determined effort to acquire protective qualities—that is, the proportion of being and having that enters into the composition of the ego. (50–51; cf. 60-62)

This eruption of "homosexual" cathexis is bracketed and contained by Fanon's poisonous attack on black women who go outside the race.

In the above passage, Fanon adds another, no less fundamental distinction to Freud's primary distinction between having or not-having the penis (a distinction Lacan reformulates as having or being the phallus): a distinction between being or not-being white. In an interesting twist on Freud and Lacan, Fanon will later indicate how the black man's symbolization as *only* a penis, his *reductio ad absurdum* to the site of sexual difference, cuts off any and all access to (having) the phallus. Fanon turns this symbolization around, however, and uses it to deflect the agency of homoerotic desire from the black man and *onto* the white man. He effectively recuperates black male heterosexuality (black men as only heterosexual) by arguing that the racist fixation on the black man *as* a penis actually testifies to the white man's homosexual longing: "[T]he Negrophobic woman is in fact nothing but a putative sexual partner—just as the Negrophobic man is a repressed homosexual" (156). For the white woman and the white man, Fanon argues, the anxiety aroused by the black man masks the desire to submit before him (171). The white woman's fear and the white man's resentment cover up their phantasmatic investment in the myth of black male sexual superiority, a myth black-man-as-penis totemically symbolizes. Fanon's strategic re-reading of this myth does double duty: it detaches identification from desire (by dispatching them into separate subjects); and it reconfigures the black man's body as whole. As Lee Edelman observes, this move also positions homosexuality, and *not* homophobia, as the analog to racism (1994, 58–59)—a point I will come back to momentarily.

In his chapter on "The Man of Color and the White Woman," Fanon unveils another strategy for managing the homoerotic switch points of identification. The black man's identification *as* white and *with* the white man is mediated through a white woman. Representing the point of view of the universal black male subject, Fanon asks: "I wish to be acknowledged not as *black* but as *white*. Now … who but a white woman can do this for me?" (63; emphasis in original). Who indeed. As with Memmi's colonized, so with Fanon's man of color. The black man asserts an identification with the white man by inserting himself between the white man and "his woman."

Is it possible to read this interposition as an aggressive break from homosexual attachment? The wishful thinking Fanon attributes to his hypothetical black man—"By loving me she proves that I am worthy of white love. I am loved like a white man. I am a white man" (63)—recalls Freud's account of delusional jealousy. Delusional jealousy is "what is left of a homosexuality that has run its course, and it rightly takes its position among the classical forms of paranoia" (Freud 1922, 225; cf. Butler 1993a, 180). In this type of jealousy, an ostensibly heterosexual subject represses his or her homosexual desire by projecting it onto his/her spouse or lover. In the case of a man, this defense may be encapsulated in the following formula: "*I* do not love him, *she* loves him!" (1922, 225). His homosexual desire becomes her heterosexual desire. Might the imaginary scene Fanon describes above be rewritten as a kind of delusional jealousy? *By loving me she proves that I am worthy of his love.* But, what is the preferred form of this wished-for love? Is this an express call for mutual respect or the muted strains of desire between men? And what are the criteria for deciding between these two options: homosexuality and homosociality? Arguably, much of the genius and serious provocation of Eve Kosofsky Sedgwick's nearly homophonous pair, homosociality and homosexuality, derive from how easily one term is mistaken for—misheard as—the other.[15] But perhaps it is not, after all, either necessary or possible to decide between homosociality (identification) and homosexuality (desire). This is not a case of either/or, but the ambivalent situation of either/and. I am no more interested in "proving" that the interracial identifications Fanon details are "really" all about homosexuality than I am in making Fanon himself out to "be" a repressed homosexual. *Black Skin, White Masks* cannot be so easily pinned down. What I am interested in doing is identifying and putting back into play the ambivalent operations of identification in Fanon's text.

If Fanon is keeping something under wraps, it is not repressed homosexuality, but homo*phobia*. Nor does he even cover that up very well. Consider, for example, the restless slide of this passage: "Fault, Guilt, refusal of guilt, paranoia—one is back in homosexual territory. In sum, what others have described in the case of the Jew applies perfectly in that of the Negro" (183).

119

The movement in this sequence is dizzying: looking over its shoulder at "homosexual territory," paranoia points somewhere else—"In sum"—to the Jew who, in his turn, points to the black man. In sliding from one subject to another, this relay actually symptomatizes paranoia, that reaction formation through which a subject defends against his/her own best nightmares by deflecting them onto another. It matters less onto whom the guilt-provoking burden is shifted than that it is shifted somewhere else. Or, to cite Fanon: "Here it is the Jew, somewhere else it is the Negro. What is essential is a scapegoat" (183). Fanon's scapegoat is the homosexual. Fanon has already insisted that, in their secret heart of hearts, Negro-haters are "really" Negro-lovers (155–56). Now he seems to be making the same accusation against Jew-haters, implying that their anti-Semitism is a cover for repressed homosexuality. Fanon thus unites his *other* interracial male couple—the black man and the Jewish man—by assimilating the operations of anti-Semitism to those of Negrophobia. In the passage cited above, this assimilation works over and through the "psychotic homosexual."[16]

Given the terms of their introduction, it is not surprising that the meanings and conditions Fanon assigns to Black-Jewish identifications are not the same as those he identifies between black and white men. In the latter case, black men identify with white men's power. Black men's desire for white women represents an attempt to lay hold of the cultural power associated with straight, white masculinity. To put what is at stake for black men in slightly different terms: having and holding the white man's (white) woman opens up the possibility of having, rather than being the (white man's) phallus. Identifications with Jewish men, on the other hand, do not express the fantasy of sharing power, but the fantasy of shared *powerlessness*. But what is the cost of making shared suffering the generative occasion or condition of political coalitions? What price is too high? And is this the only way that identification across difference may be forged: by remanding some differences to the other side, "them"? In the case I have detailed above, the connection Fanon forges between black men and Jewish men is achieved at the expense of a scapegoated homosexuality.

Ironically, in thus placing the blame for anti-Semitism and Negrophobia at the closet door, Fanon gives a walking tour of the "scapegoat complex" (183). There are other moments too in *Black Skin, White Masks* where a homophobic "reactional phenomenon"—to use Fanon's own term against him (182)—is open to view. I have already mentioned one such occasion: Fanon's proclamation that neither Oedipus nor overt homosexuality is to be found in the Antilles (180n44). The denial takes on interesting new dimensions where lesbianism, or, rather, Fanon's version of lesbianism, is concerned. In the one place where Fanon explicitly admits the lesbian's possibility, he immediately expels her from the scene: "Imagine a woman saying of another woman: 'She's

so terribly desirable—she's darling… '" (201; ellipsis in original). The reader is left to fill in Fanon's elliptical insinuation. Love between women … is it not farcical, beyond all imagining?

In its larger context, this "absurd" scene also fulfills another mandate. Fanon is launching an all-out offensive against the putative racism of a Jewish physician, Michel Saloman. Fanon's double strategy consists of gay-baiting Saloman and then professing his own ignorance on the subject of male homosexuality: "I have never been able, without revulsion, to hear a *man* say of another man: 'He is so sensual!' I do not know what the sensuality of another man is" (201; emphasis in original). It is at this juncture that Fanon invites his would-be interlocutor to laugh with him at the absurd comedy of lesbian desire. If Fanon's "straight man" gets that joke, then perhaps he will also join Fanon in finding male homosexuality at once unimaginable (as in: "I do not know what … ") *and*—through some trick of the imagination whereby an image or possibility is admitted into consciousness if only to perish the thought—revolting.

On the one occasion when Fanon explicitly repudiates male homosexuality, he scapegoats a Jewish man. In light of historical associations among Jewish masculinity, effeminacy, and homosexuality, Fanon's targeting of Saloman is not innocent. Does Fanon's hypothetical conversation with Saloman unravel the ties of empathy and identification Fanon elsewhere establishes between black men and Jewish men and perhaps expose, in the most overt way, Fanon's own *dis*identification with Jewish men?

Even Fanon's ostensibly sympathetic analogies between anti-Semitism and Negrophobia return something of the ambivalence and aggressivity of Fanon's identification with Jewish men. Building on Sartre's *Anti-Semite and Jew*, Fanon argues that "Negro" and "Jew" both symbolize absolute otherness for the Negro-hater and the Jew-hater. He does not claim that these terms signify "race" or "racial" difference in the same way. But his ability to distinguish between their symbolic meanings and associations is itself dependent upon his (re)citation of *sexualized* differences: "The Negro symbolizes the biological danger; the Jew the intellectual danger … " (165); or, "in the case of the Jew, one thinks of money and its cognates. In that of the Negro, one thinks of sex" (160). The anti-Semite decodes the signs of the Jew's "acquisitiveness;" the Negrophobe finds in the black man's every gesture the proof of his sexual potency (157). Whereas the black man is all and only body, the Jew seems to have no body at all.

Fanon says he wants to resist assimilating Negrophobia and anti-Semitism (183). However, he does so by assimilating Jewish men to the feminine. Fanon's conception of the symbolic work "Jew" performs for the anti-Semite does not just catalogue stereotypes of Jewish male effeminacy, it seems also to recapitulate their terms:

No anti-Semite, for example, would even conceive of the idea of castrating the Jew. He is killed or sterilized. But the Negro is castrated. The penis, the symbol of manhood is annihilated, which is to say that it is denied. The difference between the two attitudes is apparent. The Jew is attacked in his religious identity, in his history, in his race, in his relations with his ancestors and his posterity; when one sterilizes a Jew, one cuts off the source; every time that a Jew is persecuted, it is the whole race that is persecuted in his person. But it is in his corporeality that the Negro is attacked. It is as a concrete personality that he is lynched. It is as an actual being that he is a threat. (162–63)

So, the Jewish man is always already castrated. As has been amply argued and demonstrated by Gilman, Boyarin, Garber, Geller and others, this way of symbolizing Jewish difference has been a common trope in anti-Semitic literature on the difference of the Jew. Moreover, in claiming that the black man is attacked in his body and his individual person, while the Jewish man is attacked in his group and his collective identity, Fanon effectively denies Jewish men personality and particularity.[17] The Jew is an abstraction; he stands in for his entire race, part for a whole. The black man, by contrast, is a concrete whole reduced to his part (cf. Edelman 1994, 42–75).[18]

Fanon's expanded consideration of differences and commonalities between the "case of the Jew" and "that of the Negro" implicitly returns Jewish men to "homosexual territory." To return to Fanon's formulation of the scapegoat complex:

> Fault, Guilt, refusal of guilt, paranoia—one is back in homosexual territory. In sum, what others have described in the case of the Jew applies perfectly in that of the Negro. (183)

In the relay homosexual–Jew–Negro, the Jew's body comes between the homosexual's and the black man's, symbolically buffering the black male subject from the Scylla and Charybdis of same-sex desire and cross-sex identification. Following Fanon's logic of (dis)identification to its bitter end: if each Jewish man stands in for his people entire, then Fanon's homophobic insinuation of Saloman's repressed homosexuality catches all (male) Jews in its net.

Fanon's efforts to conserve black masculinity are founded on a series of exclusions; he sets homosexuality, the feminine, and black womanhood outside the parameters of his study of racialized identity. His exclusionary tactics are an attempt to shore up black masculinity against the very real social and psychical pressures of white racism. Unfortunately, this way of proceeding puts black men at the center and black women no place; it also marks out all black women and black gay men (insofar as male homosexuality is identified by Fanon with the feminine and with whiteness) as potential "double agents." Although the black woman does briefly appear in the series of sexual tableaus

Fanon stages, her presence here is overshadowed by Fanon's larger interests, namely the meaning of racial difference for the black man. For Fanon, black-ness means black masculinity. It is the black man's body Fanon must reinte-grate, re-member.

Fanon's articulation of what and how race means is dependent upon mak-ing sexual difference appear and, paradoxically, women of color disappear. Fanon seems to take for granted that having the white man's woman means having a *white* woman. While it is true that this is the "effrontery" which has centrally attracted the punitive sanctions of white racism—"justifying" the lynching of black men in the American south for their sexual assaults, real and imagined, on white womanhood and for their "usurpation" of white male prerogatives; and "rationalizing" well into the present day the disproportionate attention given to heterosexual rapes where the victim is white and the accused, of color—it is also the case historically that colonialism and slavery gave white men virtually unlimited access to women of color. Within this racial economy of compulsory heterosexuality, in whose terms Fanon certain-ly speaks, a case might thus be made for holding that the white man's woman was *any* woman. Yet Fanon completely brackets from his analysis the specific forms of terror women of color have experienced under slavery and colonial-ism. His analysis and privileging of black male victimization leaves no space for the historical experiences of black women, who were raped, separated from their children, denied the right to choose who would or would not have access to their bodies.[19] Nor does Fanon's study leave room for black female agency.[20] It is not a question of asking or answering, who has suffered more, black women or black men or (to invoke a comparison implicit in Fanon's study) Blacks or Jews. Suffering, as Patricia J. Williams also notes (1995, 31), is not a sweepstakes, and winning on these terms could only by Pyrrhic.

The breathtaking course Fanon charts in his exegesis of the fantasy "A Negro is raping me" is an exemplary instance of both Fanon's privileging of black male suffering and the exclusions structuring his analysis of this suffering. In interpreting this fantasy, Fanon does not simply invert the posi-tions of agent and victim, but "lesbianizes" and racially homogenizes the fan-tasy-scenario of heterosexual, interracial rape. The fantasy-scene in which a white woman "lives the fantasy of rape by a Negro" will turn on a series of substitutions. The "real" fantasy behind a "A Negro is raping me" is "I wish the Negro would rip me open as I would have ripped a woman open" (179). The white woman's masochistic and racially charged fantasy of rape is at the same time a sadistic wish to take the black man's place and rape another woman as herself. We are not far from the logic—nor the grammar—uncov-ered in Freud's "A Child is Being Beaten" (1919, 179–204). Additionally, and not unlike Helene Deutsch, whose very brief treatment of white women's fantasies of rape by black men helps to make her case for feminine masochism

123

(1944, 256), Fanon extrapolates from the fantasy "A Negro is raping me" to indict the *sadism* of white femininity (1967, 179). As Fuss notes, Fanon's deconstruction of this fantasy takes place in an historical context "when fabricated charges of rape were used as powerful colonial instruments of fear and intimidation" (1994, 31). But the colonial scene of Fanon's writing cannot account for Fanon's dismissal of the woman of color. The punchline to Fanon's discussion of the interracial rape fantasy is: "Those who grant our conclusions on the psychosexuality of the white woman may ask what we have to say about the woman of color. I know nothing about her" (1967, 179–80).

What makes Fanon's erasure of black women even more troubling is that it is a repeat performance. From the founding declarations of black nationalism in the late-eighteenth and early-nineteenth centuries, the integrity and uplift of the race have been identified with the production and promotion of an heroic black masculinity (Gilroy 1993, 135–36).[21] Despite significant differences between black nationalist rhetoric then and now, one theme consistently played out is the priority of averting and avenging threats to black manhood. It is the black man alone whose body is laid open, eviscerated by the rapacious white gaze, subjected to a "racial epidermal schema" (112). Fanon thus misses an opportunity to make his important insight concerning the "double process" of inferiorization work to explain the interstructuration of race and gender. For Fanon's description of the social and the psychical as co-implicating but *not* co-extensive influences is, I suggest, a description also of the relations between gender and race. The relations between these two terms cannot be sketched analogically (even if I have just introduced them by way of analogy to Fanon's "double process"). The operations of one may not be merrily deduced from, or referred to, those of the other, as if there is, finally, only the careless indifference or optimistic enthusiasm of *etc.* or *op. cit.*[22]

Fanon wants to lay bare the "relations of dependence" binding black subjects to whiteness and incarnating black subjects as "black" (1967, 211). Yet, his analysis itself enacts other relations of dependence. To represent the push-pull of "race" and racialization, Fanon calls up and upon other levers of subjectivation: the instrumentalities of gender and sexuality. His anguished analyses of interracial, cross-sex desire and interracial, same-sex identification are curiously dependent upon the mobilization and repression of homosexual desire. Curiously dependent also upon a disidentification with Jewish men. Finally, curiously dependent upon the invocation, then erasure of women of color. In *Black Skin, White Masks*, sexual difference does not finally signify. Or it signifies only for black men struggling to escape the confines of black-man-as-penis. The place of black women in Fanon's text is really to be no place at all. The either/or of race or gender might seem to recreate the situation encapsulated in the title of the popular black feminist anthology *All the Women Are White, All the Blacks Are Men, But Some of Us Are Brave.*[23]

NOTES

1 Of course, as Paul Gilroy argues, it is an open question whether the "sec-
ond sight" with which Du Bois says black men are "gifted" is really all
that much of a boon. For Gilroy's historical and philosophical contextu-
alization of the phrase "double consciousness," see 1993, 134.

2 There is a rich literature on the disproportion between representation and
reality. The very images which might seem, prima facie, to attack and
erase whole groups may also be the site of a subversive reappropriation
and political re-activation. For starters, see L. Williams (1989); Butler
(1990c); Mercer (1991); Halberstam (1993); Hammonds (1994).

3 In *The Liberation of the Jew*, a largely autobiographical study of the divi-
sion colonizer/colonized as it unfolds in the very particular historical and
cultural situation of Jews, especially Arab Jews, Memmi describes the
social utility of speaking the "language of the colonizer" thus: "But this
superbly sophisticated instrument [French] could express everything and
opened every door. One's cultural attainments, intellectual prestige and
social success were all measured by one's assurance in the use of the con-
queror's language" (1966, 183).

4 I do not want to underestimate the differences between Fanon's and
Memmi's linguistic situation. In Tunisia, the linguistic divide was not
primarily between those who spoke beautiful, "pure" French versus
those who spoke a "bastardized" version—as it was in Fanon's
Martinique—but between those who spoke French at all and those who
spoke Arabic or other local dialects. In Memmi's very particular case, the
linguistic situation was, to paraphrase his self-description, still more
ambiguous. He was a Tunisian national of Italian descent on his father's
side. His mother was a "native" Jewish Berber woman, who spoke only
the Judeo-Arabic dialect common to the region. Even after his forced
entry into the "public" language of the region—French—Memmi
would continue to speak Judeo-Arabic at home with his mother.
Beyond the walls of his immediate and extended family, however,
Memmi's "mother tongue" was a distinct handicap. It was, he says, "a
crippled language reinforced by Hebrew, Italian and French words.
Hardly understood by the Moslems and completely ignored by every-
one else it became inadequate as soon as I left the narrow streets of the
ghetto" (1966, 182). To build up his "Hebraic culture," as he called it,
Memmi applied himself to learning Hebrew; but, this too "led [him]
nowhere" (1966, 193). Like most Tunisian Jews, Memmi could converse
with "the Moslems" in their language, Arabic, though he never learned
to write it nor speak it properly (1965, xiv; 1966, 183). At the age of
eleven, Memmi entered a French-sponsored primary school, where he
was first forced to learn French.

5 Compare, however, Memmi's call for a language that "the" Jewish people might call their own (1966, 182–95).

6 This portrait of psychical rupture is one that Memmi consistently draws. Compare, for example: "The bilingualism of the oppressed is not a simple technical matter, in which he who can command two tools is more favored than he who possesses only one. A double inner-kingdom literally imperils the unity, the psychic harmony of the oppressed. His second language, far from complementing his solidly acquired, self-confident mother tongue, dethrones and crushes it. And worst of all, the oppressed finally consents to this defeat and accelerates the decadence. The rejection of one's native language and the embarrassment which it henceforth creates is certainly one of the most cruel manifestations of self-rejection: what is the profoundest, the most affective, the most intimate is repressed, made inferior, despised to the advantage of the most recent and the most artificial" (1966, 188).

7 For a provocative examination of the way shame may operate to bar homosexual desire and generate and justify homophobia, see Sedgwick (1993). Her reading builds on Goffman's study of stigmatization (1963). See also Adam (1978).

8 Although Memmi's text does not lay explicit claim to the territory of psychoanalysis, it does share some areas of concern: e.g., "internal catastrophes," the question and crisis of identification, and the family's role in acculturation. Moreover, in his 1965 preface to the English edition, where he is in part responding to Sartre's critique of *Colonized* as not offering a sufficiently Marxist economic account of oppression, Memmi positions his text as taking the middle road between Marxism and psychoanalysis (xii–xiii).

9 Fanon married Josie Dublè in the same year as the French publication of *Peau Noire, Masques Blancs*.

10 Memmi repeats his criticism of the shortsightedness of mixed marriages in the preface to *The Colonizer and the Colonized* (1965, vii).

11 For a slightly different account—and even prefigurative defense—of marriages between black men and white, European women, see Fanon (1967, 202). Here Fanon defends his (then) hypothetical marriage to a white woman by asserting his French-ness.

12 Compare Butler's discussion of Venus Xtravaganza's fantasy of white femininity (1993a, 130).

13 Holmes spoke for the majority in the 1927 Supreme Court case *Buck v. Bell*: "We have seen more than once that the public welfare may call upon the best citizens for their lives. It would be strange if it could not also call upon those who already sap the strength of the state for these lesser sacrifices.... Three generations of imbeciles are enough" (qtd. in Gould

1981, 335). *Buck v. Bell* concerned the constitutionality of Virginia's compulsory sterilization laws. The Court decided for the state and against Carrie Buck, a young white mother the state said had the mental age of a seven-year-old. However, as Stephen Jay Gould has established in his reconsideration of the "facts," Buck actually received average grades in school and would not be considered mentally retarded by today's standards.

14 Mary Ann Doane discusses Fanon's erasure of the black female body in her essay "Dark Continents: Epistemologies of Racial and Sexual Difference in Psychoanalysis and the Cinema," in 1991, 209–48.

15 For the meaning and extension of the term "homosocial," see Sedgwick (1985).

16 This accusation is not new. For Arnold Zweig's identification of German anti-Semites and "psychotic homosexuals," see Gilman (1993a, 196–97).

17 Fanon also misrepresents the historical forms persecution of Jewish men has taken. He claims, for example, that no one would ever think of castrating the Jew. Yet, this "remedy" was proposed in the case of Nathan Leopold and Richard Loeb, whose 1924 "thrill-killing" of Bobby Franks reinforced associations among Jewishness, criminality, and sexual perversion. Fanon misses the way in which lynching too was selectively enforced against Jewish men in the American south—as the 1915 case of Leo Frank attests. After Frank's death sentence for the murder of a 13-year-old female employee was commuted, he was kidnapped by a mob of white Christians and lynched. See MacLean (1991).

127

18 Compare Fanon's offhand remark in "West Indians and Africans": "Philosophically and politically there is no such thing as an African people. There is an African world. And a West Indian world as well. On the other hand, it can be said that there is a Jewish people ... " (1964, 18n2).

19 In his solitary mention of the unequal power relations between white men and women of color, Fanon speaks wholly from the point of view of the *white man* (1967, 46n5).

20 Compare, however, "Algeria Unveiled," where Fanon eulogizes Algerian women's role in hastening Algerian political independence (rpt. in 1965, 35–67). See Fuss's reading of "Algeria Unveiled" and Fanon's gendered theory of imitation without identification (1994).

21 As Gilroy points out, this picture becomes complicated in the case of Du Bois. According to Gilroy, Du Bois promoted "successive images of the *female* form [to] embody the harmony, mutuality, and freedom that can be acquired by dissolving individuality into the tides of racial identity" (1993, 135; emphasis added). However, as Gilroy also points out, the idealized image of black womanhood Du Bois offers in his nonfiction is not matched by a corresponding celebration of black femininity in his fictional works (136). Moreover, Du Bois's personifications of Africa and of black

cultural forms as black women stage racial integrity as a sexual striptease performed before the invited gazes of black and white men. For instance, Du Bois represents Africa as an "African form [whose] color and curve is the beautifullest thing on earth; the face is not so lovely, though often comely with perfect teeth and shining eyes—but the form of the slim limbs, the muscled torso, the deep full breasts!" (Du Bois, *The Crisis* 27:6 [April 1924]: 273; qtd. in Gilroy 1993, 135). In *Black Reconstruction in America*, Du Bois portrays black music as a black woman whom white southerners "sneered at" and white northerners "raped and defiled" (qtd. in Gilroy 1993, 136).

22 Unfortunately, in too many white feminist accounts of gender, it is race which waits in the wings, entering the scene, if it does, as an afterthought or as more of the same. The disappearance of women of color (and all lesbians) under the putative catchall "woman" has been critically analyzed and denounced from within feminist theory. From Frances Beal's 1970 essay on black women's double jeopardy, to the groundbreaking early '80s anthologies *This Bridge Called My Back* and *Home Girls*, to the operations of late '80s and early '90s critical race theorists, such as Norma Alarcón, Hortense Spillers, Chela Sandoval, Chandra Talpade Mohanty, and Gayatri Spivak—women of color inside and outside the academy have critically identified the inability or refusal of white feminisms to interrogate and attend to the meaning of racial difference for the category "woman." This very brief listing is not intended to present either an exhaustive bibliography or a detailed chronology of the rich work accomplished and ongoing in the areas of black and "third world" feminist theories. Nor, in mentioning some women by name do I mean to give "star billing" to a chosen few. Finally, I do not mean to discount the serious critical attention some white feminists have given to elucidating the relations between gender and race. One important development among white feminists is the move to interrogate whiteness, for too long the unseen of white feminist theory. (See, for example, Frankenberg and Spelman.) I would also be remiss if I did not also acknowledge the important early attention white lesbian-feminists such as Adrienne Rich and Minnie Bruce Pratt gave to questions of gender, sexuality, and race.

23 Hull et al. (1982).

WOMANLINESS

We all know women
with a strong dash
of the masculine
temperament, and
we all know men
whose almost femi-
nine sensibility and
intuition seem to
belie their bodily
forms. Nature, it
might appear, in
mixing the elements
which go to com-
pose each individual,
does not always keep
her two groups of
ingredients—which
represent the two
sexes—apart, but
often throws them
crosswise in a some-
what baffling man-
ner, now this way
and now that....

—Edward
 Carpenter,
The Intermediate Sex

FEMMES FUTILES
Womanliness, Whiteness, and the Masquerade

The reader may now ask how I define womanliness or
where I draw the line between genuine womanliness and
the "masquerade." My suggestion is not, however, that
there is any such difference; whether radical or superficial,
they are the same thing.

—Joan Riviere,
"Womanliness as a Masquerade"

IN FANON'S exegesis of "A Negro is raping me," he uncovers a fantasy of
"race," rape, and heterosexuality to reveal the sublimated site of lesbian desire.
His "discovery" of same-sex desire and cross-gendered and cross-racial identifi-
cations at the secret heart of the phantasmatics of race bears a striking resem-
blance to the fantasy Joan Riviere uncovers en route to revealing "Womanliness
as a Masquerade." It is outside the scope of this study to examine the overlap
between Riviere's and Fanon's analyses of masquerade in any depth. One
place to begin such a study would be a consideration of Riviere's and Fanon's
shared concern with the role of language and linguistic mastery in maintain-
ing social distinctions of gender and race, respectively. Reading Riviere and
Fanon with and against each other on the topic of fantasy and masquerade
might indicate the extent to which sexualized and racialized taboos come
together in subject-formation, but generally fall apart in psychoanalytic

accounts of subjectivity. Both Riviere's "Womanliness as a Masquerade" and Fanon's *Black Skin, White Masks* are representative of this latter tendency.

But it is Riviere's study—its insights, omissions, and subversive possibilities—that occupies my attentions below. This 1929 essay has been at the center of numerous feminist investigations of masquerade, gender performativity, and the politics of imitation.[1] My return to "Womanliness as a Masquerade" is motivated by a concern to specify just which femininity Riviere unmasks. With the exception of Mary Ann Doane's reconsiderations of masquerade and female spectatorship (1991), previous feminist interpretations of Riviere's essay, and the theories of masquerade generated from it, have left out of view the critical role played by race and racial identifications in womanliness as a masquerade. By retracing the cross-gendered and cross-racial identifications which together effect the masquerade of womanliness detailed by Riviere, I mean to unmask not just womanliness, but whiteness.

Riviere's most lasting contribution to psychoanalysis may be her English translations of Freud's works, her presence captured in such now standard phrases as "civilization and its discontents."[2] She was the translation editor for the *International Journal of Psychoanalysis*, through which many of Freud's papers were first introduced to an English-language audience.[3] Ernest Jones, from whom Riviere took over the responsibilities of overseeing translations for the *Journal*, wrote to Freud of Riviere's talents in this area: "There is no one who

could do it as well…. "[4] But he also expressed to Freud his reservations about giving her the title of assistant editor, a title to which (as Jones himself allowed) Riviere "would logically have had the better claim" than John Rickman, the American whom Jones preferred for the position. (Rickman was, Jones said, "far easier to work with," and, besides, it was important not "to give such a slap in the face to the Americans" by officially appointing yet another lay analyst to a top position.) To justify giving Riviere the responsibilities of assistant editor, while withholding from her the official name, Jones tells Freud that he doubts "whether Mrs. R. would attach any weight to the title." Invoking a theme which will figure prominently in Riviere's analysis of womanliness as masquerade, Jones goes on to say that:

> [Riviere] speaks a lot about "recognition," but it seems to me on the part
> of yourself, myself and a couple of others, rather than on the part of the
> outside public. I am glad to be able to shift this delicate matter on to your
> broad shoulders! I will write to her gratefully accepting *your* offer
> (Verschreiben for "her" because I know it is thanks to you that she has
> [offered to take over supervising translations]), but saying nothing of the
> title. (Freud 1993, 466)

Jones had already shifted "Mrs. R." from himself to Freud. After undergoing

four years of analysis with Jones, from 1916 to 1920, Riviere was passed off to Freud in 1921.[5]

Riviere was, Jones writes to Freud in 1922, "the worst failure I have ever had."[6] In this letter Jones also describes Riviere as a "typical hysteric," a woman whose "most colossal narcissism" and "masculine identification with [her father]" renders her unable, finally, to get past her masculinity complex. Riviere, for her part, writes to Jones in October 1918 of "the long tragedy of my relationship with you."[7] In a letter written just five days later, she criticizes him for rejecting her, calling his "'hardness' quite brutal in *my* then 'quivering' and 'wounded' state" (emphasis in original).[8] Whether there was ever anything directly sexual between Riviere and Jones is unknown; what is clear are the strong currents of transference and counter-transference between them.

As Stephen Heath also notes, the terms in which Jones assures Freud that there has never been anything sexual between himself and Riviere anticipate Riviere's 1929 analysis of a "masculine" type of woman. "She is not the type that attracts me erotically," Jones tells Freud in the 1922 letter referred to earlier, "though I certainly have the admiration for her intelligence that I would have for a man" (qtd. in Heath 1986, 46). In Jones's *Sigmund Freud: Life and Work*, he names Riviere to a class of women favored by Freud:

> Freud was also attracted to another type of woman, of a more intellectual and perhaps masculine cast. Such women several times played a part in his life, accessory to his male friends though of a finer calibre, but they had no attraction for him. The most important of them were first his sister-in-law Minna Bernays, then in chronological order: Emma Eckstein, Loë Kann, Lou Andreas-Salomé, Joan Riviere, Marie Bonaparte. (qtd. in Heath 1986, 46)

133

"Masculinized" by their intellectual caliber (that is, by Jones's identification of their formidable intellects with the masculine), Riviere and company were, he says, but appendages to Freud's male circle. In view of the fact that Jones effectively traded Riviere to Freud and, through her, reinforced his own ties to the great man, isn't Riviere first and foremost an access/ory for Jones? In both her professional and personal life, Riviere played go-between: mediating Freud to an English-speaking public and mediating between Jones and Freud.

Riviere the intermediary may herself prefigure the "intermediate type" who centrally occupies the analysis of "Womanliness as a Masquerade." In that essay, Riviere narrates and interprets the case history of a "particular type of intellectual woman" (1986, 35). It used to be, Riviere tells us, that such women were uniformly and overtly masculine; they made no attempt to conceal their wish or claim to be men. But things have changed:

> Of all the women engaged in professional work today, it would be hard
> to say whether the greater number are more feminine than masculine in
> their mode of life and character. In university life, in scientific professions
> and in business, one constantly meets women who seem to fulfil every
> criterion of complete feminine development.... At the same time they
> fulfil the duties of their profession at least as well as the average man. It is
> really a puzzle to know how to classify this type psychologically. (35–36)

It is to this puzzling task that Riviere applies her own considerable professional talents and intellect.[9]

Though never named, Edward Carpenter's theory of the "intermediate sex" underwrites Riviere's discussion of women whose gender identifications and character traits "contradict" their "sex." In *The Intermediate Sex* (1908) and *Intermediate Types Among Primitive Folk* (1914), Carpenter argues that the binary framework male/female oversimplifies human sexual differences. "The sexes," he suggests, "form in a certain sense a continuous group" (1956 [1908], 144). Between the "normal man and the normal woman," there is "a great number of intermediate types—types, for instance, in which the body may be perfectly feminine, while the mind and feelings are decidedly masculine, or *vice versâ*" (1975 [1914], 9; emphasis in original).

Openly homosexual (for his day), Carpenter was also a utopian socialist and an ardent champion of women's rights. He dreamed of a new human society, whose citizens were neither "excessively" male nor "excessively" female, where bisexuality and, with it, sexual tolerance were the new human norms (Weeks 1981, 173). Carpenter assigned to intermediate types a "positive and useful function" in the achievement of this brave new world (1975, 9). In *The Intermediate Sex*, Carpenter plainly describes "Uranians" (his term for intermediate types of men) as "the teachers of future society" (1956, 142) and a "moving force in the body politics" (1956, 175). They are, in Carpenter's estimation, prophets and diviners who do not just reconcile masculine and feminine in one body, but also draw together whole societies. In both *The Intermediate Sex* and *Intermediate Types Among Primitive Folk*, Carpenter seeks to complicate the opposition male/female as well as to multiply the division normal/homosexual:

> ... the varieties of human type, intermediate and other, are very numerous, almost endless, so we shall do well to keep in mind that the varieties of love and sex-relation between individuals of these types are almost endless, and cannot be dispatched in sweeping generalisations—whether such relations be normal or homosexual. (1975, 164)

Although Riviere deploys Carpenter's term, "intermediate type," she does not mind his caution about "fixing" the relations of same-sex desire and cross-gendered identification—a claim I will clarify below.

In fairness, there is no reason to suppose Riviere even knows she is using the term Carpenter popularized. Indeed, she seems to credit Ernest Jones as her source. Positioning her essay as a companion piece to Jones's 1927 essay "The Early Development of Female Sexuality," Riviere writes, "In his paper … he sketches out a rough scheme of types of female development which he first divides into heterosexual and homosexual, subsequently subdividing the latter homosexual group into two types. He acknowledges the roughly schematic nature of his classification and postulates a number of *intermediate types*" (1986, 35; emphasis mine). However, in that 1927 essay, Jones never uses the term "intermediate types"; Riviere has interpolated it into his text. But if Jones and Riviere do not share the same conceptual vocabulary, they do make some strikingly similar claims regarding female homosexuality; both Riviere and Jones tend to de-emphasize same-sex desire and stress cross-sex identification. Their "homosexual" women seem to know little of sexual desire.

In view of the leading role Riviere assigns language and speech acts in the masquerade, it is ironic that her principal case in point should have been an American woman "engaged in work of a propagandist nature, which consisted principally in speaking and writing" (1986, 36). In places, Riviere will come very close to describing this analysand as "homosexual," and not because the analysand desires other women sexually, but because the woman identifies with the masculine and wishes for recognition of her masculinity from "other" men. (I will come back to Riviere's curiously *desexualized* homosexual later.) The woman displays her cross-gendered identifications by seizing the powers of speech and self-possession normatively identified with maleness and masculinity. She subsequently guards against the feared reprisals of the "father-figures," whose powers and prerogatives she has usurped, by performing herself as "woman." After giving a particularly successful public talk, for example, she plays the coquette with her male colleagues, demurring to their opinions, and refusing their praise of her professional abilities. "The extraordinary incongruity of this attitude with her highly impersonal and objective attitude during her intellectual performance, which it succeeded, was a problem" (36)— the *woman's* problem, Riviere makes clear.

135

Riviere's essay implies, even if Riviere does not say so directly, that the incongruity between the woman's intellectual (read: "masculine") performances and her assumed femininity is a "problem" only to the degree that being intelligent and "being woman" are conceived as mutually exclusive possibilities. Riviere will later assert that there is nothing to decide between "genuine womanliness and the 'masquerade' " (38). In the final analysis, there is only imitation, only performance. But it would be going too far to say that Riviere is arguing for imitation with no original, for masculinity remains the ungrounded ground of her analysis of womanliness as masquerade. Masculinity is the original, the true-real, of which femininity is a pale imitation.

(By way of conclusion, I will suggest that Riviere does point the way towards unmasking masculinity too, even if this was not the line of attack taken in her essay.) Riviere does not subject to scrutiny the power relations that compel the woman to put on womanliness and become woman, an over-sight or resistance that distinguishes Riviere's analysis of masquerade from social and political critique (cf. Doane 1991, 38–39). This does not mean, however, that "Womanliness as a Masquerade" cannot be the starting point for a feminist critique of femininity's constitutive psychical and political conditions. Nor does it mean that Riviere's psychoanalytic conclusions are therefore to be dismissed as a- or even anti-political. It may be that Riviere's inability (or strategic refusal) to push her analysis any farther registers her own definite position between men. This is not, I want to urge, a reduction of "Womanliness as a Masquerade" to Riviere's personal biography. But it is a recognition of the history of identifications within which her analysis is inscribed.

Riviere traces her patient's strategy of oscillating between intellectual and feminine performances back to fantasies and daydreams that had obsessively occupied the woman during her childhood in the American south (37). The fantasies concerned the strategy the girl would take if a black man broke into her house and tried to attack her. She planned to defend herself by propitiating him with sexual favors until such time as she was able to deliver him up to justice. Riviere interprets these childhood fantasies, with their tactics of propitiation, as the prototype for the rituals the woman employed as an adult, when she puts on a mask of womanliness and thereby attempts to woo and reassure her male colleagues (and herself) of her "essential" womanliness. Riviere generalizes from this woman's case history to make the startling claim that there is no difference between "genuine womanliness and the 'masquerade' … [t]hey are the same thing" (38).

At no point in her analysis does Riviere explicitly consider the generative place of racial identifications and racialized taboos in producing womanliness as a masquerade. Nor does she ever name which (or whose) womanliness the woman is performing. Blackness as a term of difference drops out; Riviere speaks of the woman as endeavoring to "evok[e] friendly feeling towards her in the man," race-neutral (38). Yet, race or, rather, sexualized fantasies of race and racialized fantasies of forbidden sexual desires are pivotal to Riviere's analysis. To identify what "really" lies behind her patient's oscillations between masculinity and a caricatured femininity, she must work through and decode the woman's childhood sexual fantasies and daydreams about black men, transgressive desire, submission, and the father's law (cf. Doane 1991, 38). But Riviere's exegesis of these fantasies frames them around, and ultimately narrows them to, sexual difference and the white woman question.

The black man becomes a figure for the white father, avenging the girl-

turned-career-woman's expropriation of the white phallus: "Obviously it was a step towards propitiating the avenger to endeavor to offer herself to him sexually. This phantasy, it then appeared, had been very common in her childhood and youth, which had been spent in the Southern States of America; if a negro came to attack her, she planned to defend herself by making him kiss her and make love to her... " (37). To locate the meaning of this conscious daydream, Riviere presses her analysand to go farther back and reveals "a further determinant of the obsessive behaviour." *Which* obsessive behavior? The woman's "compulsive ogling and coquetting" *or* the racial fantasy so "common," as Riviere says, "in her childhood and youth"? Ultimately, Riviere inclines to the former view, privileging the claims of gender over race. She details a dream similar in content to the woman's childhood fantasy: "... she was in terror alone in the house; then a negro came in and found her washing clothes, with her sleeves rolled up and arms exposed. She resisted him, with the secret intention of attracting him sexually, and he began to admire her arms and caress them and her breasts" (37).

The meaning Riviere "uncovers" in this dream assigns priority to gender over race:

> The meaning was that she had killed father and mother and obtained everything for herself (alone in the house), became terrified of their retribution (expected shots through the window), and defended herself by taking on a menial rôle (washing clothes) and by *washing off* dirt and sweat, guilt and blood, everything she had obtained by the deed, and "disguising herself" as merely a castrated woman. (37–38; emphasis in original)

Race is not just bracketed by gender, but is referred back to it. Within the terms of Riviere's analysis of gender, black women do not signify, and black men are reincorporated into or as a sign of white parental authority. Riviere makes racial difference function only as a lever of sexual difference. The fantasies of race, rape, and retribution are peeled back to reveal repressed Oedipal desires. Oedipus and the sexual difference it narrativizes are over all. The childhood fantasies and dreams provide Riviere with the hermeneutic key for understanding the gender masquerades her patient performs as an adult. Together, both the conscious fantasies of interracial desire and the unconscious fantasies of seducing the father-figures work to defend against the anxieties unleashed by wanting to "have," and not just "be" the phallus (cf. 44).[10]

When Riviere refers to the "double-action" whereby the woman seeks simultaneously to "secure reassurance by evoking friendly feelings towards her in the man" and "to make sure of safety by masquerading as guiltless and innocent" (38), she overlooks another "double-action." Namely, the sexualization of race and the racialization of gender and sexuality. The white femininity the woman puts on, however unstably, is imbricated in sexualized and racialized

137

fantasies of blackness and heterosexual miscegenation.[11] (How far are we from the spin I have already put on Fanon's "double process"?)

To return, for a moment, to the two racial fantasies/dreams: In analyzing the second fantasy, Riviere refers to the woman's "'disguising herself' as merely a castrated woman." The gender masquerade is articulated through markers of race and class. In the dream the black man comes upon the woman "washing clothes, with her sleeves rolled up and arms exposed." Riviere glosses this position as "menial." If a dream is the fulfillment of a wish, this dream (or Riviere's "take" on it) represents a nightmare of downward mobility, the precipitous drop from performing menial tasks to "being" menial. Is this also to "be" merely a castrated woman? And, if so, are all women equally castrated—or equally "woman"?

> *Menial* (adj.): 1. of or relating to servants: LOWLY; 2a: appropriate to a ser-
> vant: HUMBLE, SERVILE <answered in ~ tones>; 2b: lacking interest
> or dignity <a ~ task> syn: see SUBSERVIENT.
> *Menial* (n.): a domestic servant or retainer.

In the American south (but not only there), where Riviere's patient spent her childhood, the class of domestic servants was disproportionately filled with black women and women from the white working class—a situation not so far different from our own day. In taking up the "menial rôle" customarily assigned to *other* women, Riviere's woman expresses an identification *with* blackness—and not simply a phantasmatic, heterosexualized desire *for* it, as represented by the spectral black man.[12]

For Riviere's patient, cross-class and cross-racial identifications may undercut the powerlessness the white woman experiences vis à vis the law of the father. As Mary Ann Doane has suggested (1991, 38), by rearticulating gender and sexual transgression in and through racial difference, the white analysand (not to mention her white analyst) may recuperate for herself both social power and racial privilege. This is *Oedipus Tyrannos* as reconceived by D. W. Griffith. Putting herself into the place of a lower-class woman, black or white, or a black man, the white woman can look back at and down on her other(ed) self. Because Riviere nowhere explicitly addresses the social conditions or historical context in which the woman's psychical defenses against anxiety are negotiated, she leaves out of consideration also questions of power, resistance, and complicity.

To extend Doane's re-reading of Riviere, there is yet another and interlocking field of power relations within which the woman and her analyst reinscribe—"code"—transgressive sexual desires and cross-gender identifications: heterosexuality. In both of the fantasies interpreted by Riviere, the white woman's sexual submission before the black man is ultimately made in the name of the father. In the first case, we learn that the woman feigns sexual

interest in the interloper "so that she could ultimately deliver him over to jus-
tice" (1986, 37). She thus resists the black man by faking sexual interest in him.
In the course of the second fantasy, however, the once-dutiful daughter has
turned this strategy on its head: "She resisted him, with the secret intention of
attracting him sexually." Here resistance is a sexual come-on, and the secret
plan to deliver the black man over to the father's law crumbles before the
secret wish to have the black man all to herself—a reversal that casts some
doubt on the justifications offered for the first phantasmatic surrender as well.

That a white woman might actively desire and willingly "submit" to a black
man cannot, however, be finally admitted. This (im)possibility is very quickly
displaced from the scene of analysis in favor of another more familiar, because
familial, drama of forbidden desires: the Oedipal tableau. The meaning of the
dream, Riviere tells us, relates *only* to the father and mother. The focus of
Riviere's reading shifts from the woman's sexual blandishments to her menial
occupation (washing clothes), shifts, that is, from a transgressive white female
sexuality to its domestication.

One of the effects of this displacement is the preservation of the prohibition
on incest as the founding law of language, culture, and sociality. Prohibitions on
miscegenation, whose limits the woman's fantasies might seem to be testing,
turn out to be "merely" precipitates of this prior taboo. Nonetheless, the
"whitening" of gender and sexuality is not complete, and it is not finally clear
that Riviere or her analysand can so easily short-circuit the race/gender sys-
tem. Something of the social consequences of interracial desire and, so, some-
thing of the psychical meaning of racial difference return to haunt Riviere's
reading of the second fantasy. The "expected shots through the window,"
which Riviere says signify the woman's terrified anticipation of her parents'
retribution, crystallizes one of the forms of terrorism practiced in "real life" by
white supremacists as well as by more "casual" racists and signals at what social
and psychic cost the wishful inviolability of whiteness is breached.

If, as Riviere herself allows, the woman's masquerades are guilt-ridden and
anxiety-driven compensatory acts for her masculine identifications, there is no
reason to assume that she identifies only with *white* masculinity. Perhaps the
woman's fantasies express not only a desire for the black man, but a wish to
be him. What Diana Fuss observes of Freud's hysteric and Fanon's phobic
white woman may also be true of Riviere's masquerading woman; that is,
Riviere's patient too "can apparently occupy in fantasy two or more positions
at once" (Fuss 1994, 31). But Riviere interprets her way round this cross-gen-
dered and cross-racial possibility. In both of the fantasy-scenarios Riviere ana-
lyzes, the black man is imagined (by Riviere or by her patient?) as seizing what
does not belong to him, the white man's daughter. But in the fuller course of
Riviere's analysis, it turns out that it is the *white woman* who is trespassing in
the father's place. Caught in the act of taking what did not properly belong to

her—the father's penis, totemic signifier of that other phallus—she metamorphoses once again, this time into "merely a castrated woman" and invites the black man's sexual advances. "In that guise," Riviere informs us, "the [black] man found no stolen property on her which he need attack her to recover and, further, found her attractive as an object of love" (1986, 38).

An identification between the white woman and the black man becomes still clearer when Riviere compares the woman's habit of enacting a hyperbolic femininity on the heels of addressing an audience of men to the anxious pose of the thief, who "will turn out his pockets and ask to be searched to prove that he has not the stolen goods" (38). Like the black man caught breaking and entering the white man's domain, the woman too has attempted to take what does not belong to her. If gender is a speech act, then Riviere's woman is a thief of language. In speaking publicly, she steals the phallus. Although Riviere does not pursue the links between sexual positioning and speech, she does—as Doane suggests—here lay the groundwork for Lacan's later views on symbolic exchange within language.[13]

The homosexual possibility latent in these fantasies of miscegenation—which all Riviere's and her analysand's efforts cannot finally suppress—surfaces (where else) in this overdetermined exchange of place and position, desire for identification. The woman enacts her desire for another woman by trading places with the black man, a figure who stands in for transgressive sexual desire. And if the white woman then shifts position again, to accept her socially determined "menial rôle"? Caught "within the circle of … negative narcissism" and melancholic identification, the woman becomes what she cannot have; she takes the place of the object she is forbidden to love (Butler 1990a, 53).

The "homosexual" is at once everywhere present and nowhere active in "Womanliness as a Masquerade." Her homosexuality comes down to and stops at cross-gendered identification with the masculine; same-sex desire drops out. Riviere does express surprise that her masquerading woman's intense identifications with men and masculinity should have stopped short of actively desiring and pursuing other women (39).[14] But her surprise is predicated on the assumption that identification with one "sex" necessarily produces or necessarily symptomatizes desire for the other.[15] If Riviere's analysis of womanliness as masquerade ignores race in order to privilege gender, it also, in the end, subsumes sexuality under gender.

Among the social pressures shaping and distorting this masquerading woman's mental life, the masculinist rules of her profession loom large. Recall, in this regard, Riviere's observation that until recently "intellectual pursuits for women were associated almost exclusively with an overtly masculine type of woman" (35). This is something of which Riviere would have had "intimate" knowledge, having herself ventured into a professional arena—psychoanalysis—whose (male) practitioners were very anxious about its (and their) mas-

culine qualifications.[16] Implicit in Riviere's analysis of the gendered difficulties encountered by women entering the professions is this interesting possibility: the sexist assumptions and attitudes of male colleagues potentially homosexualize all "public" women. Women who venture into man's professional arenas face recriminations (anticipated, actual, or phantasmatic) from their less than collegial male colleagues. (To state the obvious, the constraints Riviere describes are still much in force today.[17])

The predicament of women entering previously all-male professions supplies Riviere with "another case from everyday observation" from which to tease out the meaning of womanliness and its impostures. As with Riviere's featured case study, this superwoman too has successfully combined family and career; she is a "university lecturer in an abstruse subject which seldom attracts women" (39). (Given the historical moment of Riviere's writing and given also what she takes for granted in narrating the first woman's case history, it is safe to assume that this lecturer specializes in an "abstruse subject" that seldom *invites* women or men who are not white.) The sartorial signature of the lecturer's masquerade is the markedly feminine attire she puts on whenever she is lecturing to her colleagues; when she is addressing her students, her dress "properly" befits her professional role. When she speaks before her male colleagues, her manner of speech is, like her clothing, "marked by an inappropriate feature: she becomes flippant and joking, so much so that it has caused comment and rebuke. She has to treat the situation of displaying her masculinity to men as a 'game', as something *not real*, as a 'joke'" (39; emphasis in original). Riviere communicates her disapproval of this woman's behavior and polices her own: "She cannot treat herself and her subject seriously, cannot seriously contemplate herself on equal terms with men; moreover, the flippant attitude enables some of her sadism to escape, hence the offence it causes" (39). Does Riviere's upset at the woman's flippancy and gamesplaying (gamesmanship?) bespeak Riviere's own masquerade of womanliness? By criticizing the woman's lack of professionalism, Riviere represents herself as someone willing and able to play by men's rules.[18]

Because the female university lecturer is *not* on equal terms with the men in her audience, her unconscious performance is actually well tailored to her professional circumstances, a point also made by Heath (1986). Moreover, her joking presentation to men of the femininity they demand of her (as woman's representative) may constitute an embodied commentary on masculinity "itself." She returns it—masculinity, the phallus—to them as no less contrived, performed, artifactual than femininity (Heath 1986, 56). Despite (or perhaps because of) the fact that the joke is really on them, it is the woman who must bear the brunt of their inability (or refusal) to "get" the joke.[19] Either way, however, the female lecturer cannot win; she is damned if she does perform femininity in a place it does not belong *and* damned if she does not. As Biddy

141

Martin argues in an important 1994 essay and as the case of the female lecturer clearly shows, "the subordination of women does not follow simply from the failure to conform to convention, but also from the performance or embodiment of it" (106). Ultimately, masculinity and femininity are no joking matters, but may even be life and death performances.

The lecturer's feminine clothing is a defensive cover anxiously dispossessing her of the precious phallus. By bodily signaling—in speech and in dress—her submission to and *as* lack, she thereby keeps off the castration she fears to undergo (again) at the hands of the men in her audience. On the other side of this gender performative, the men can reassure themselves of phallic integrity and potency by rebuking and commenting on her misuse of speech. This is the Lacanian paradox that virile display should appear as feminine:

> ... it is in order to be the phallus, that is to say, the signifier of the desire of the Other, that a woman will reject an essential part of femininity, namely her attributes in the masquerade. It is for that which she is not that she wishes to be desired as well as loved. But she finds the signifier of her own love in the body of him to whom she addresses her demand for love. Perhaps it should not be forgotten that the organ that assumes this signifying function takes on the value of a fetish. (1977, 290-91)

The woman's feminine attire wards off not only her own castration anxiety, but the men's; by theatricalizing her lack, she gives them the mirage of phallic wholeness. Where this woman dresses up, Riviere's first patient dresses down. Yet, on Riviere's reading, they are both dressing with the "same" aim in mind: to defend against lack. To the degree that all *three* women—the two women discussed by Riviere and Riviere "herself"—have succeeded, at least in part, in penetrating the male barricades, perhaps the lack each woman is covering up is her lack of "lack."

The fact that the men take such offense at the female lecturer's over-the-top presentation suggests that her feminine dress and inappropriate speaking style simultaneously conceal and advertise her usurpation of masculine prerogatives, simultaneously conceal and advertise as well that no one finally has the phallus. Riviere elsewhere says that men suspect some "hidden danger" lurking behind the mask of womanliness (1986, 43). Is this hidden danger the fear of their own lack, which they project onto woman? A fear, then, that masculinity is no more real and no more intact than womanliness? Arguably, the "real," though suppressed, threat of womanliness as masquerade is this "truth" of masculinity. Manliness too is a pose; the phallus is an infinitely detachable, moving part (cf. Heath 1986, 55–56).[20]

Perhaps the fetishist's solution (Elizabeth Grosz's term) offers a way round the masculinist claims of Riviere's essay, in which masculinity and heterosexuality appear as the ungrounded ground of femininity's masquerade. In his

1927 essay on "Fetishism," Freud restricts woman's role in the fetishistic scenario to the part of overvalued object and/or metonymic signifier for the hopelessly absent maternal phallus. Female fetishism is, however, explicitly admitted in Freud's unpublished and recently rediscovered 1909 paper "On the Genesis of Fetishism" (rpt. as 1988).[21] In that "lost" essay, Freud names *all* women as belonging to a very particular class of fetishists:

> In the world of everyday experience, we can observe that half of humanity must be classed among the clothes fetishists. All women, that is, are clothes fetishists.... Only now we understand why even the most intelligent women behave defenselessly against the demands of fashion. For them, clothes take the place of parts of the body, and to wear the same clothes means only to be able to show what the others can show, means only that one can find in her everything that one can expect from women, an assurance which the woman can only give in this form. (1988, 156–57)

According to Freud, the assurance female dress offers is that the woman has all that a woman has (which is not all). But what if we re-read the "particularly feminine clothing" Freud's female fetishist and Riviere's woman lecturer put on as a fetish that goes both ways, his *and* hers. Re-reading this passage alongside Riviere's "Womanliness as a Masquerade" and through Lacan's "Signification of the Phallus" suggests that the assurance a "woman can only give a man in this form" is that he's got it and she hasn't. But the assurance is only needed because he does not really have "it" either. The masquerade of femininity covers up what neither the woman nor the man has in the first place. For there is no first place, and there is no *there* there, only its phantasmatic dislocations. Masculinity and femininity are both up for grabs.

143

NOTES

1 There is an important feminist literature on Riviere and the masquerade. Her essay has been put to use in formulating strategies of female spectatorship, female subjectivity, gender performatives, and subversive sexualities. For starters, see Mary Ann Doane, "Film and the Masquerade: Theorizing the Female Spectator" and "Masquerade Reconsidered: Further Thoughts on the Female Spectator" (both reprinted in Doane 1991); Judith Butler, *Gender Trouble: Feminism and the Subversion of Identity* (1990a); Gaylyn Studlar, "Masochism, Masquerade, and the Erotic Metamorphoses of Marlene Dietrich" (1990); and Luce Irigaray, *This Sex Which Is Not One* (1985b). Emily Apter takes a slightly less sanguine view of the feminist possibilities of "Womanliness as a Masquerade," in her *Feminizing the Fetish: Psychoanalysis and Narrative Obsession in Turn-of-the-Century France* (1991, esp. 65–98). See also Stephen Heath's "Joan Riviere

and the Masquerade," a strong companion piece to the 1986 reprinting of "Womanliness" (Heath 1986, 45–61).

2 Freud's own proposal for this phrase had been "man's discomforts in civilization" (qtd. in Heath 1986, 46). As Heath notes, a full-scale biography of Joan Riviere is yet to be written. In the meantime, a very brief version of her life may be found in Appignanesi and Forrester (1992, 352–65).

3 Riviere was also responsible for the four-volume *Collected Papers*, a series which was the prototype for the *Standard Edition*. The latter post–World War II project was headed by James Strachey.

4 Ernest Jones, letter to Sigmund Freud, 1 April 1922; letter 352 in Freud (1993, 465–68).

5 Upon concluding her analysis with Freud in 1924, Riviere was analyzed by Melanie Klein, whose works Riviere also translated and helped to popularize among English readers.

6 Jones's letter to Freud, 22 January 1922; letter 339 in Freud (1993, 453). Cf. Heath (1986, 45 and 59n2). Heath, following Brome's *Ernest Jones: Freud's Alter Ego*, incorrectly dates this letter 21 January 1921 (1986, 59n3).

7 Letter of 25 October 1918; qtd. in Heath (1986, 45).

8 Letter of 30 October 1918; qtd. in Appignanesi and Forrester 1992, 354.

9 In her desciption of all this new generation of superwomen are capable of, Riviere seems to count femininity "itself" as among the professional woman's career obligations: "They are excellent wives and mothers, capable housewives; they maintain social life and assist culture; they have no lack of feminine-interests, e.g. in their personal appearance, and *when called upon they can still find time to play the part of devoted and disinterested mother-substitutes* among a wide circle of relatives and friends" (36; emphasis added).

10 Compare Freud's analysis of "a child is being beaten" (1919) and Fanon's "a Negro is raping me" (1967, 178-79). In both cases, a conscious, third phase fantasy covers over an unconscious, second phase fantasy. Too predictably, the repressed content of the latter fantasy implicates the girl's forbidden incestuous wishes—for the father, Freud says; for the mother, Fanon implies. The answer Riviere supplies is mixed.

11 Riviere never tells us in so many words that her analysand is white, but she doesn't have to. One of the ways that whiteness makes itself known is by refusing to declare its "racial" identity as such.

12 I am not trying to establish the "truth" of my readings of these dreams as against the missed opportunities, or blind spots, of Riviere's. To the extent, however, that Riviere's understanding of womanliness as a masquerade depends upon the backgrounding of race, re-readings that squarely consider the co-implications of race and gender are not just necessary, but already too long delayed. My "rival" readings, then, are intended to lift up

the unstated assumptions underwriting Riviere's. This interpretive move should no more strain the credulity of my readers than Riviere's did and does hers.

13 Though neither Riviere nor Lacan pursues the implications of racial and class difference for this exchange, such meanings may be teased out of their accounts by following up the leads suggested by Fanon.

14 What homosexual desire Riviere does detect is unconscious. When the analysand's husband had an affair with another woman, Riviere's patient reports having had an intense identification with her husband (39). Riviere also notes: "It is striking that she had had no homosexual experiences (since before puberty with her younger sister); but it appeared during analysis that this lack was compensated for by frequent homosexual dreams with intense orgasm" (39).

15 If I have followed Riviere in calling her masculine woman "homosexual," this is not because I wish to repeat the collapse of sexuality into gender, desire into identification. Rather, I am attempting to expose and undermine the unstated premises of Riviere's analysis, compulsory heterosexuality (Adrienne Rich's term), within whose binary logic "masculine" subjects desire "feminine" objects—a point Judith Butler also makes in *Gender Trouble*.

16 At the same time that the low status of psychoanalysis vis à vis other medical specialties made it more open to women and (other) lay practitioners, its stigmatization as a "Jewish" science (which contributed to its low status) made its male practitioners, including Freud, all the more anxious to make it into—*engender* it as—a "hard" science. For "hard" science, read also: "masculine," "gentile." On the relegation of (male) Jewish medical practitioners to low status medical specialties—such as dermatology—and the effect that this had on the development of psychoanalysis, see Gilman (1987).

17 Exemplary notice of the ongoing and gendered policing of academic discourse is given in Martin Jay's censure of a new generation of women academics. In a 1993 essay on "The Academic Woman as Performance Artist," Jay criticizes the abandonment of the regulative ideal of neutral and disembodied critical discourse in which "persuasive ideas come before personal authority" (33). This regulative ideal has, he argues, been dangerously disrupted by recent moves on the part of some academic theorists towards blurring the line between "the warranted assertability" of their arguments and how they are making their arguments; "like performance artists, they make themselves—and the uproar they cause—into works of art" (28).

Though Jay does name some male academics who blur this line, he focuses his essay on the "clear dominance" of women among this new

class of academic performance artists, singling out for criticism Judith Butler, Jane Gallop, Avital Ronell, Eve Kosofsky Sedgwick, and Gayatri Chakravorty Spivak. In a particularly odd move, Jay accuses these academic guerrilla girls of preparing the way for Camille Paglia. If, Jay argues, Paglia can come in and, to the delight of audiences, erase the line between substantive commentary and public persona, this is because the likes of Butler, Gallop, Ronell, Sedgwick, and Spivak had already subverted the distinction between constative and performative utterances and, in so doing, had warmed up an audience for Paglia (32). Jay does not say that there is a causal line running from his five fall gals to Camille Paglia, but he does identify them as both principal contributors to Paglia's rise and representative figures for changing (for the worse) scholarly ideals.

But Jay's argument is itself dependent upon his effacement of some important and substantive distinctions, among them the vast differences in terms of theoretical and political commitments between Paglia's audience of address and the audiences variously addressed by Butler, Gallop, Ronell, Sedgwick, and Spivak. Paglia is not speaking to the same audiences who turn out to hear or read these other women. In linking his call for the restoration of a "neutral culture of critical discourse in which ... disembodied minds argue without reference to their corporeal ground" to a gender-specific critique of some academics who perform too much and too well (33), Jay's essay is uncannily reminiscent of Riviere's description of the consternation female academics may cause their male colleagues by masquerading in the open. (I am grateful to Mary Cappello and Jean Walton for bringing Jay's essay to my attention.)

18 The limitations set on Riviere's professional career by a male–dominated psychoanalytic establishment suggest that, however dutifully she may have played the game, she could never play it well enough. In this connection, it is interesting to note that Riviere was known, and even feared, for her sharp tongue. In a 1922 letter to Jones, Freud himself described her as "a real power and ... a concentrated acid" (qtd. in Appignanesi and Forrester 1992, 354). An image of Riviere as acid–tongued and acerbic recurs throughout their brief biographical sketch of her. Appignanesi and Forrester's uncritical reporting of this characterization of Riviere implicates them on the side of the university lecturer's male colleagues. Riviere, meanwhile, is put in the place of the beleaguered lecturer whose "unprofessionalism" she publicly rebukes in "Womanliness as a Masquerade."

19 For more on what is at stake in getting or not getting the joke, see Doane (1991, 39-43).

20 Given the success with which heterosexuality has (been) posed as the "norm," one might even say, along with Marjorie Garber, that it is the most thoroughgoing fetish of them all. Indeed, her question "Why is

fixation on the phallus not called a fetish when it is attached to a man?"
is answered: to secure the place of heterosexuality (1990, 46). Garber's
thematization of the fetish as a kind of theater or form of theatricaliza-
tion of the body fits in well with some of the themes explored in
"Womanliness as a Masquerade."

21 Handwritten notes for the 1909 lecture were taken by Otto Rand and
discovered in the Rand collection at Columbia University.

THE INCLUDED MIDDLE
Uncoupling Sex and Gender

… what constitutes masculinity or femininity is an unknown
characteristic which anatomy cannot lay hold of.

—Sigmund Freud,
"Femininity"

THE STEREOTYPE of the wishfully manly female homosexual has been a sta-
ple of sexology and psychoanalysis. She has also figured in political discourse
at both ends of the century (most recently as a favorite whipping "butch" of
the radical right) in order to mark out and contain deviations from cultural-
ly defined norms of womanliness and manliness. But there is an ambivalence
in Riviere's account, an uneasy sense that these borderline cases are in fact
much closer to the "normal" picture than has been realized or allowed. This
difficulty in finally drawing the line between the "pathological" and the "nor-
mal" has not only shaped the course of psychoanalytic discourse, but might
even be its generative conceit, as I will argue in more detail below.

For now let me simply suggest that this concern to draw and *hold* the line
between normal and "aberrant" continues to shape popular representations of
male homosexuality, lesbianism, and feminism. At this century's end, for

example, a certain (dis)taste for feminism has returned with all the force of the never repressed to signal at once the lesbian body and, on a grander scale, the menace that body poses for the "general public." In the words of Christian Coalition founder and one-time Presidential candidate Pat Robertson, "[Feminism] is about a socialist, anti-family political movement that encourages women to leave their husbands, kill their children, practice witchcraft, destroy capitalism, and become lesbians."[1] Within the terrified and violently eroticized political imaginary of Pat Robertson, the women's movement entire is caught *in flagrante delicto*, just one leather jacket removed from murder, magic, and monstrous intimacy. In this brave new world *chez* Robertson, the lesbian is *the* fantastic form of heterosexuality's failure. Her spectral shape means quite literally the death of the family and, in a hyperbolic sequence dizzying all logic, both causes and foretells the demise of civilization as "we" know it: the capitalist, Christian nation-state.

For sexology at the turn of the century, the figure of the female sexual invert provided the embodied occasion for heterosexualizing one woman's desire for another. Some sexologists sought the stigmata of female inversion in the invert body itself, feverishly (and fetishistically) aiming at the detection and measurement of enlarged clitorises, protruding labia minora, and erect nipples.[2] The sexological discourse of female sexual inversion elaborated a semiotics of the body to reveal and interpret the "more or less distinct trace of masculinity" that, in Havelock Ellis's view, was inscribed across the "actively inverted woman's" behavior, bodily carriage, and mental attitude (1936a [1897], 222).[3] Active female inverts are to be distinguished, on the one side, from those "mannish" women who "imitate men on grounds of taste and habit," but stop short of "sexual perversion." (These mannish types may be the non-kissing cousins to Jones's and Riviere's "intermediate types," who desire recognition of their masculinity from "other" men, but do not sexually desire "other" women.) On the other side, Ellis contrasts his actively inverted women with the "women to whom the actively inverted woman is most attracted." The latter are "always womanly" and are "the pick of the women whom the average man would pass by." Ellis's femmes "possess a genuine, though not precisely sexual, preference for women over men" (222).

Ellis's allowance that "mannishness" in women does not in every instance predict or go hand in hand with "sexual perversion" fails to break the chain of association between masculinity and same-sex object-choice in women. Set alongside his hairsplitting description of the "womanly" woman's "genuine, though not precisely sexual, preference for women," masculinity becomes a necessary, if no longer sufficient, distinguishing mark of female sexual inversion. The trace of masculinity may be more or less distinct, apparent to the untrained eye or visible only to the expert's gaze. However, that there must be

some sign of masculinity Ellis does not seem to question. Some female inverts literally embody their difference. So, for example, Ellis points to "a certain tonicity" and firmness of the inverted woman's muscles and repeats without comment Magnus Hirschfeld's observation that "two-thirds of inverted women are more muscular than normal women," while inverted men "often" have "weak" musculature (Ellis 1936a, 255). In other cases, Ellis argues, the inverted woman's "masculine element may, in the least degree, consist only in the fact that she makes advances to the woman to whom she is attracted and treats all men in a cool, direct manner ... " (222-23). In assuming what he is arguing for, namely that having and acting upon sexual desire for women is masculine, Ellis's ability to find the masculinity whereof he seeks is signed for in advance.

Ellis was not alone in reading through the body for the underlying masculinity of desire. Freud too stressed that the body offered, at best, equivocal evidence of sexual inversion, arguing that "sporadic secondary characteristics of the opposite sex are very often present in normal individuals, and that well-marked physical characteristics of the opposite sex may be found in persons whose choice of object has undergone no change in the direction of inversion" (1920, 154).[4] He also expressed his reservations concerning the "mental sphere" of *psychical* hermaphroditism (1905b, 141; cf. 1920, 170-71), although he failed to apply this caution to his own studies of *female* sexual inversion, or lesbianism. Thus Freud observed how in women "inversion of the sexual object [was] ... accompanied by a parallel change-over of the subject's *other* mental qualities, instincts and character traits into those marking the other sex" (1905b, 142; emphasis added). Freud not only implies that same-sex object choice is one mental quality among others symptomatic of psychical hermaphroditism, but, in so doing, he reinvests his elsewhere careful attempts to disentangle sexual instinct from sexual object with the normalizing power of heterosexuality.

In the first of his *Three Essays on the Theory of Sexuality*, Freud distinguishes among sexual instinct, sexual aim, and sexual object. Previous psychiatric theories had insisted on a constitutive link between the object and the aim of the sexual instinct, an insistence that effectively identified the specific object of the sexual instinct (normatively, a member of the "opposite" sex) as well as the specific aim (again normatively, reproductive genital intercourse) as the content of that instinct. From this perspective, same-sex object-choice was not merely a neutral difference with respect to object choice; it represented a deviation in *function* of the sexual instinct—a point both Arnold I. Davidson and Teresa de Lauretis have developed in greater detail in their readings of Freud's *Three Essays*.[5]

Freud, however, attempted to "loosen the bond that exists in our thought between instinct and object" (1905b, 148). He separated the sexual object from the sexual instinct by a refusal, albeit unevenly applied, to isolate inversion from the cycle of "normal" sexual development. At the juncture in Freud's argument

151

regarding sexual inversion where he seems poised to offer an aetiological account of it, he defers. In place of a "satisfactory explanation of the origin of inversion," Freud substitutes "a piece of knowledge which may turn out to be of greater importance to us than the solution of that problem [*sic*]" (146-47):

> Experience of the cases that are considered abnormal has shown us that in them the sexual instinct and the sexual object are merely soldered together—a fact which we have been in danger of overlooking in consequence of the uniformity of the normal picture, where the object appears to form part and parcel of the instinct. (148)

The sexual instinct is capable of taking *any* object. In a famous footnote added in 1915, Freud argues that "from the point of view of psycho-analysis the exclusive sexual interest felt by men for women is also a problem that needs elucidating and is not a self-evident fact based upon an attraction that is ultimately of a chemical nature" (146n). As he forces the "nature" and importance of the sexual object into the background of his theory of sexuality, Freud momentarily stops the slippage from the "normal picture" to normalization.

If the first essay, on the sexual aberrations, destabilized the "normal picture"—to wit, a human sexual desire innately predisposed to cross-sex object-choice and reproductive genital intercourse—its immediate sequels promote a more orthodox view. Moving from infantile sexuality to the transformations and promises of puberty, Freud effectively restores a normalizing function to sexual theory: a genitally focused heterosexuality returns as source and end of human sexual life. The final course of an individual's "sexual attitude," as Freud calls it, is an achievement negotiated through organic changes and, more importantly, psychic inhibitions or constraints. These psychical inhibitions are themselves shaped in reaction to social and inter-psychic forces, such as the "structures of morality and authority erected by society" (1905b, 231) and enshrined in and as the family cell. This might seem to suggest—as indeed Freud all but admits in the first essay—that heterosexuality is a cultural achievement, not a brute fact. However, in his recapitulation of the *Three Essays*, Freud appeals to the very normal picture he has earlier decentered. The perversions in their negative and positive forms (that is, the neuroses and the perversions, "properly so-called," Freud has set out in the essay on the sexual aberrations) retain the character of universal possibility, but with a twist. The "positive" perversions now represent a refusal to "progress" through the normal stages of sexual development and derive "not merely from a fixation of infantile tendencies but also from a regression to those tendencies as a result of other channels of the sexual current being blocked" (232n1).

Teresa de Lauretis has identified the structural ambivalence of Freud's theory of the perversions (1992). Following the logic of the first essay, the difference between normal sexuality and the perversions ought not be mea-

sured in terms of deviation. On Freud's own accounting, both would represent arrivals, or (temporary) endpoints, in a process whose ultimate destination is not so much preordained as achieved. Accordingly, in the first essay on the sexual aberrations, heterosexuality appears as one among many possible conclusions—albeit the one most frequently noticed—and not the manifest destiny of the sexual instinct. Nonetheless, in both the second and concluding essays, reproductive genital sexuality asserts itself as the guiding premise of sexual development. Here, the perversions constitute a falling backwards and apart. These contradictory claims, de Lauretis argues (1992, 227), concerning the role and status of the perversions do not so much reflect hypocrisy as they do Freud's inability to keep pace with his own theory.

Freud's failure to complete his own theoretical trajectory mirrors the structural failure he will impute to the perversions in the second and third essays: a falling backwards into a pre-Freudian worldview. If Freud defers before the strictures and structures of conventional morality and fails to follow through, he demonstrates, by way of his own example, the effectivity of the socially-mediated psychical inhibitions identified and elaborated in his "Summary" of the *Three Essays*: "Among the forces restricting the direction taken by the sexual instinct we laid emphasis on shame, disgust, pity and the structures of morality and authority erected by society" (231). Recent historical work on the imbrication of anti-Semitic stereotypes of the male Jew in pathologizing representations of sexual inversion suggests other reasons for Freud's inability to follow through.[6]

The perversions are the motor that drives Freud's theory of sexuality almost, but not quite, to the point of distraction. For Freud, the only way to glimpse the developmental course pursued by the sexual instinct is to trace its failures, namely those occasions where its component parts dissociate themselves in the perversions (231). Thus, in a perverse role reversal, Freud's master-narrative of sexuality is actually founded upon perversion. Normal sexuality becomes, as it were, a *back-formation* of the perversions (cf. Ellis 1936b, xxi). Moreover, inversion of sexual object stands in and (to redeploy Freud's own image) falls apart as the paradigmatic occasion of the perversions. Yet this theoretical centering of the perversions cannot hold, and he ultimately reinvests inversion, especially female inversion, with the markings of heterosexuality.

Although Freud allows that some male inverts or homosexuals may be virtually indistinguishable from "normal" (heterosexual) men (1905b, 144; 1920, 154), he cannot conceive a female homosexuality apart from gender inversion:

> It is only in inverted women that character-inversion of this kind [psychical hermaphroditism] can be looked for with any regularity. In men the most complete mental masculinity may be combined with inversion. (1905b, 142)

Or again:

> The position in the case of women is less ambiguous; for among them the active inverts exhibit masculine characteristics, both physical and mental, with peculiar frequency and look for femininity in their sexual objects—though here again a closer knowledge of the facts might reveal greater variety. (1905b, 145)

Intriguingly, by the time Freud gets around to pursuing this "closer knowledge of the facts" in the 1920 case study of homosexuality in a woman, male and female homosexuality will have changed places. Female homosexuals, who in the terms of his 1905 analysis constituted the "less ambiguous" case of sexual inversion, are now figured in a very different light: "Homosexuality in women, which is certainly not less common than in men, although *much less glaring...* " (1920, 147; emphasis added).[7] Freud did not change his mind on every point; in the 1920 essay, he still insists that in homosexual women, though not in homosexual men, "bodily and mental traits belonging to the opposite sex are apt to coincide" (154).

The relationship between female and male inversion, or homosexuality, bears further analysis.[8] I want to point to a certain tension in Freud's account. He insists upon the masculine cast of a female invert's desire. At the same time, Freud admits the regular occurrence of complete mental masculinity in men who take other men as their sexual objects. On one level, then, the structure of inversion in women and men is *not* symmetrical. In men, inversion of the sexual object does not regularly involve inversion of the subject's gender role. However, Freud's attention in both accounts is focused on what he calls the "active" invert, and activity for Freud means "masculinity." In a 1915 footnote, Freud is at pains to point out "that the concepts 'masculine' and 'feminine,' whose meaning seems so clear to ordinary people, are among the most confused that occur in science." Psychoanalysis employs these terms, he says, "in the sense of activity and passivity ... " (1905b, 219n). But he does insist that in human beings pure masculinity or femininity is not to be found either in a psychological or biological sense (219–20n1).[9] In the 1933 lecture on "Femininity," Freud concedes that his alignment of masculinity, activity, and libido is only a "conventional" one, reminding his readers, again, "There is only one libido, which serves both the masculine and the feminine sexual functions. To it itself we cannot assign any sex... " (131).

This concession notwithstanding, Freud's model for female sexual inversion remains beholden to the conventional coupling masculinity/activity and femininity/passivity. Within this master narrative, the object of desire, whatever the "actual" pairing, is by definition "passive" and by implication "feminine." Female and male inversion thus converge in the masculine agency and feminine direction of their desire. There is a sense, then, in which there is one model for inversion of object-choice: male. But the same may

not be said for inversion of sexual character. In this latter case, it is female inversion—where the active invert becomes something of a man—which "less ambiguously" and "with peculiar frequency" more "truly" merits the name.

By identifying the regular coincidence of "character-inversion" and same-sex object-choice in female inverts, Freud effectively reasserts the heterosexual and masculine trajectory of desire even as he transplants it to an anatomically sexed female body. If a woman sexually desired another woman, she desired her *as* a man. However abject that desiring subject, at least the heterosexual structure remains intact. "Feminine" women too could be accommodated within this schema. As *objects* of another woman's masculinized desire, these otherwise "normal" appearing women occupied the traditional feminine position of passivity—albeit in the rather less traditional circumstance of passivity before the advances of a mannish woman. Alternatively, their feminine narcissism encouraged any and all comers (Terry 1990, 322). But in neither case was the feminine partner granted any sexual subjectivity. Moreover, the exceptional status of her mannish lover only served to approve an alignment of femininity with passivity and narcissism.

The familiar coupling of masculinity and femininity, of anaclitic object-choice and narcissistic object-choice does preserve the heterosexual mandate (Freud 1920, 154)—although at significant cost to the binary scheme of masculinity and femininity. Freud retains the privilege of sexual activity and agency for things and persons "masculine" only by detaching masculinity from males; some women, he says, might love according to the masculine type. This allowance, in its turn, effectively uncouples gender from "sex" and separates "men" (and "their" masculinity) from males.

155

NOTES

1 Qtd. in *Time*, 7 September 1992: 22. The immediate context for Robertson's much-cited equation of feminism and lesbianism was his 1992 political campaign against an Iowa ballot measure to pass a state Equal Rights Amendment. The ballot measure was defeated.

2 On morphological patterns identified with female "sex variants," see Jennifer Terry (1990). For a select bibliography of medical literature on the size of the sexual organs of the female "invert," see George Chauncey, Jr., (1989, 113–14n50).

3 For a brief history of the 1898 criminal charges brought against *Sexual Inversion*'s English distributor, George Bedborough, for selling the "lewd, wicked, bawdy scandalous libel," see Weeks (1977, 57–67). No charges were brought against Ellis.

4 As early as 1905, Freud espoused a low opinion of the explanatory value of somatic and psychical hermaphroditism for inversion of sexual object-choice. See "The Sexual Aberrations," in 1905b, 142.

5 I am here condensing much of the argument of Arnold I. Davidson (1987) and Teresa de Lauretis (1992).

6 See chapter one of this study for a discussion of these issues and relevant bibliography.

7 For a reading of "The Psychogenesis of a Case of Homosexuality in Women" that calls attention to the evocative possibilities of *larmënd* ("glaring"), see Fuss 1993.

8 For suggestions that Freud's theory/ies of female homosexuality are all and only about male homosexuality, see Irigaray (1985a, 98–112) and Roof (1991, 191). Cf. Fuss's suggestions about the different oedipal orientations of Freud's theories of male homosexuality and female homosexuality (1993, esp. 64n2).

9 This is a point he stresses again in an even longer footnote added to *Civilization and Its Discontents* (1930 [1929], 105–6n3).

OEDIPUS REPS
Woman as Sequel

"Have you ever been mistaken for a man?"
"No, have you?"

—Conversation between male and female characters in
Aliens

If muscles make a man "masculine," what do they make a
woman?

—Video jacket of *Pumping Iron II: The Women*

SOME BODIES appear to test and strain beyond recognition boundaries between
masculinity and femininity. These are the muscled, "excessive" bodies on view
in professional bodybuilding—a job category that nominates the embodied
fictions I mean to flesh out below. I am particularly interested to consider the
ways in which hypermuscularity blurs the lines between "man" and "woman,"
original and sequel. In specifying the relations between musclemen and mus-
clewomen, as they operate in and upon a film and *its* sequel (*Pumping Iron* and
Pumping Iron II: The Women), I hope also to indicate that there is, finally, no
place to draw the line between "sex" and gender, identification and desire. It
is, of course, precisely this no man's land against which heterosexuality com-
pulsively defends itself.

As part of his ethnographic case study of male bodybuilding subculture,
anthropologist Alan Klein conducted a street-corner survey in a major north-

western city (he does not say which one).[1] He showed 105 women and 120 men photographs of male bodybuilders and asked them to rate the men's attractiveness on a scale of one to five, where one meant "extremely repulsive," and five meant "extremely attractive." The spin Klein placed on "attractive-ness" depended on the "sex" of the person interviewed. For women, he trans-lated "attractiveness" as "sex appeal." (Is he the sort of man you want to have?) For men, attractiveness meant "aesthetic interest." (Is he the sort of man you want to be?) Of the women surveyed, an overwhelming 94% rated the male bodybuilders "extremely repulsive." By contrast, only 49% of the men in Klein's sample gave the male bodybuilders the same rating. Additionally, whereas no women found the bodybuilders "extremely attractive," 10% of the men (it *would* be 10%) gave them the highest marks. Within the heterosexed parameters of Klein's survey, the "pumped up" male body was a dismal failure. It is not women, but men—especially other musclemen—who are drawn to it. What does woman want?

The insistence that bodybuilding will make a man more manly and, so, more attractive to women is one of the selling points of mainstream muscle mags.[2] Moreover, as more and more *women* have begun weight training, the anxious reassurance that muscles will not detract from a woman's essential femininity and "sex appeal" to men, but may even enhance them, has been no less ritualistically repeated.[3] (It is not to me clear whether these claims regard-ing the sex appeal of women's bodybuilding are intended primarily to assure would-be musclewomen *or* the men who desire them. Maybe both at once.) In bodybuilding's promise to enhance a man's manliness and a woman's wom-anliness, it straddles the fence between constructionism and essentialism: it will lift up and make bigger and better what was there all along. Or, as one of the female competitors says in *Pumping Iron II*, there is "a new me growing out of all these muscles." And if a man is turned off by her "new me"? "Men who can't handle women's muscles," she continues, "are insecure about their own masculinity."

If female hypermuscularity appears to pose an especial "problem" to the heterosexual contract of desire, this is, in large part, in too large part, because it erases the *seen* of sexual difference. Within the Freudian schema of sexual differentiation, what matters to the boy, as to the girl, is "the" visible difference between them—what he has and she doesn't. For the (male) fetishist, of course, the question is rather: does she or doesn't she. In either case, the phallus func-tions as the signal prop of masculinity's presumption to activity and wholeness. Female bodybuilding enacts at once the woman's claim to the phallus *and* no one's final hold on it. In a particular sense, in bodybuilding no one—whether "male" or "female"—has the phallus. Everyone wants to be the phallus, or, to use Marcia Ian's more colorful terms, everyone is striving to be "a fucking human penis" (1991).

Female hypermuscularity resists the conventional alignment of manliness, strength, and activity "versus" womanliness, weakness, and passivity—a point I will come back to. For now, I want to ask and tentatively answer this question: If heterosexuality depends, in large part, on the fiction of sexual difference, especially visible sexual difference, what should we make of musclewomen and their male admirers? One possible solution to this "problem" is the male fetishist's:

> Yes, in his mind the woman *has* got a penis, in spite of everything; but this penis is no longer the same as it was before. Something else has taken its place, has been appointed its substitute, as it were, and now inherits the interest which was formerly directed to its predecessor. (Freud 1927, 154; emphasis in original)

Preserving the maternal phallus—albeit in altered form—"saves the fetishist from being homosexual, by endowing women with the characteristic which makes them tolerable as sexual objects" (154). But the male fetishist's solution is also Freud's. That is, only by withholding the fetish from women can Freud preserve man's wished-for phallic integrity. It bears asking, with Marjorie Garber, why the phallus is a fetish only when it is *not* attached to a man (1990, 46). Drawing the musclewoman and the men who love her too much through the terms of Freud's fetishistic scenario: The armored body parts of the woman they love substitute for the woman's (the mother's) missing piece.

The solution I have just offered to the riddle of the musclewoman's "heterosexual" allure (if that is what it is) itself recapitulates Freud's masculinist terms. My point, however, is not to affirm the timeless "truth" of Freud's views. Rather, I mean to show that his way of looking at things underpins how contemporary culture makes sense of female bodybuilders and their male fans. If psychoanalysis-as-discourse is very much a product of its times, at this historical juncture we are no less a product of it. My invocation of psychoanalytic concepts thus represents an attempt to unsettle them and us in the process. In drawing bodybuilding through psychoanalysis, I mean also—I mean principally—to reverse direction, redrawing psychoanalytic theories of the feminine in the musclewoman's (and perhaps the muscleman's) image.

159

Conventionally speaking, muscled female bodies may "save" their male admirers from homosexual object-choice, but they do not head off insinuations of latent homosexuality for either the man or his putative object of desire. As Laurie Schulze writes: "The danger to male heterosexuality lurks in the implication that any male sexual interest in the muscular female is not heterosexual at all, but homosexual: not only is *she* 'unnatural,' but the female bodybuilder possesses the power to invert normal *male* sexuality" (qtd. in Holmund 1989, 42). Women who are attracted to female bodybuilding, either as participants or as fans, are correspondingly "lesbianized"—a point Holmund also makes. As I will make more clear below in my discussion of *male* hyper-

muscularity, musclemen too may be "homosexualized," suspected of hiding their homosexuality (read: "effeminacy") under a layer of muscles. Evidently, there is line beyond which muscularity may be too much of a good thing.

One index of bodybuilding's heterosexual insistence—and its failure—is the mixed pairs competition. Together, a man and a woman performatively declare the heterosexual intentions of the sport. They pose as a couple; they stage their mutual interest. The mixed pair is also the site (and the sight) of sexual difference. The man is bigger; he is more of everything. Just as, in the individual competition, points are awarded for achievement and display of proportionality between and among body parts, so in the mixed pair, points are given for displaying the proper, the proportionate symmetry and comple-mentarity not merely on each body, but *across* the two bodies.

What emerges most conspicuously from this heterosexual posturing is pre-cisely its sexual *in*difference. In my view, the pairing of male and female body-builders ultimately succeeds not in reaffirming sexual difference, but in desta-bilizing the very figurations of that difference. Markers of the masculine and feminine are still readable; but they are no longer "absolute" positions. There is even something ridiculous, to the point of embarrassment, about the whole affair. Rather than reasserting an essential difference (separating woman from man, femme from butch, boys from men), the proximity of her ripped physique to his achieves quite the opposite effect: it shows how contrived are the presumed differences between the two.

The mixed pair is trying too hard. They try to look interested in each other, but their "real" interest lies elsewhere. Each of them has shaped her or his body not in order to satisfy the other's desires, but to meet her own. The body has been refashioned, sculpted, in line with an idealized self-image. The "mutual interest," or sexual symmetry, which the event is supposed to demonstrate through and in its perfect shaping of heterosexuality, takes on a different aspect: narcissistic object-choice. What the mixed pair finally has in common, then, may be their point of reference; both male and female bodybuilders shape and refigure their bodies with an eye (or an "I") to an idealized self-image.

This is one way to look at the matter. But there is another version of sex-ual *in*difference that the mixed pairs competition and, indeed, female hyper-muscularity in general stage. This is the sexual indifference that derives woman from man, femininity from masculinity. Rather than blurring the difference between manliness and womanliness, male and female, sex and gender, this type of sexual indifference—as both Luce Irigaray (1985a) and Teresa de Lauretis (1988) have argued—positions woman as man's copy, his sequel as it were. How does this "other" perhaps more familiar sexual indifference work in bodybuilding? Klein suggests that the entry of women bodybuilders into the elite gyms and into both amateur and professional competitions has not challenged bodybuilding's self-image as male. Women have assimilated them-

selves to masculine ideals of bigger is better. Even where some women have sought to distance themselves from the "pernicious" connotations of hyper-muscularity, they have done so in the name of meeting male standards of acceptable muscle mass for women—albeit, "acceptable" in the redefined terms of bodybuilding subcultures.[4] It may well be the case, then, that female and male bodybuilders alike remake their bodies with an eye towards the "same" idealized body type, a man's. For the sake of argument, let's call this man "Arnold."

Arnold Schwarzenegger's role as the body that men most want to beat and to be is explicitly represented in *Pumping Iron* (1976). His function as muscle-*women's* ego ideal is on view in two cinematic sequels: *Pumping Iron II* (1984) and *Terminator II: Judgment Day* (1991). *Pumping Iron* documents the 1975 Mr. Olympia competition. It follows the mental and physical preparations of four men (Arnold Schwarzenegger, Lou Ferrigno, Franco Columbu, and Mike Katz) as they train for the most prestigious prize in men's professional body-building. Of these four, it is Schwarzenegger, the defending champion, who is the central figure of and *for* the 1976 film.[5] Arnold Schwarzenegger: a man whose "Christian" name, more than any other, has come to mean muscles; a man who is synecdochical whole for "cut" body parts. So powerful is Arnold's name that Lou Ferrigno, whom the film casts as the easily impressed ingenue, counts off his standing pectoral lifts not "one-two-three," but to the chant "Arnold-Arnold-Arnold." Ferrigno's desire to beat Schwarzenegger is matched only by his desire to *be* Schwarzenegger. Nor is Ferrigno the only Arnold wanna-be. As a series of magazine covers, all graced by Schwarzenegger, passes in front of the camera's "I" the voice of another Arnold-acolyte declares, wor-shipfully and wishfully: "That's the way I want to look." What does man want?

In *Pumping Iron*, Arnold is billed (and built) as the idealized image for a whole generation of younger male (and female?) bodybuilders, and, in this, his function resembles the one Freud attributed to the narcissistic ego ideal in his 1914 essay "On Narcissism." There, Freud argues that repressed libidinal impulses, such as self-love, are drawn up into the subject, where they consti-tute his ego ideal and are the foundation of conscience (93–96). Once estab-lished, the ego ideal substitutes for the lost narcissism of childhood, a time when he was his own ideal (94). Freud does offer one other example of the sort of libidinal impulses that are forcibly given up, then drawn into the for-mation of the ego ideal: homosexual object-choice (96). The prohibition on homosexual object-choice, which the ego ideal enforces, requires the subli-mation of homosexual feeling. Homosexuality retires in favor of homo*sociali-ty*. Since Freud elsewhere glosses male homosexuality as a case of narcissistic object-choice, it is not really clear if he is offering two different examples or two ways of looking at the same old story.[6] In either case, the transformations the ego libido and homosexual libido undergo in repression are, Freud says,

what enable social instincts to develop.[7] Changes in the former facilitate the formation of object-cathexes. Changes in the latter ensure that only the "right" objects are cathected.

At the risk of reinstating Freud's homophobic and misogynist identification of male homosexuality and narcissism, I want to suggest that the exemplary status Freud accords self-love and homosexual object-choice in the development of the ego ideal might actually be rearmed and reactivated to challenge the status quo of both *Pumping Iron* (the "original") and *Pumping Iron II* (the "sequel"). One of the things securing (in theory) the heterosexual fiction of male bodybuilding is the foregrounding of same-sex identification and the backgrounding of same-sex desire. For Arnold's clones, modeling themselves on him is the closest thing to being there for him, the next best thing, then, to being had by him. In other words: in a context, such as the bodybuilding subculture, in which homosexuality is *officially* under sanction, hero worship must do the work of all other forms of male-bonding.[8] (In this regard, bodybuilding is not so far different from a broader range of cultural institutions and practices which attempt to hold the line between male homosociality and homosexuality.)

According to Freud, a boy's hero worship follows the patterns first established within the Oedipal cycle, where object-love for the father is repressed in favor of an identification with him. As Jonathan Goldberg has argued in his trenchant reading of Arnold's cinematic corpus (1992), the role that Arnold most consistently occupies in *Pumping Iron* is that of the father-figure. For instance, Arnold dismisses the threat that the little man, Franco Columbu, represents to him at the upcoming championships: "Franco is a child, and when it comes to the day of the contest, I'm his father." Arnold also brushes Lou Ferrigno aside. On the day of the competition, Arnold plans to get Ferrigno alone and, in the guise of giving him good advice, put one over on him.

Arnold's strategy depends upon his ability to supplant Ferrigno's ever-present father, Mattie, and exercise paternal authority in his stead. But, on the day in question, Arnold does not have the younger Ferrigno all to himself. Instead, he breakfasts with both father and son. Throughout this meal, Arnold's fatherly "advice" for his young rival is directed through Mattie Ferrigno. At no point does Arnold address Lou directly. Does Arnold defer to the father, addressing him and him alone, so as all the more fully to infantilize and "psyche out" the son?[9] Or, more provocatively, does this speaking through the father betoken a courtly romance? Underneath all Arnold's body armor lurks a true gentleman, who will address his intended only through the father. Of course, it is precisely Arnold's "hidden" motives that the father should be worrying about.

Although Arnold will triumph over Mattie's son, the father need not worry on every score. As the prototype of the bodybuilder's bodily ego, Arnold requires no object nor subject outside himself:

162

> The most satisfying experience you can get in the gym is the pump.…
> It's like someone blowing air into it, into your muscles.… It's fantastic …
> as satisfying to me as coming is, you know, as having sex with a woman,
> coming. So can you believe how much I am in heaven? … I'm coming
> day and night.

That sex with a woman enters Arnold's panegyric to the "pump" as an after-thought gives the lie to the alloerotic claims of male bodybuilding. However, as against the notion that what Arnold's specification "with a woman" covers up is homosexual desire, I want to offer another reading. "Having sex with a woman" is a poor substitute for the real thing, for Arnold's pump, a point Goldberg also makes in his discussion of this scene (1992, 175–76). This helps to account also for Arnold's response to a female reporter at the Mr. Olympia competition concerning his special woman: "It really doesn't matter, as long as she has a good personality and is charming." *It really doesn't matter.* The multiple satisfactions of pumping up are Arnold's alone.

Goldberg suggests that part of what this scene declares is a displacement of phallic value from the penis to the body entire (175). He argues also against the reduction of Arnold's—or any other male bodybuilder's—muscular over-development to a simple case of overcompensation: the bigger the body, the smaller the dick. Rather than pointing to an inadequacy on a specific male body, the displacement and dispersal of phallic value indicates what Goldberg calls "an inadequacy within the Symbolic, a lack at the very site of the real-ization of the equation of penis and phallus" (176). This seems to me a very neat way to read and reintegrate the hypermuscular body, a body whose Herculean development has already cut it into discrete parts: abdomen, del-toids, quadriceps, biceps, pectorals. Even here, the shortened form is preferred: abs, delts, quads, bis, pecs. The phallus is everywhere on the muscle-bound body, because every part of his *or her* body has been transformed into a phal-lus. S/he has become *a fucking human penis.*

Resisting the pull to attribute male hypermuscularity to castration anxiety, in some form, has the surplus value of resisting also some familiar ideological associations between, for example, hypermasculinity and homosexuality in men. This is an association made by Joan Riviere, among others, who opined that "homosexual men exaggerate their heterosexuality as a 'defence' against their homosexuality."[10] Within the binary terms of compulsory heterosexuality, where same-sex identification orients cross-sex desire, one way to display het-erosexuality is to make the body's masculine signature more insistently visible. Riviere's suggestion (though not hers alone) is that homosexual men overplay their hand; their masculine displays cross into self-parody.

In the context of bodybuilding, the male bodybuilder seems an easy mark for such a virulently homophobic re-reading.[11] His excessive, even "compul-sive," attention to making his body bigger and buffer are interpretable as

163

strategies of exaggeration and evasion. Moreover, some of the techniques he employs to build a bigger, more manly body have side effects which might seem to contradict his claims to manliness. The anabolic steroids taken by so many bodybuilders, both professionals and amateurs, men and women, produce a range of visible and not-so visible symptoms. Acne and thin, brittle hair are common to both men and women who take steroids. In men, the side effects also include the development of breast tissue, shrinkage of the testicles, and anal bleeding. Additionally, as Klein reports, cessation of steroid use also poses hazards; the rapid change in the body's nitrogen level may negatively affect the body's ability to fight off infections and injuries (150). This combination of signs—from the shrinking testicles to anal bleeding to immune-system disorders—makes the hypermuscular male body over into a vector of HIV and, so, of "contaminated" masculinity. But this way of reading things—of, as it were, setting matters "straight"—is itself readable as a strategy of evasion and exaggeration, through which heterosexuality may recuperate itself and its masculine prerogatives by claiming to "know" the difference between "real" men and their pathetic "impostors."

I do not want to deny the possibility that, for some gay men, hypermuscularity is a reaction-formation of sorts. However, what they are defending against is not their "essential" effeminacy, but rather the conventional reading of their bodies as always already unmanned. In this respect, then, hypermuscularity does not compensate for homosexuality, but for *homophobia*. As D.A. Miller writes, "Though always the effect of homophobia, ... such ... acts are not always performed homophobically" (1992, 14).

There is, I believe, a way to unmask the hypermasculine male bodybuilder without falling back on the "usual suspects," without, that is, repeating the homophobic gesture I have just dangerously rehearsed. Revealing the muscleman for who and what he isn't need not assume the shape of homophobia, where the hypermasculine is revealed as an attempted (and failed) cover of the really "feminine," where the "really" feminine means effeminate, emasculated, homosexual. Rather, and this is the point I want to stress and develop here, unmanning the muscleman means *unmanning masculinity*. If masculinity belongs to no one and if the phallus is proper to no one's and no one body part, but is something men and women alike may put on or take off, then there are no men to "unman" (nor women to "man"). There are only "men" and "women," their bodies shaped in culture, not "sex." Indeed, the insistence that sharp lines may be drawn between masculinity and femininity, men and their "opposite" sex, is one of the ruses by which culture passes itself off as nature. Have you ever been mistaken for a man? Are only women mistaken for a man or might manliness "itself" be the chronic condition of being mistaken for a man?

Pumping Iron II: The Women puts this question into slightly different form: "If muscles make a man 'masculine,' what do they make a woman?" The film

dramatizes this question by focusing on two female bodybuilders, Rachel McLish and Bev Francis, as they prepare for the 1983 Ms. Olympia contest, at that time the richest prize in women's or men's bodybuilding. Continuing the either/or construction of its leading question, the film turns the contest into a contestation in meaning. On one side stands the "sultry and curvaceous Rachel McLish"; on the other there is "the almost manly, super-muscular Bev Francis, Rachel's toughest competitor."[12] The various personalities in the film—judges, competitors, spouses, and trainers, as well as the cinematic spectators—must all take a position for or against Bev, for or against "femininity."

Although it poses as documentary, *Pumping Iron II* is closer to a docudrama. One of the most suspense-filled sequences in the film, when Francis and McLish go head to head (or muscle to muscle) in the pose down, was a setup. According to Klein, Francis had not placed high enough to be called out on stage for the face-off (1993, 305n14). The filmmakers convinced the judges to let Francis return to the stage in order to enhance the dramatic structure of the film. The judges' willingness to comply with this request was a calculated move on the part of the International Federation of Bodybuilders (IFBB), whom the judges were representing. The IFBB hoped that *Pumping Iron II* would do for women's bodybuilding what *Pumping Iron* had done for men's: confer legitimacy on the sport *as* a sport and deflect the "freakish" associations of hypermuscularity.

Where the IFBB would not compromise was on the question where to draw the line between acceptable and unacceptable female musculature. The film follows Ben Weider, the chairman of the IFBB, as he instructs the judges what to look for in the competitors. He tells them to choose a woman "that's right down the middle. A woman that has a certain amount of aesthetic femininity, but yet has muscle tone to show that she is an athlete" (cf. Holmund 1989, 41). Though the film seems to take a younger male judge's side (and with him, Bev Francis's) as he challenges Weider to identify precisely what constitutes femininity's middle ground (like Potter Stewart drawing the line between "legitimate" and "obscene" representations, Weider knows it when he sees it), in this contest of male wills, one patriarchal and unyielding, the other enlightened and progressive, the older man will out. Weider's uncompromising position is reflected in the championship's final results: out of a field of eight competitors, Francis places last. She crossed the Maginot line of sexual difference. Nonetheless, Francis is the crowd's favorite. Her pumped up physique has wowed the mostly male audience; when her name is called out as the last place finisher, the decision is greeted by jeers.

Francis also wins over her two Steves (Michalik and Weinberger), the men who get her into top form for the competition. The film documents their first encounter with Bev Francis. The Steves are at the airport to meet Francis's flight from Australia. They have neither met nor, so we are told, even seen

pictures of her before. It will turn out that they have never seen anything like her. As the passengers deplane, Francis's two-man greeting party keeps a look-out for her. How will we recognize her, one Steve wonders aloud. They say she is big, responds the other. On the first occasion when they see Francis, nei-ther man can believe his eyes. "That's a woman! God, look at the size of her!" Steve Michalik exclaims. The other Steve gives a low whistle. They carry their disbelief through to the end, the film's end. "What did Tina Plakinger [the sec-ond-place finisher] have over Bev? What did Carla [the first-place finisher] have over Bev? You tell me," Steve Weinberger asks in utter disbelief. He can-not believe she lost; she was the biggest, the most muscular woman up there. He pleads his or her case three times: "You explain it to me. Explain it to me. Explain it to me." His demand to know brings the film's quest to uncover what woman is, and wants, full circle: "Can anyone tell me what those girls have that Bev doesn't?"

In Francis's case, the "problem" is that she has too much, not too little, of what the other "girls" have. Indeed, she has as much, if not more, as any (other) man. By placing Francis last, the judges can put as much distance as possible between women's bodybuilding and the figure the film everywhere points to, but nowhere names: the mythic mannish lesbian. The other women in the film also attempt to distance themselves from the lesbian's spectral shape.[13] The one female judge and many of the other female competitors decry what Francis is "doing to the sport." "A woman's a woman, and I think she should look like one," says another competitor. Where Francis's fellow (sister?) competitors are concerned, voicing their concerns over what Francis is doing to the sport serves to put still more distance between themselves and this other woman, who has gone "too far." Francis's is the path not to be taken.

One powerful exception to this gamesmanship is Carla Dunlap, the only black competitor and the woman crowned Ms. Olympia 1983. In what is to me an uncanny coincidence, this is also the year in which the first black Miss America, Vanessa Williams, was crowned. (Through a by-now familiar blend of racial and sexual politics, Williams would be "dethroned" some ten months into her "reign."[14]) Dunlap is openly sympathetic to Francis's position, perhaps because she too knows something about being subjected to the imperial stric-tures of white femininity. Dunlap also states her admiration for Francis's physique: "She's got muscularity that most men wish they had.... At some point I'd really like to look like Bev, but it's really on a different frame."

But Dunlap's first prize does not impress Francis's circle of male admirers. To return to Steve Weinberger's lamentation for Bev, which closes the film:

> Same old story. Just picking a pretty girl—what *they* call "pretty." Girl with no, well, Carla's got a little bit of muscle. It's not like she's a tooth-pick. But Tina Plakinger!? What did Tina Plakinger have over Bev? What

did Carla have over Bev? You tell me. Maybe I don't see nothin'. Maybe I'm stupid. You explain it to me. Explain it to me. Explain it to me.

Weinberger contrasts the bodily ideals of bodybuilding with those of "beauty pageants." By the standards of the former, he says, Bev should have been first pick. Carla Dunlap might win the latter contest, although Weinberger makes clear she would not be his first choice here either: "What *they* call pretty ... " It is not, I want to make clear, that Steve Weinberger or the film *Pumping Iron II* is intentionally racist. Rather, in the larger symbolic field within which the film signifies and is signified on, linking race, femininity, and aesthetics (read: "sex appeal") is never an innocent operation.[15]

If the film is worried that a woman's femininity declines in direct proportions to an increase in her muscle mass and definition, it seems to be no less concerned with the racial dimensions of muscularity and femininity. What is different about these two worries, however, is that *Pumping Iron II* is able to ask the former question openly. The latter problem is suppressed, expressible only in questions whose apparent referents are elsewhere. The visibility of racial difference might be one way to take pressure off the apparent disappearance of sexual difference that women's bodybuilding—especially Bev Francis's bodybuilding—enacts. But the femininity that matters to the film and to the IFBB is the white woman's, the straight white woman's. The rise and rapid fall of Vanessa Williams is instructive in this regard, as is Dunlap's very limited success in turning her Ms. Olympia title into commercial endorsements.

Ultimately, the anxious defense of white femininity that the film records (and exploits for its own ends) in its Greek chorus of judges and competitors overreaches. The film sets itself up as an investigation of the query, "If muscles make a man 'masculine,' what do they make a woman?" But the answer all parties involved agree *not* to name is "lesbian." Yet, the more they seek to keep off the "deviant" associations of muscularity, masculinity, and female homosexuality, the more they invite them. Among the management strategies the film deploys to keep the lesbian's spectral shape as far from the scene of women's bodybuilding as possible is its parallel tracking of another competitor, Lori Bowen, whose fiancé is always prominently featured. But, even here, the film blurs its own line. We see Bowen's fiancé at work, where he "works it" for pay. He is an exotic dancer—which makes Bowen "crazy" (whether with jealousy or shame, neither Bowen nor the film will say). She wants to win the contest, and its $25,000 first prize, so as to rescue him from a degrading job. The fable of a knight in shining armor, come to rescue the fair maiden in distress, is rewritten, its roles reversed. Bowen makes the heterosexual best of this situation, however. She makes amply clear throughout that her bodily recomposition is done for her man. In one scene, she even apologizes to him because their hotel room is pink.

Even Francis's hypermuscularity can be domesticated. In a fascinating 1991 article about her—an article billed on the cover of *Bodybuilding Lifestyles* as "Bev Francis: her most intimate interview"—the physical and emotional sensations Francis experiences while pumping iron are translated by the writer into terms that place her squarely within the trajectory of "normal" female sexual development: "She exudes the same radiance as that of a new parent showing off baby pictures" (Hayden 1991, 57). Francis as the phallic mother in the flesh? Only by the wildest stretch of imagination can what Francis actually said to her interviewer be made to fit the (stork's) bill:

> I can transform myself into an abstract form of energy, of totally concentrated strength and power and desire. Every ounce of my being—emotional, physical, and mental—is focused into my strength, into working with the weight to overcome gravity. (57)

Fascinatingly, this repackaged version of Arnold's pump (an experience that for him was unmediated, orgasmic bliss) fulfills, in Bev Francis's case, the teleological project of femininity. *She exudes the same radiance as that of a new parent showing off baby pictures.* However, if her "pump" is really analogous to his, as I believe it is, then the only way she could make issue in the gym would be by doing it all herself. Within the narcissistic terms of bodybuilding, reproduction is self-replicating, cloned. Perhaps the song "Future Sex," which accompanies the opening scenes and closing credits of *Pumping Iron II*, prefigures this brave new "maternal" development?[16]

For women, of course, the accusation of narcissism is an old story; repeating it here might seem to reinforce its ideological weight. However, for the "masculine" woman (who is so often read as a "lesbian") and for the lesbian (who may be readable as a lesbian only to the extent that she appears "mannish"), it is possible that claiming narcissism for this pair might actually function as a kind of reverse discourse.[17] The female bodybuilder, drawn to her own image above all, is a female narcissist, but with a difference. Her hypermuscularity, conventionally interpreted as a masculine sign, shakes up the equally conventional psychoanalytic alignments of narcissism with the feminine, and female sexual inversion with (regressive) female masculinity. This is, I hasten to add, a discursive strategy beholden to convention. But it is not, or so I hope, its "clone." This narcissism with a difference may also resist the splitting of self-love and object-love, identification and desire. In her reading of female narcissism, Kaja Silverman goes so far as to suggest that "[it] may represent a form of resistance to the positive Oedipus complex, with its inheritance of self-contempt and loathing" (154). In other words, female narcissism represents a refusal to enter into symbolic oedipalization, a refusal to consent to its prescription of some objects and proscription on others—more familiarly known as the heterosexual contract. In a politico-cultural climate where

the re-fortification and re-institutionalization of oedipal relations proceeds with a vengeance (I mean here to invoke another contract, the Republican's contract *on* America) the unsettling possibilities of female narcissism—for theory and for politics—seem to me worth pursuing further.

As a first move in this strategy to reclaim and resignify narcissism for lesbians (and all women?), let me argue from negation and show how *Pumping Iron II* tries to shut down these possibilities, tries, that is, to insure that women-identified-women stop short of desiring other women. The woman–woman identification foregrounded by the film runs between Lori Bowen and Rachel McLish. Bowen models her entire look, from her coiffure down to her poses, on McLish. McLish is also supposed to be men's preferred object-choice. According to Charles Gaines, author of *Pumping Iron: The Art and Sport of Bodybuilding* (1981) and *Pumping Iron II: The Unprecedented Woman* (1984), the future of female bodybuilding is a question of "how well it can be marketed to the general public—on how many women can be made to want to look like ... Rachel McLish, and, to a lesser degree, on how many men can be made to want to sleep with them" (qtd. in Holmund 1989, 48). So, the crossover success of female bodybuilding depends less on what men want in a woman and more on the sort of woman women want—to be like, Gaines suggests. It depends, then, on making sure that identification does not get crossed with desire. Or vice versa.

Pumping Iron II's ability to up-end and refigure the opposition between wanting to have and wanting to be is constrained in advance by its dependence on an apparently self-generated "original": *Pumping Iron* (the men). When measured against the "original," "women" are but the sequel of the man. This coupling of *Pumping Iron* and *Pumping Iron II* may even recuperate heterosexuality's losses. In *this* mixed pair, the muscleman comes first. Masculinity here poses as the authorizing condition of female hypermuscularity. This reconstitution of masculinity as ungrounded ground warns against investing too much in whatever subversive possibilities female hypermuscularity might open up.

However, it is not a matter of deciding whether the musclewoman (or the muscleman) represents progress or status quo. Attending to the places where hypermuscularity resists and reasserts Oedipal reps may open a window onto the political and psychical register of the body. As Marjorie Garber argues with respect to transsexualism (1992, 110), I want to say of hypermuscularity: If we want to know what and how gender means we need to look to the limits, to bodies and subjectivities not amenable to "simple" classification or even reclassification, once for all. Paradoxically, then, it is these borderline bodies that catch *us*, in flagrante delicto, in our own self-generative fictions.

During one of my own very frequent sessions at the gym, I had occasion to witness a scene of identification and desire. Four boys, two black and two

white, each poised on the precipice of puberty, entered the free weight room where I was (as usual) the only woman to be seen. The boys paused to watch a twenty-something white man, who was pressing well more than his weight in iron. To their excited exclamations—"Look how much weight he's lifting!" and "Wow, he can lift all that!"—the man did as they said: belt tightened, buttocks pressed to the bench, bar extended to the finish. The perfect specular object of admiration and emulation, he completed his performance by teasing the boys—"Do you want to give it a try?"—and telling or perhaps warning them that "the bigger you are, the smaller you look." The boys tried their lesson out on me. As I was finishing a set of curls, the boys stopped to watch and measure my "performance." Said one boy to another: "She's bigger than you are." In light of the man's fatherly advice to the boys, it was (and remains) unclear to me just *who* was being displaced from "being" to "seeming" in this exchange.

The phantasmatic pulse of identification and desire on display in this Oedipal scene of manly tutelage, the boys identifying with and desiring manliness, is part of what it means to idealize someone or something. The uncertain impulses of desire and identification are also, I want to stress, what it means to be a subject. Within the binary schema of identification "versus" desire, masculinity "versus" femininity, white "versus" black, having "versus" being, us "versus" them: bodies bear the burden of signification. If they are the surface onto which sexual and, as I have also argued, racial differences are projected, this may be because they are its first and last point of reference. As Freud says, "[T]he ego is first and foremost a bodily ego."[18]

If I have played up and played out the ways certain bodily performances—Bev Francis's, Anna Deavere Smith's, Sandra Bernhard's, and, of course, Freud's—may interrupt and unsettle binary logic, I also recognize the limits on my own analysis. Trying to play the bedeviled terms of gender, race, and sexuality from the inside out may result in reinforcing those terms as the only game in town. But they *are* the only game in town. The task is to repeat and reiterate them in a way that undoes them—and not "us." To repeat, with a difference.

NOTES

1 See Klein (1993, 216).

2 A point Klein also makes (1993, 137–55).

3 See Schulze (1990).

4 See Klein (1993, 159–93). However, Klein does not consider the impact of race on what counts as acceptable female musculature.

5 *Pumping Iron*, dir. George Butler and Robert Fiore, White Mountain Films, 1976. That Schwarzenegger is part for filmic whole is indicated by his imposing presence in advertising for *Pumping Iron*. On the sleeve of

the 1992 home video, for example, Schwarzenegger is the sole figure; his body, pictured from the belly up, is cut out against a black backdrop; he stares icily at the viewer, his right arm flexed in classic bodybuilding form. Nor is Schwarzenegger's prominence in promotional materials for the home video version a later development—a delayed reaction to his commercial success in such films as *Running Man, Terminator, Terminator II,* and *Total Recall.* Schwarzenegger received star billing for *Pumping Iron,* his first film, at the time of its initial release.

6 For Freud's identification of (male) homosexuality and narcissism, see *Psychoanalytical Notes on an Autobiographical Account of a Case of Paranoia,* also known as *The Case of Schreber* (1911, 60–61), and "Some Neurotic Mechanisms in Jealousy, Paranoia and Homosexuality" (1922, 230–32).

7 See, for example, *Group Psychology* (1921, 141) and "Some Neurotic Mechanisms in Jealousy, Paranoia and Homosexuality" (1922, 231–32).

8 Klein documents the prevalence of "gay" sex for pay in the elite gyms he studied. Many of the younger male bodybuilders would more or less occasionally (depending on their economic situations) take on male clients, through whom they subsidized their expensive training regimens.

9 This is Goldberg's reading. For his analysis of Arnold's paternalism with regard to Columbu and Ferrigno, see 1992, 173–75.

10 Riviere bases this claim on the research of Sándor Ferenczi. See "Womanliness as a Masquerade" (1986, 35).

11 For one white gay man's feminist critique of the "gay male gym body," so-called, which does not depend upon a homophobic elision of gender identification and sexual object-choice, see Paul B. Franklin, "Orienting the Asian Male Body in the Photography of Yasumasa Morimura" (forthcoming).

12 Quoted from the jacket cover for the home video.

13 Marjorie Garber also points to the "consternation" Bev Francis's appearance causes for "the on-lookers—and [for] the other competitors" (1992, 345).

14 For a reading of the cultural forces that combined to bring Williams's "reign" to an end, see Goldsby (1993).

15 This is a point that Christine Holmund also makes in her essay "Visible Difference and Flex Appeal: The Body, Sex, Sexuality, and Race in the *Pumping Iron* Films" (1989, 46–47). Holmund acknowledges black feminist Gloria Joseph for helping her to see how linking race and femininity is never a neutral procedure.

16 Holmund is also interested in the work this anthem does (1989, 47).

17 For the difficulty of making the "femme" appear, see Teresa de Lauretis, "Sexual Indifference and Lesbian Representation" (1988).

18 Freud, *The Ego and the Id* (1923, 26). Compare Butler's use of this passage in 1993a, 59.

171

WORKS CITED

Adam, Barry D. 1978. *The Survival of Domination: Inferiorization and Everyday Life*. New York: Elsevier.

Alarcón, Norma. 1990. "The Theoretical Subject(s) of *This Bridge Called My Back* and Anglo-American Feminism." *Making Face, Making Soul/Haciendo Caras: Creative and Critical Perspectives by Feminists of Color*. Ed. Gloria Anzaldúa. San Francisco: Aunt Lute. 356–69.

Allis, Sam. 1991. "An Eye for an Eye." *Time,* 9 September: 20.

Anzaldúa, Gloria, ed. 1990. *Making Face, Making Soul/Haciendo Caras: Creative and Critical Perspectives by Feminists of Color*. San Francisco: Aunt Lute.

Appiah, K. Anthony. 1992. *My Father's House: Africa in the Philosophy of Culture*. New York: Oxford University Press.

Appignanesi, Lisa and John Forrester. 1992. *Freud's Women*. New York: Basic Books.

Apter, Emily. 1991. *Feminizing the Fetish: Psychoanalysis and Narrative Obsession in Turn-of-the-Century France*. Ithaca: Cornell University Press.

Aschheim, Steven E. 1985. "'The Jew Within': The Myth of 'Judaization' in Germany, 1904–38." *The Jewish Response to German Culture: From the Enlight-enment to the Second World War*. Ed. Jehuda Reinharz and Walter Schatzberg. Hanover, New Hampshire: University Press of New England. 212–41.

Bakan, David. 1990. *Sigmund Freud and the Jewish Mystical Tradition*. London: Free Association Books.

Beck, Melinda. 1991. "Bonfire in Crown Heights: Blacks and Jews Clash Violently in Brooklyn." *Newsweek*, 9 September: 48.

Berlant, Lauren and Elizabeth Freeman. 1993 "Queer Nationality." *Fear of a Queer Planet: Queer Politics and Social Theory*. Ed. Michael Warner. Minneapolis: University of Minnesota Press. 193–229.

Bernhard, Sandra. 1988. *Confessions of a Pretty Lady*. New York: Harper and Row.

———. 1993. "Egos and Ids: Goodbye to All That Cool Stuff." Interview by Degen Pener. *New York Times*, 8 Aug., sec. 9: 4.

Bernhardt, Sarah. 1907. *My Double Life: Memoirs of Sarah Bernhardt*. London: William Heinemann.

Bhabha, Homi. 1987. "What Does the Black Man Want?" *New Formations* 1 (Spring): 118–124.

———. 1994. *The Location of Culture*. New York: Routledge.

Boyarin, Daniel. 1994a. "Épater L'Embourgeoisement: Freud, Gender, and the (De)Colonized Psyche." *Diacritics* 24.1 (Spring): 17–41.

———. 1994b. "What Does a Jew Want?: The Phallus as White Mask." Forthcoming essay.

———. 1995. "Freud's Baby, Fliess's Maybe: Homophobia, Anti-Semitism, and the Invention of Oedipus." *GLQ: A Journal of Lesbian and Gay Studies* 2.1–2 (Winter–Spring): 115–47.

———. 1996. *Unheroic Conduct: The Rise of Heterosexuality and the Invention of the Jewish Man*. Berkeley: University of California Press. Forthcoming.

Briggs, Sheila. 1985. "Images of Women and Jews in Nineteenth- and Twentieth-Century German Theology." *Immaculate and Powerful: The Female in Sacred Image and Reality*. Ed. Clarissa W. Atkinson, Constance H. Buchanan, and Margaret R. Miles. Boston: Beacon Press. 226–59.

Butler, Judith. 1990a. *Gender Trouble: Feminism and the Subversion of Identity*. New York: Routledge.

———. 1990b. "Performative Acts and Gender Constitution: An Essay in Phenomenology and Feminist Theory." *Performing Feminisms: Feminist Critical Theory and Theatre*. Ed. Sue-Ellen Case. Baltimore: Johns Hopkins University Press. 270–82.

———. 1990c. "The Force of Fantasy: Feminism, Mapplethorpe, and Discursive Excess." *differences: A Journal of Feminist Cultural Studies* 2.2 (Summer): 105–25.

———. 1991. "Imitation and Gender Insubordination." *Inside/Out: Lesbian Theories, Gay Theories*. Ed. Diana Fuss. New York: Routledge. 13–31.

———. 1993a. *Bodies that Matter: On the Discursive Limits of "Sex"*. New York: Routledge.

———. 1993b. "Critically Queer." *GLQ: A Journal of Lesbian and Gay Studies* 1.1: 17–32.

Caldwell, Paulette M. 1991. "A Hairpiece: Perspectives on the Intersection of Race and Gender." *Duke Law Journal* 2: 365–95.

Carpenter, Edward. 1956. [1908]. "The Intermediate Sex: A Study of Some Transitional Types of Men and Women." *Homosexuality: A Cross Cultural Approach*. Ed. Donald Webster Cory. New York: The Julian Press. 139–204.

———. 1975 [1914]. *Intermediate Types Among Primitive Folk: A Study in Social Evolution*. New York: Arno Press.

174

Colombier, Marie. 1884. *The Memoirs of Sarah Barnum*. Trans. Ferdinand C. Valentine and Leigh H. Hunt. New York.

Carson, Claybourne, Jr. 1984. "Blacks and Jews in the Civil Rights Movement." *Jews in Black Perspectives: A Dialogue*. Ed. Joseph R. Washington, Jr. London and Toronto: Associated University Presses. 113–131.

Chauncey, George, Jr. 1989. "From Sexual Inversion to Homosexuality: The Changing Medical Conception of Female 'Deviance.'" *Passion and Power: Sexuality in History*. Ed. Kathy Peiss and Christina Simmons. Philadelphia: Temple University Press. 87–117.

Clines, Frances X. 1992. "At Work With Anna Deavere Smith: The 29 Voices of One Woman in Search of Crown Heights." *New York Times*, 10 June, late ed., sec. C: 1.

Combahee River Collective. 1983. "The Combahee River Collective Statement." *Home Girls: A Black Feminist Anthology*. Ed. Barbara Smith. New York: Kitchen Table Press. 272–282.

Davidson, Arnold I. 1987. "How to do the History of Psychoanalysis: A Reading of Freud's *Three Essays on the Theory of Sexuality*." *The Trial(s) of Psychoanalysis*. Ed. Françoise Meltzer. Chicago: University of Chicago Press. 39–64.

De Beauvoir, Simone. 1989. *The Second Sex*. New York: Vintage.

De Lauretis, Teresa. 1988. "Sexual Indifference and Lesbian Representation." *Theatre Journal* 40: 155–77.

———. 1989. "The Essence of the Triangle or, Taking the Risk of Essentialism Seriously: Feminist Theory in Italy, the U.S., and Britain." *differences: A Journal of Feminist Cultural Studies* 1.2 (Summer): 3–37.

———. 1992. "Freud, Sexuality, and Perversion." *Discourses of Sexuality: From Aristotle to AIDS*. Ed. Domna Stanton. Ann Arbor: University of Michigan Press. 216–234.

Deutsch, Helene. 1944. *The Psychology of Women: A Psychoanalytic Interpretation, Volume One*. New York: Grune and Stratton.

Diamond, Elin. 1989. "Mimesis, Mimicry, and the 'True-Real.'" *Modern Drama* 32.1 (March): 58–72.

———. 1990. "Refusing the Romanticism of Identity: Narrative Interventions in Churchill, Benmussa, Duras." *Performing Feminisms: Feminist Critical Theory and Theatre*. Ed. Sue-Ellen Case. Baltimore: Johns Hopkins University Press. 92–105.

Diamond, Elin. 1992. "The Violence of 'We': Politicizing Identification." *Critical Theory and Performance*. Ed. Janelle G. Reinelt and Joseph R. Roach. Ann Arbor, MI: University of Michigan Press. 390–98.

Dimock, George. 1994. "The Pictures Over Freud's Couch." *The Point of Theory: Practices of Cultural Analysis*. Ed. Mieke Bal and Inge E. Boer. New York: Continuum; Amsterdam University Press. 239–50.

Doane, Mary Ann. 1991. *Femmes Fatales: Feminism, Film Theory, Psychoanalysis*. New York: Routledge.

Du Bois, W. E. B. 1994. *The Souls of Black Folk*. Mineola, New York: Dover.

Edelman, Lee. 1991. "Seeing Things: Representation, the Scene of Surveillance, and the Spectacle of Gay Male Sex." *Inside/Out: Lesbian Theories, Gay Theories*. Ed. Diana Fuss. New York: Routledge. 93–116.

———. 1994. *Homographesis: Essays in Gay Literary and Cultural Theory*. New Yok: Routledge.

175

Eilberg-Schwartz, Howard. 1994. *God's Phallus and Other Problems for Men and Monotheism*. Boston: Beacon Press.

Ellis, Havelock. 1936a. *Sexual Inversion*. 3rd ed. In *Studies in the Psychology of Sex*. Vol. 1. New York: Random House.

———. 1936b. Foreword to *Studies in the Psychology of Sex*. Vol. 1. New York: Random House.

Evanier, David. 1991. "Invisible Man: The Lynching of Yankel Rosenbaum." *New Republic,* 14 October: 21–26.

Fanon, Frantz. 1963. *The Wretched of the Earth*. Trans. Constance Farrington. New York: Evergreen-Grove Press, 1991. Trans. of *Les Damnés de la Terre*. (1961). Paris: François Maspero.

———. 1964. *Toward the African Revolution*. Trans. Haakon Chevalier. New York: Evergreen-Grove Press, 1988.

———. 1967. *Black Skin, White Masks*. Trans. Charles Lam Markmann. New York: Evergreen-Grove Press, 1982. Trans. of *Peau Noire, Masques Blancs*. (1952). Paris: Editions de Seuil.

———. 1973. "[Letter] To Richard Wright." 6 January 1953. Reprinted in *Richard Wright: Impressions and Perspectives*. Ed. David Ray and M. Farnsworth. Ann Arbor: University of Michigan Press. 150.

Feuchtwang, Stephen. 1987. "Fanonian Spaces." *New Formations* 1 (Spring): 124–30.

Foucault, Michel. 1980. *History of Sexuality*, Volume I: *An Introduction*. Trans. Robert Hurley. New York: Vintage Books.

———. 1991. "Governmentality." *The Foucault Effect: Studies in Governmentality*. Ed. Grahem Burchell, Colin Gordon, and Peter Miller. Chicago: University of Chicago Press. 87–104.

Frankenberg, Ruth. 1993. *White Women, Race Matters: The Social Construction of Whiteness*. Minneapolis: University of Minnesota Press.

Franklin, Paul B. 1996. "Orienting the Asian Male Body in the Photography of Yasumasa Morimura." *The Passionate Camera: Photography and Formations of Desire*. Ed. Deborah Bright. Forthcoming.

Freedman, Barbara. 1990. "Frame-Up: Feminism, Psychoanalysis, Theatre." *Performing Feminisms: Feminist Critical Theory and Theatre*. Ed. Sue-Ellen Case. Baltimore: Johns Hopkins University Press. 54–76.

Freud, Sigmund. 1955. *The Standard Edition of the Complete Psychological Works of Sigmund Freud*. Ed. James Strachey. Trans. James Strachey et al. 24 vols. London: Hogarth Press and the Institute of Psycho-Analysis.

[1886]. "Report on My Studies in Paris and Berlin." 1: 5–15.

[1893]. "Charcot." 3: 11–23.

[1900]. *The Interpretation of Dreams*. 4 and 5: 1–625.

[1901]. *The Psychopathology of Everyday Life*. 6.

[1905a]. *Fragment of an Analysis of a Case of Hysteria*. 7: 7–122.

[1905b]. *Three Essays on the Theory of Sexuality*. 7: 130–243.

[1905c]. *Jokes and their Relation to the Unconscious*. 8: 9–236.

[1908]. "On The Sexual Theories of Children." 9: 209–26.

[1909a]. "Some General Remarks on Hysterical Attacks." 10: 229–34.

[1909b]. *Analysis of a Phobia in a Five-Year-Old Boy*. 10: 5–149.

[1914a]. "Remembering, Repeating, and Working-Through (Further Recommendations on the Technique of Psycho-Analysis II)." 12: 147–56.

[1914b]. " On Narcissism: An Introduction." 14: 73–102.

[1915]. "A Case of Paranoia Running Counter to the Psycho-Analytic Theory of the Disease." 14: 263–72.

[1916–17]. "The Libido Theory and Narcissism." *Introductory Lectures on Psycho-Analysis* (Lecture XXVI). 16: 412–30.

[1917a]. "Mourning and Melancholia." 14: 243–58.

[1917b]. "On Transformations of Instinct as Exemplified in Anal Erotism." 17: 127–33.

[1918]. "The Taboo of Virginity." 11: 193–208.

[1919]. "A Child is Being Beaten." 17: 179–204.

[1920]. "The Psychogenesis of a Case of Homosexuality in a Woman." 18: 147–72.

[1921]. *Group Psychology and the Analysis of the Ego.* 18: 69–143.

[1922]. "Some Neurotic Mechanisms in Jealousy, Paranoia and Homosexuality." 18: 223–32.

[1923]. *The Ego and the Id.* 19:12–66.

[1925]. "Some Psychical Consequences of the Anatomical Distinction Between the Sexes." 19: 248–58.

[1926]. "The Question of Lay Analysis: Conversations with an Impartial Person." 20: 183–258.

[1927]. "Fetishism." 21: 152–57.

[1930]. *Civilization and Its Discontents.* 21: 64–145.

[1931]. "Female Sexuality." 21: 225–43.

[1933]. *New Introductory Lectures on Psycho-Analysis.* 22: 5–182.

[1937]. "Constructions in Analysis." 23: 257–69.

[1939]. *Moses and Monotheism.* 23: 7–137.

[1942]. "Psychopathic Characters on the Stage." 7: 305–10.

———. 1960. *Letters of Sigmund Freud.* Ed. Ernst L. Freud. Trans. Tania and James Stern. New York: Basic Books, Inc.

———. 1985. *The Complete Letters of Sigmund Freud to Wilhelm Fliess, 1887–1904.* Ed. and Trans. Jeffrey Moussaieff Masson. Cambridge: Harvard University Press.

———. 1987. *A Phylogenetic Fantasy: Overview of the Transference Neuroses.* Ed. Ilse Grubrich-Simitis. Trans. Axel Hoffer and Peter T. Hoffer. Cambridge: Belknap Press–Harvard University Press.

———. 1988. "Freud and Fetishism: Previously Unpublished Minutes of the Vienna Psychoanalytic Society." Ed. and Trans. Louis Rose. *Psychoanalytic Quarterly* LVII: 147–66.

———. 1993. *The Complete Correspondence of Sigmund Freud and Ernest Jones, 1908–1939.* Ed. R. Andrew Paskauskas. Cambridge: Belknap Press–Harvard University Press.

"Funny Face." 1992. *The Face,* Sept.: 40–46.

Fuss, Diana. 1989. *Essentially Speaking: Feminism, Nature, and Difference.* New York: Routledge.

———. 1992. "Fashion and the Homospectatorial Look." *Critical Inquiry* 18: 713–37.

———. 1993. "Freud's Fallen Women: Identification, Desire, and 'A Case of Homosexuality in a Woman'." *Fear of a Queer Planet: Queer Politics and Social Theory.* Ed. Michael Warner. Minneapolis: University of Minnesota Press. 42–68.

———. 1994. "Interior Colonies: Frantz Fanon and the Politics of Identification." *Diacritics* 24.2–3 (Summer–Fall): 20–42.

———. 1995. *Identification Papers*. New York: Routledge.

Gallop, Jane. 1982. *The Daughter's Seduction: Feminism and Psychoanalysis*. Ithaca: Cornell University Press.

———. 1985. *Reading Lacan*. Ithaca: Cornell University Press.

Garber, Marjorie. 1987. *Shakespeare's Ghost Writers: Literature as Uncanny Causality*. New York: Methuen.

———. 1990. "Fetish Envy." *October* 54 (Fall): 45–56.

———. 1992. *Vested Interests: Cross-Dressing and Cultural Anxiety*. New York: Routledge.

———. *Vice Versa: Bisexuality and the Eroticism of Everyday Life*. New York: Simon and Schuster.

Gates, Henry Louis, Jr. 1991. "Critical Fanonism." *Critical Inquiry* 17 (Spring): 457–70.

———. 1994. "A Liberalism of Heart and Spine." *New York Times,* 27 March, sec. E: 17.

Gay, Peter. 1987. *A Godless Jew: Freud, Atheism, and the Making of Psychoanalysis*. New Haven: Yale University Press.

Geller, Jay. 1992a. "Blood Sin: Syphilis and the Construction of Jewish Identity." *Faultline* 1: 21–48.

———. 1992b. "(G)nos(e)ology: The Cultural Construction of the Other." *People of the Body: Jews and Judaism from an Embodied Perspective*. Ed. Howard Eilberg-Schwartz. Albany: State University of New York Press. 243–82.

———. 1992c. "'A glance at the nose': Freud's Inscription of Jewish Difference." *American Imago* 49: 427–44.

Gilman, Sander L. 1985. *Difference and Pathology: Stereotypes of Sexuality, Race, and Madness*. Ithaca: Cornell University Press.

———. 1987. "The Struggle of Psychiatry with Psychoanalysis: Who Won?" *Critical Inquiry* 13: 293–313.

———. 1988. *Disease and Representation: Images of Illness from Madness to AIDS*. Ithaca: Cornell University Press.

———. 1991. *The Jew's Body*. New York: Routledge.

———. 1993a. *Freud, Race, and Gender*. New York: Routledge.

———. 1993b. "Salome, Syphilis, Sarah Bernhardt, and the 'Modern Jewess'." *German Quarterly* 66 (Spring): 195–211.

Gilroy, Paul. 1992. "It's a Family Affair." *Black Popular Culture*. Ed. Gina Dent. Seattle: Bay Press. 303–15.

———. 1993. *The Black Atlantic: Modernity and Double Consciousness*. Cambridge: Harvard University Press.

Gold, Arthur and Robert Fizdale. 1991. *The Divine Sarah: A Life of Sarah Bernhardt*. New York: Vintage Books.

Goldberg, David Theo. 1992. "The Semantics of Race." *Ethnic and Racial Studies* 15: 543–69.

Goldberg, Jonathan. 1992. "Recalling Totalities: The Mirrored Stages of Arnold Schwarzenegger." *differences: A Journal of Feminist Cultural Studies* 4.1 (Spring): 172–204.

Goldsby, Jackie. 1993. "Queen for 307 Days: Looking B[l]ack at Vanessa Williams and the Sex Wars." *Sisters, Sexperts, Queers: Beyond the Lesbian Nation*. Ed. Arlene Stein. New York: Plume/Penguin. 110–28, 151–61, 59–61.

Goffman, Erving. 1963. *Stigma: Notes on the Management of Spoiled Identity*. Englewood Cliffs, N.J.: Prentice-Hall.

Gossy, Mary. 1995. *Freudian Slips: Women, Writing, the Foreign Tongue*. Ann Arbor: University of Michigan Press.

Green, Jesse. 1992. "The Divine Sandra." *Mirabella,* August: 38–40, 42, 44.

Gribble, Francis. 1911. *Rachel: Her Stage Life and Her Real Life*. London: Chapman and Hall.

Griffith, F. Ridgway and A.J. Marrin. 1880. *Authorised Edition of the Life of Sarah Bernhardt*. New York.

Grosz, Elizabeth. 1993. "Lesbian Fetishism?" *Fetishism as a Cultural Discourse*. Ed. Emily Apter and William Pietz. Ithaca: Cornell University Press. 101–115.

Grubrich-Simitis, Ilse. 1987. Afterword. "Metapsychology and Metabiology." *A Phylogenetic Fantasy: Overview of the Transference Neuroses*. Cambridge: Belknap Press–Harvard University Press. 75–107.

Hake, Sabine. 1990. "Chaplin Reception in Weimar Germany." *New German Critique* 51: 87–111.

Halberstam, Judith. 1993. "Imagined Violence/Queer Violence: Representation, Race, and Resistance." *Social Text* 37 (Winter): 187–201.

Halperin, David M. 1995. *Saint Foucault: Towards a Gay Hagiography*. Oxford: Oxford University Press.

Hammonds, Evelynn. 1994. "Black (W)holes and the Geometry of Black Female Sexuality." *differences: A Journal of Feminist Cultural Studies* 6.2–3 (Summer–Fall): 126–45.

Haraway, Donna. 1990. "A Manifesto for Cyborgs: Science, Technology, and Socialist Feminism in the 1980s." *Feminism/Postmodernism*. Ed. Linda J. Nicholson. New York: Routledge. 190–233.

Harding, Sandra, ed. 1993. *The "Racial" Economy of Science: Toward a Democratic Future*. Bloomington: Indiana University Press.

Harrowitz, Nancy A. and Barbara Hyams, eds. 1995. *Jews and Gender: Responses to Otto Weininger*. Philadelphia: Temple University Press.

Hayden, Allyson. 1991. "Bev Beyond the Legend." *Bodybuilding Lifestyles,* Jan./ Feb.: 54–7.

Heath, Stephen. 1986. "Joan Riviere and the Masquerade." *Formations of Fantasy*. Ed. Victor Burgin, James Donald, and Cora Kaplan. London: Methuen. 45–61.

Harper, Phillip Brian. 1991. "Eloquence and Epitaph: Black Nationalism and the Homophobic Impulse in Responses to the Death of Max Robinson." *Social Text* 9.3: 68–86.

"Hips, Lips, Tits, POWER!" ("Sandra Bernhard—Read My Lips!") 1992. *The List: Glasgow and Edinburgh Events Guide,* 21–27 August: 8–9.

Hoberman, John. 1995. "Otto Weininger and the Critique of Jewish Masculinity." *Jews and Gender: Responses to Otto Weininger*. Ed. Nancy A. Harrowitz and Barbara Hyams. Philadelphia: Temple University Press. 141–53.

Holmund, Christine. 1989. "Visible Difference and Flex Appeal: The Body, Sex, Sexuality and Race in the *Pumping Iron* Films." *Cinema Journal* 28.4 (Summer): 38–51.

Hooks, Bell. 1981. *Ain't I a Woman: Black Women and Feminism*. Boston: South End Press.

———. 1990. *Yearning: Race, Gender, and Cultural Politics.* Boston: South End Press.

———. 1992. *Black Looks: Race and Representation.* Boston: South End Press.

Hull, Gloria, Patricia Bell Scott, and Barbara Smith, eds. 1982. *All the Women Are White, All the Blacks Are Men, But Some of Us Are Brave: Black Women's Studies.* New York: Feminist Press.

Hurvitz, Nathan. 1974. "Blacks and Jews in American Folklore." *Western Folklore* 33 (Oct.): 301–25.

Ian, Marcia. 1991. "The Subject of Fantasy." Bodily Refigurations. The Fifth Annual Lesbian and Gay Studies Conference. New Brunswick, New Jersey, 2 Nov.

———. 1993. *Remembering the Phallic Mother: Psychoanalysis, Modernism, and the Fetish.* Ithaca: Cornell University Press.

"Idol-Woman and the Other." 1885. *London Times,* 28 March. N. pag.

Irigaray, Luce. 1985a. *Speculum of the Other Woman.* Trans. Catherine Porter. Ithaca: Cornell University.

Irigaray, Luce. 1985b. *This Sex Which Is Not One.* Trans. Catherine Porter. Ithaca: Cornell University.

Jardine, Alice. 1981. "Introduction to Julia Kristeva's 'Women's Time.'" *Signs: A Journal of Women in Culture and Society* 7.1 (Aug.): 5–12.

Jay, Martin. 1993. "Force Fields: The Academic Woman as Performance Artist." *Salmagundi* 98 (Spring): 28–34

Jones, Ernest. 1927. "The Early Development of Female Sexuality." *International Journal of Psychoanalysis* 8: 459–72.

Kaplan, Marion A. 1979. *The Jewish Feminist Movement in Germany: The Campaigns of the Jüdischer Frauenbund, 1904–1938.* Westport, Connecticut: Greenwood Press.

———. 1991. *The Making of the Jewish Middle Class: Women, Family, and Identity in Imperial Germany.* New York: Oxford University Press

Keller, Evelyn Fox. 1985. *Reflections on Gender and Science.* New Haven: Yale University Press.

Klein, Alan. 1993. *Little Big Men: Bodybuilding Subculture and Gender Construction.* Albany: State University of New York Press.

Klein, Dennis B. 1981. *Jewish Origins of the Psychoanalytic Movement.* New York: Praeger.

Koestenbaum, Wayne. 1989. *Double Talk: The Erotics of Male Literary Collaboration.* New York: Routledge.

Lacan, Jacques. 1977. *Écrits: A Selection.* Trans. Alan Sheridan. New York: W.W. Norton.

Lacan, Jacques. 1978. *The Four Fundamental Concepts of Psychoanalysis.* Ed. Jacques-Alain Miller. Trans. Alan Sheridan. New York: W.W. Norton.

Langmuir, Gavin I. 1990. *Toward a Definition of Antisemitism.* Berkeley: University of California Press.

Lee, Sharon M. 1993. "Racial Classifications in the U.S. Census: 1890–1990." *Ethnic and Racial Studies* 16: 75–94.

Levitt, Laura. 1997. *Ambivalent Embraces: Jews, Feminists, and Home.* New York: Routledge. Forthcoming.

Logan, Andy. 1991. "Ya Me? Ya You!" *New Yorker,* 4 November: 106–12.

"Look at Me, I'm Sandra B." 1992. *Elle* (British), June: 12–16.

Lynch, Hollis R. 1984. "A Black Nineteenth-Century Response to Jews and Zionism: The Case of Edward Wilmot Blyden, 1832–1912." *Jews in Black Perspectives: A*

Dialogue. Ed. Joseph R. Washington, Jr. London and Toronto: Associated University Presses. 42–54.

MacLean, Nancy. 1991 "The Leo Frank Case Reconsidered: Gender and Sexual Politics in the Making of Reactionary Populism." *Journal of American History* 78 (December): 917–48.

Martin, Biddy. 1994. "Sexualities Without Genders and Other Queer Utopias." *Diacritics* 24.2–3 (Summer–Fall): 104–21.

McCulloch, Jock. 1983. *Black Soul, White Artifact: Fanon's Clinical Psychology and Social Theory*. Cambridge: Cambridge University Press.

Memmi, Albert. 1962. *Portrait of a Jew*. Trans. Elisabeth Abbott. New York: Orion Press.

———. 1965. *The Colonizer and the Colonized*. Trans. Howard Greenfeld. Afterword by Susan Gilson Miller (1991). Boston: Beacon Press, 1991. Trans. of *Portrait du Colonisé, Précédé du Portrait du Colonisateur*. (1957). Paris: Éditions Buchet.

———. 1966. *The Liberation of the Jew*. Trans. Judy Hyun. New York: Orion Press.

———. 1968. *Dominated Man: Notes Towards a Portrait*. Boston: Beacon Press.

———. 1971. Rev. of *Fanon*, by Peter Geismar and of *Frantz Fanon*, by David Caute, ed. Frank Kermode. *The New York Times Book Review,* 14 March: 5, 20.

———. 1975. *Jews and Arabs*. Trans. Eleanor Levieux. Chicago: J. Philip O'Hara, Inc.

Mercer, Kobena. 1991. "Skin Head Sex Thing: Racial Difference and the Homoerotic Imaginary." *How Do I Look? Queer Film and Video*. Ed. Bad Object-Choices. Seattle: Bay Press. 169–210.

Michaels, Walter Benn. 1992. "Race Into Culture: A Critical Genealogy of Cultural Identity." *Critical Inquiry* 18: 655–85.

Miller, D. A. 1992. *Bringing Out Roland Barthes*. Berkeley: University of California Press.

Mosse, George L. 1985. "Jewish Emancipation: Between *Bildung* and Respect-ability." *The Jewish Response to German Culture: From the Enlightenment to the Second World War*. Ed. Jehuda Reinharz and Walter Schatzberg. Hanover, New Hampshire: University Press of New England. 1–16.

Mulvey, Laura. 1989. "Visual Pleasure and Narrative Cinema." *Visual and Other Pleasures*. Bloomington: Indiana University Press. 14–28.

Ockman, Carol. 1991. "'Two Large Eyebrows *à l'orientale*': Ethnic Stereotyping in Ingres's *Baronne de Rothschild*." *Art History* 14.4 (December): 521–39.

———. 1995. "When Is a Jewish Star Just a Star? Interpreting Images of Sarah Bernhardt." *The Jew in the Text: Modernity and the Politics of Identity*. Ed. Linda Nochlin and Tamar Garb. London and New York: Thames and Hudson.

O'Connor, John J. 1993. Rev. of *Fires in the Mirror*. American Playhouse, Public Broadcasting Corporation. *New York Times,* 28 April, late ed., sec. C: 18.

Olender, Maurice. 1992. *The Languages of Paradise*. Trans. Arthur Goldhammer. Cambridge: Harvard University Press.

Oram, Alison. 1989. "'Embittered, Sexless or Homosexual': Attacks on Spinster Teachers 1918–39." *Not a Passing Phase: Reclaiming Lesbians in History 1840–1985*. Ed. Lesbian History Group. London: The Women's Press. 99–118.

Pener, Degen. 1993. "Egos and Ids: The Stuff that Plays Are Made Of." *New York Times,* 13 June, late ed., sec. 9: 4.

Peskowitz, Miriam and Laura Levitt, eds. 1996. *Judaism Since Gender*. New York: Routledge. Forthcoming.

Phelan, Peggy. 1993. *Unmarked: The Politics of Performance*. London: Routledge.

———. 1995. "Performing Talking Cures: Theatre, Lies, and Audiotape." Language Machines. English Institute. Cambridge, Massachusetts, 27 Aug.

Probyn, Elspeth. 1993. *Sexing the Self: Gendered Positions in Cultural Studies*. New York: Routledge.

Richards, Sandra L. 1993. "Caught in the Act of Social Definition: *On the Road* with Anna Deavere Smith." *Acting Out: Feminist Performances*. Ed. Lynda Hart and Peggy Phelan. Ann Arbor: University of Michigan Press. 35–53.

Rieder, Jonathan. 1991. "Crown of Thorns: The Roots of the Black-Jewish Feud." *New Republic*, 14 October: 26, 28–31.

Ritvo, Harriet. 1994. "Barring the Cross: Hybridization and Purity in Eighteenth- and Nineteenth-Century Britain." Humane Societies. English Institute. Cambridge, Massachusetts, 2 Sept.

Riviere, Joan. 1986. "Womanliness as a Masquerade." *Formations of Fantasy*. Ed. Victor Burgin, James Donald, and Cora Kaplan. London: Methuen Books. 35–44. 1929. *International Journal of Psychoanalysis* 10: 303–13.

Roderich-Stoltheim, F. 1927. *The Riddle of the Jew's Success*. Trans. Capel Pownall. Leipzig: Hammer-Verlag.

Rodriguez, Clara E. and Hector Cordero-Guzman. 1992. "Placing Race in Context." *Ethnic and Racial Studies* 15: 523–41.

Roediger, David R. 1994. *Towards the Abolition of Whiteness*. London: Verso.

Rogin, Michael. 1992. "Blackface, White Noise: The Jewish Jazz Singer Finds His Voice." *Critical Inquiry* 18: 417–53.

Roith, Estelle. 1987. *The Riddle of Freud*. New York and London: Tavistock Publications.

Roof, Judith. 1991. *A Lure of Knowledge: Lesbian Sexuality and Theory*. New York: Columbia University Press.

Rosenberg, Alfred. 1970. *Race and Race History and Other Essays by Alfred Rosenberg*. Ed. Robert Pois. New York: Harper and Row.

Rothstein, Mervyn. 1992. "Racial Turmoil in America: Tales from a Woman Who Listened." *New York Times*, 5 July, late ed., sec. 4: 7.

Rubin, Gayle. 1975. "The Traffic in Women: Notes on the 'Political Economy' of Sex." *Towards an Anthropology of Women*. Ed. Rayna R. Reiter. New York: Monthly Review Press. 157–210.

———. 1993. "Thinking Sex: Notes for a Radical Theory of the Politics of Sexuality." *The Lesbian and Gay Studies Reader*. Ed. Henry Abelove, Michèle Aina Barale, David M. Halperin. New York: Routledge. 3–44.

Sandoval, Chela. 1991. "U.S. Third World Feminism: The Theory and Method of Oppositional Consciousness in the Postmodern World." *Genders* 10 (Spring): 1–24.

"Sandra's Blackness." 1992. *Vibe* 1: 116.

Sartre, Jean-Paul. 1948. *Anti-Semite and Jew*. Trans. George J. Becker. New York: Schocken Books. Trans. of *Réflexions sur la Question Juive*. (1946). Paris: Éditions Morihien.

Schulze, Laurie. 1990. "On the Muscle." *Fabrications: Costume and the Female Body*. Ed. Jane Gaines and Charlotte Herzog. Routledge: New York. 59–78.

Sedgwick, Eve Kosofsy. 1985. *Between Men: English Literature and Male Homosocial Desire*. New York: Columbia University Press.

———. 1990. *Epistemology of the Closet.* Berkeley: University of California Press.

———. 1993. "Queer Performativity: Henry James's *The Art of the Novel.*" *GLQ: A Journal of Lesbian and Gay Studies* 1.1: 1–16.

Sedgwick, Eve Kosofsky and Andrew Parker, eds. 1995. *Performance and Perfor-mativity: Essays from the English Institute.* New York: Routledge.

Sessums, Kevin. 1994. "Simply Sandra." ["Sandra in Wonderland: Bernhard Gets Bigger"]. *Out* (Sept.): 68–73, 124–7.

Shattuck, Roger. 1991. "Sacred Monster." Rev. of *The Divine Sarah: A Life of Sarah Bernhardt,* by Arthur Gold and Robert Fizdale. *New Republic,* 14 Oct.: 34–8.

Silverman, Kaja. 1988. *The Acoustic Mirror: The Female Voice in Psychoanalysis and Cinema.* Bloomington: Indiana University Press.

Smith, Anna Deavere. 1992a. "Defining Identity: Four Voices (George C. Wolf, Angela Davis, Robert Sherman, Ntozake Shange)." *New York Times,* 24 May, late ed., sec. 4: 11.

———. 1992b. "Cultural View: Inside the Political Mimic's Fun-House Mirror." *New York Times,* 16 August, late ed., sec. 2: 20.

———. 1992c. "Anna Deavere Smith." Interview by Thulani Davis. *Bomb* 41 (Fall): 40–43.

Smith, Anna Deavere. 1993a. *Fires in the Mirror: Crown Heights, Brooklyn and Other Identities.* New York: Anchor-Doubleday.

Smith, Anna Deavere, writer and solo performer. 1993v. *Fires in the Mirror: Crown Heights, Brooklyn and Other Identities.* Dir. George C. Wolfe. American Playhouse. Public Broadcasting System. 28 April.

———. 1994a. "Media Killers." Interview by Kevin L. Fuller and Andrea Armstrong. *Appendx: Culture, Theory, Praxis* 2: 104–37.

———. 1994b. Anna Deavere Smith on *Fires in the Mirror.* Interview by Kay Ellen Capo with Kristin M. Langellier. *Text and Performance Quarterly* 14.1 (Jan.): 62–76.

Smith, Chris. 1994. "Back to Crown Heights/Crown Heights Witness." *New York,* 29 August: 34–9.

Spelman, Elizabeth V. 1988. *Inessential Woman: Problems of Exclusion in Feminist Thought.* Boston: Beacon Press.

Spillers, Hortense. 1987. "Mama's Baby, Papa's Maybe: An American Grammar Book." *Diacritics* 17.2 (Summer): 65–81.

Spivak, Gayatri Chakravorty. 1994. "Examples to Fit the Title." *American Imago* 51 (Summer): 161–96.

Studlar, Gaylyn. 1990. "Masochism, Masquerade, and the Erotic Metamorphoses of Marlene Dietrich." *Fabrications: Costume and the Female Body.* Ed. Jane Gaines and Charlotte Herzog. Routledge: New York. 229–49.

Terry, Jennifer. 1990. "Lesbians Under the Medical Gaze: Scientists Search for Remarkable Differences." *The Journal of Sex Research* 27 (August): 317–39.

Trachtenberg, Joshua. 1943. *The Devil and the Jews: The Medieval Conception of the Jews and its Relation to Modern Anti-Semitism.* New York: Harper and Row.

Tyler, Carol-Anne. 1994. "Passing: Narcissism, Identity, and Difference." *differences: A Journal of Feminist Cultural Studies* 6.2–3 (Summer–Fall): 212–48.

Van Herik, Judith. 1982. *Freud on Femininity and Faith.* Berkeley: University of California Press.

Walton, Jean. 1994. "Sandra Bernhard: Lesbian Postmodern or Modern Postlesbian?" *The Lesbian Postmodern*. Ed. Laura Doan. New York: Columbia University Press. 244–61.

Weber, Bruce. 1993. "On Stage, and Off." *New York Times,* 23 April, late ed., sec. C: 2.

Weeks, Jeffrey. 1977. *Coming Out: Homosexual Politics in Britain, from the Nineteenth Century to the Present*. London: Quartet Books.

———. 1981. *Sex, Politics and Society: The Regulation of Sexuality Since 1800*. London: Longman.

Weininger, Otto. 1906 [1903]. *Sex and Character*. London: W. Heinemann. New York: G. P. Putnam's Sons. Translation of the sixth German edition.

Weinraub, Melvin. 1993. "Condensing a Riot's Cacophany into the Voice of One Woman." *New York Times,* 16 June, late ed., sec. C: 15.

West, Cornel. 1993. *Race Matters*. Boston: Beacon Press.

Williams, Linda. 1989. *Hard Core: Power, Pleasure, and the "Frenzy of the Visible"*. Berkeley: University of California Press.

Williams, Patricia J. 1991. *The Alchemy of Race and Rights: Diary of a Law Professor*. Cambridge: Harvard University Press.

———. 1995. *The Rooster's Egg: On the Persistence of Prejudice*. Cambridge: Harvard University Press.

Wright, Damon. 1992. "Theater: A Seance with History." *New York Times,* 10 May, late ed., sec. 2: 14.

Wright, Richard. 1940. *How "Bigger" Was Born*. New York: Harper and Brothers.

Yerushalmi, Yosef Hayim. 1991. *Freud's Moses: Judaism Terminable and Interminable*. New Haven: Yale University Press.

Young, Iris Marion. 1990. "The Ideal of Community and the Politics of Difference." *Feminism/Postmodernism*. Ed. Linda J. Nicholson. New York: Routledge. 300–23.

INDEX